THE **OUTDOOR** DECORATOR

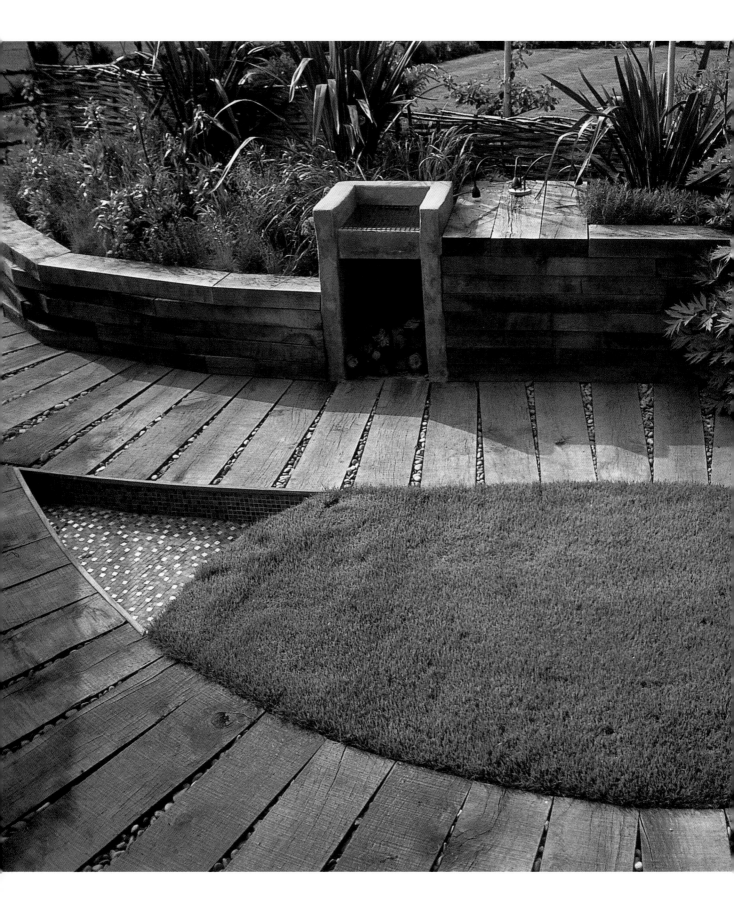

THE **OUTDOOR DECORATOR**

Design and practical ideas for creating living spaces in the garden

Kevin McCloud

Special photography by Tim Mercer

EBURY PRESS
LONDON

To Milo

First published in Great Britain in 2000

3 5 7 9 10 8 6 4 2

Text © Kevin McCloud 2000 Special photography © Ebury Press 2000

First published by Ebury Press, Random House, 20 Vauxhall Bridge Road, London SW1V 2SA. Random House Australia (Pty) Limited, 20 Alfred Street, Milsons Point,
Sydney, New South Wales 2061, Australia. Random House New Zealand Limited, 18 Poland Road, Glenfield, Auckland 10, New Zealand. Random House South Africa
(Pty) Limited, Endulini, 5A Jubilee Road, Parktown 2193, South Africa. The Random House Group Limited Reg. No. 954009 www.randomhouse.co.uk

A CIP catalogue record for this book is available from the British Library.

Special photography Tim Mercer **Editor** Judy Spours **Art direction and design** Vanessa Courtier **Design assistant** Gina Hochstein
Picture research Nadine Bazar **Styling on selected projects** Gilly Love

ISBN 0 09 186439 9

Papers used by Ebury Press are natural, recyclable products made from wood grown in sustainable forests.
Printed and bound in Singapore by Tien Wah Press

CONTENTS

THE OUTDOOR PLOT 6

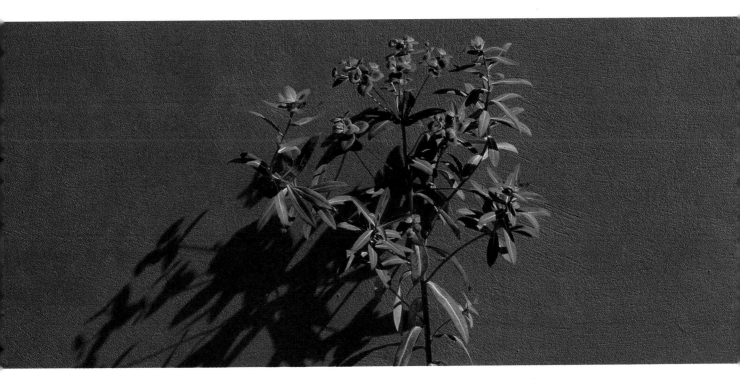

CREATING THE GARDEN 56

The Outdoor Plot

The very activity of gardening is strenuous and difficult. Physically, it can be back-breaking, a test of strength and endurance as we dig and hoe and plant and weed, only to weed and to dig again. But it is in our minds that gardening slyly presents its real challenges, its devious and persistent bluffs, calling on all our reserves of psychological stamina in challenging the superiority of the unruly. All of us gardeners grapple with nature in an effort to bend it to our will, to eradicate its devilish, invasive side and to impose our pathetic knowledge of its workings on the little green rectangles outside our houses.

At the same time, we engage in a more social version of this battle. We play a game with our friends and acquaintances of horticultural brinkmanship, of nervous display of our half-understanding of how things work in the natural world. I might talk smugly of how well I know how to prune my apple tree, only to be told by my elderly neighbour that the blasted thing has scab and bitter-pit and probably won't get through the winter without falling over. Strangely, because of this uncomfortable type of budding-gardener-meets-well-meaning-old-know-it-all encounter, I have discovered a new and deeper relationship with – of all people – my mother, who is a keen plantswoman. It amazes me that I can ask her obvious questions and swap inane tittle-tattle without embarrassment or fear of derision. It has surprised me how knowledge can be so easily exchanged in a relationship, and it is an involvement with gardening that has brought this realization.

The confused and insecure perceptions that we have about gardening derive partly from this silly game of superior skills and partly from the way that over the centuries horticulture has built its own elite phraseology and status. The very language of the soil and the Latin nomenclature of plants are difficult to grasp and this means that most of us see ourselves as failed gardeners before we have even started. After all, you are not a real gardener unless you are a member of some Horticultural Society, some Organic

Research Association or a special interest club like the Federation of Fuschia Ticklers. At its worse, gardening has become institutionalized, regulated, pompously elevated and twisted out of recognition to the ordinary person.

But gardening really is a vast and complex area of understanding, so it is not surprising to find it cloaked in all this seriousness, worthiness and self-regard. The special-interest magazines and societies have an important academic part to play, and seed banks and testing stations have crucial roles in the development of disease-resistant strains of plants and crops. And the enthusiasm and erudite learning of thousands of plant-lovers across the globe ensure that species diversity is maintained and that the rest of us have beautiful gardens to visit.

It is important also to realize that gardening is, perhaps, the last truly democratic activity, a great leveller in society, since it is open to anyone, even if he or she has no more than a plant pot, a window sill and a fascination for nature. As well as being complex and stuffy, gardening can also be incredibly simple, personal and relaxing. It can be explored at an intimate level, involving you, the seed and Mother Nature, to the exclusion of anyone else. It is a great adventure of trial and error, of understanding and of marvel at the magical and sustaining intricacies of living things. And, just as there are the great and pompous national bodies and unusual specialist publications, so there are local gardening clubs, gardening consumer magazines, television programmes and books, all exhorting us to have a go. There are also our loved ones – parents, partners and close friends – who will gladly share their knowledge and enthusiasm.

The problem, however, is knowing where to begin. Most of us start with either a blank canvas of brown soil or a second-hand garden that we inherited with the house. We are crying out for help yet swamped by information and by other people's

enthusiasms. We are told to check the pH of our soil, think about winter colour, the position of the sun, watering, organic permaculture and compost recycling. We are encouraged to distinguish between annuals and perennials, to plan planting schemes that maximize colour and flowering throughout the year and to design our borders with interest and height in mind.

In whichever direction we are pulled, as novices we are terrified by the implications. What if it all goes wrong? What if I design an idiotic planting scheme that all flowers in May and is over? What if all the plants die? Our nervous questions are rampant. I have to confess to having been there. My first garden did sort of die, and I have had ridiculous ideas for planting schemes, based on assumptions about which colours might go together while I remained blissfully ignorant of the varying soil requirements of each plant and of the fact they all flowered at different times of the year.

Like all gardeners, I still encounter disappointments every season. But after fifteen years of enthusiastic and passionate, albeit frustrating, gardening, I have finally realized the nature of the problem. It is nothing to do with the snobbery of plant academics, Latin names or even the vagaries of nature matched against our own amateur understandings, but lies one step behind these symptoms. The real problem is that our great cultural enthusiasm for gardening means that we are a nation of plant-lovers, that plantsmanship is considered important above all else and that a great garden is measured by its planting alone. This fact leads us to ignore or diminish the importance of other crucial elements in our gardens – such as design, layout, simplicity and visual integrity.

Many of these considerations cannot be taught in a book; we can be shown them or study them, but it is only in practice that we can explore them fully. Some, such as the way in which we use gardens and how they relate to interior design, are easily under-standable from experience. And some, those that are teachable, are addressed in this book.

Very few of us will ever create the perfectly designed border, let alone the complete garden. Although we are happy to choose paint, fabrics and wallpapers for our homes, designing with plants seems by comparison a vague and slippery thing to do. You just can't put your finger on a dried-up little brown bulb and say, categorically, that it's going to be perfect, matching or complementary in the way that you can with a curtain fabric. The obvious answer with garden design is to avoid making planting decisions at the outset and concentrate on the other elements. All you need do is apply the same skills, familiar ideas and judicious tastes that you use indoors to the outdoor space. Planting plays a crucial role as one element in exterior design, but it is only one of many.

This book is about cross-fertilization between interior and exterior design, exploring the ways in which we might use paint, structure, lighting and colour outside. It is also about that strange word 'hardscaping', where building materials of all kinds are used to make hard landscapes into which planting areas can be inserted. Some of the projects described are elementary, while others involve the design of an entire garden. They all, however, embody the idea that strong design, using materials and objects other than (and together with) plants, is the route to a successful, meaningful and useful garden.

To illustrate the point, it is worth considering how many gardens still rely on the nineteenth-century idea of curving, pseudo-naturalistic flower beds, bustling with confusions of colour and form. On the other hand, how many are there that integrate into their designs children's activity centres, garden furniture and barbecues as a matter of course? Good garden design is not just about visual delight, but should also involve our everyday lives: it should be friendly and ergonomic and it should offer us the opportunity to use the outside as an extension of our interior living spaces, as well as, perhaps, offering us a glimpse of our own personal Eden. Above all, it should be dedicated to our enjoyment.

Structure & Planning

Other than gardeners, I know of only five different professionals who delight in using the word 'structure': literary critics

(Structuralism and so on); beauty consultants ('She's got fabulous bone structure'); architects (the building of structures);

and lingerie designers. Oddly enough, the use of the word in gardening refers to the planting mix of herbaceous beds, rather

than to any engineering structure that the plants, or their supports, might exercise. In fact, a well-planted border has all the

structural integrity of a puddle of water, and needs the canny contrivances of man to help it even stand up. This misuse of

the word typifies in my obsessive mind everything that is wrong about current views about garden design. It is almost as

though the word is so dirty that it has to be horticulturally sanitized to take on another meaning.

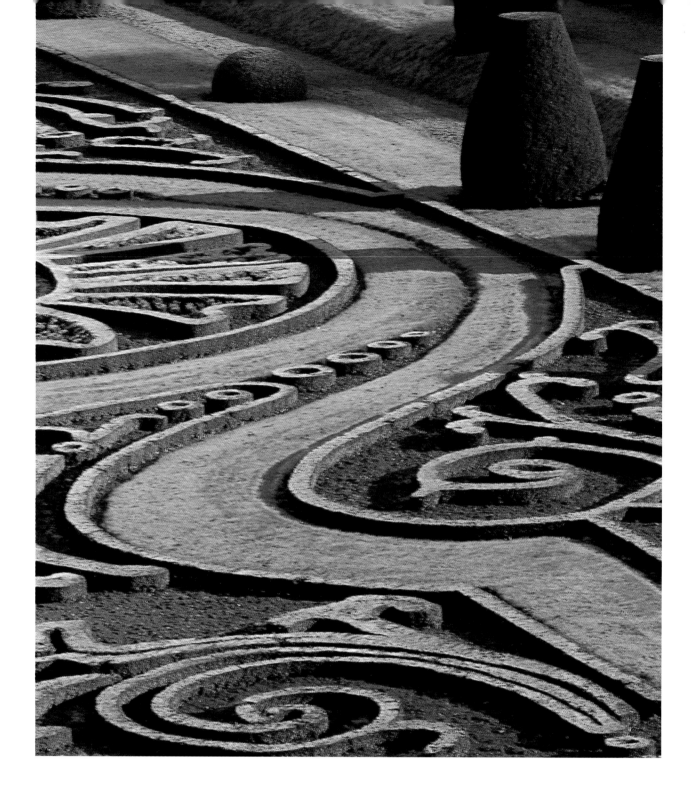

This chapter is a call for the reintroduction of true structure into the garden, not in beds but in the very fibre of a concept, in the grand scheme. The best definition of the word I can think of is 'backbone' – some purposeful idea, philosophy or even graphic layout that underscores the garden design. This approach has been admirably pursued by past generations, not least by the first Elizabethans, who spent vast sums and years of their

lives creating splendidly theatrical settings outside their houses. No doubt many of them were driven by pomp and a need to impress at court; but for the majority, garden design represented an opportunity, unshackled by the practicalities of building, to explore ideas, hopes and dreams current in the literature and philosophy of the time.

They constructed lakes to represent the oceans of the world, hills and mini-fortresses, mazes and knot gardens as mathematical, three-dimensional expressions of conundra and as representations of the ideal. These landscapes were peopled on great occasions by strange characters, such as dwarves and exotic birds, who unfolded pageants and

allegories to a privileged audience. These huge and costly charades were devised in the pursuit of Elizabethan ideas about the ennoblement of the Queen as Gloriana, and about the contemporary obsessions with deceit, wit, devices and complexity.

In every age, except perhaps our own, gardeners have been keen to express something typical of their times. At the start of a new century, a few glimmers of contem-

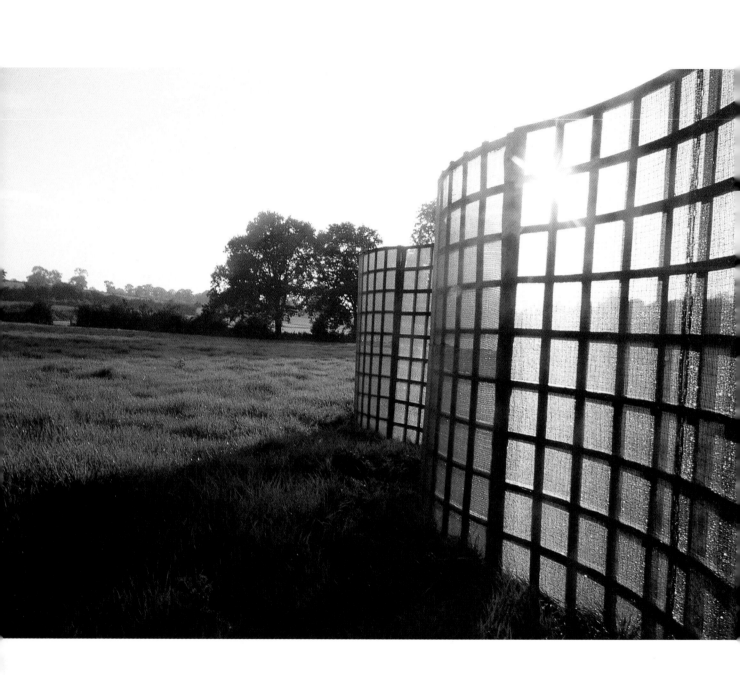

The repeating of strong, simple forms is a clever way to impose a strong sense of design. These curved trellis panels are customized with greenhouse netting and are used throughout our garden and orchards.

porary design are reflecting something of the spirit of our own age. For example, Charles Jencks and his late wife Maggie Keswick engineered an extraordinary landscape in the Borders region of Scotland. It appears simple, almost Neolithic and yet strikingly modern and is based on a complex, symbolic exploration of cosmology. Around the world, others such as Martha Schwartz in America, who makes 'virtual' gardens with few, if any, living plants and Jacques Wirtz in Belgium, who sculpts landscapes with grasses and water features, are also defining modern garden design as elegantly conceived and in touch with its context and surroundings. The gardens these talented designers have produced are somehow prisms reflecting all the other elements of our culture, encompassing many vibrant parts of our lives.

And it may sound daft, but there is no reason why any of us cannot achieve similarly great things in our own gardens if we learn the secret of structure. Its message is probably not learnt from the pages of a gardening magazine or from a philosophy textbook. Inspiration may be found during a holiday, in another garden or simply by finding a chance arrangement of three or four plants around which you can build an entire scheme. Sometimes an idea need not even be verbal, it can simply be about the colour blue, or about stone, or about love. Sometimes you don't even conceive of it as an idea but as a feeling or a passion. When this happens, go with the passion, follow it through and plan everything in the garden around it. The principle to remember is never to let your idea be diverted or compromised. For it to work, it must operate simply on a big scale and find repeated expression in all kinds of detail.

I once saw a garden that had been painstakingly assembled with gnomes, Astroturf and plastic flowers. It was a hymn to kitsch and yet it had been constructed with such commitment and belief that it worked brilliantly and defied my instinctive reaction to dismiss it. Another, more conventional example is the work of garden designer Simon Johnson, who employs a very simple structural device in some of his projects, that of 'mass planting', using the same plants again and again to create rhythms and symmetry. By keeping a plant list simple like this, you can use natural colour and texture to re-inforce an idea. The garden illustrated on page 20 is called the 'hot garden', principally because it started out as an enclosed area where oranges, reds and yellows could be planted at a distance from the tamer-coloured borders. In the end, the plants used were distributed again and again all round the garden to strengthen this idea. Moreover, the very use of this 'outdoor room', with its flower bed, barbecue, paddling pool and furniture, is intended for the warmest summer evenings when the sunlight vividly catches the patchwork of floral hues. The whole place, the big idea if you like, is about warmth and containment.

The big ideas are also often successful when they result from some kind of cross-fertilization from another discipline. This may sound highfalutin, but this book is full of ideas that have in effect just been lifted out of interior design and applied instead to the outside. By choosing appropriate, weatherproof materials and considering how plants will grow among the finished projects, you can see how relatively easy it is to come up with an original idea. This approach works not only on a small scale, but also on a larger one. Just as you might paint a room, it is almost as easy to paint the perimeter wall of a

small garden; and just as the wall colour of a room has a huge determining effect on its mood, so an entire garden's character can be brought to life in the same way.

To work on this kind of big scale, you need to be confident that your ideas are going to work. To help you, there are two key aids: first, ruthless planning; and, second, devices and techniques that can help you to visualize how it will all look when it's finished. It is bad enough trying to design your living-room, let alone an entire wasteland outside your window. Add to this the vagaries of weather, planting and nature and you might as well give up. It is all so horribly daunting. And yet designing and planning your garden is far less cumbersome a procedure than planning the design of a room. For a start, we all somehow feel more creatively liberated when we start talking about gardens. I have heard stuffy retired generals wax poetic about the emotional overtones of their shrubberies. Gardening gives vent to our softer, more expressive side and we are prepared to entertain more colour, pattern and excitement here, and we are more open to choice. There is also another huge advantage to designing outdoors. Our interiors are often relatively cramped spaces, stuffed with furniture and overburdened with function. We use dining-rooms, bathrooms and bedrooms for specific purposes and they are wired, heated and plumbed accordingly. The garden outside is a much more flexible space, a place where the imagination can live!

The first step is not to rush out and start building, but to sit and think and then think some more. The next, crucial task is to build up some overall plan of the garden, and you must first make a survey of the area you want to develop, using a tape measure and pencil and paper. This deceptively easy process usually provides you with a startlingly interesting view of the garden, one from above, that somehow helps take you a step forward in developing your ideas. I don't know exactly why it should be the case, but a well-designed garden, like a house, nearly always works well in plan – and vice versa. Equally, I have visited countless gardens that have clearly never been designed from any kind of plan and I remember them all as flaccid. The plan, although a two-dimensional flat view, will help you to solve all kinds of problems, especially when you start to imagine yourself moving around it on ground level, discovering the views and walks it will create. And, as you are laying out your garden in your mind, sketch it out in plan, and every time you make a change in your head, incorporate it on paper. Your drawing need be neither highly technical nor artistic, it should simply be an *aide-mémoire*, a visual notepad to help you resolve your scheme as it develops. A useful tip is to buy a layout pad from a stationer. Layout paper is deliberately thin in order for ink lines to be visible through a clean sheet – you simply start work at the back of the book and every time you redraw the idea you can trace through the elements you want to keep.

A lesson I have learnt is to follow the path of simplicity wherever possible. This is a gentle plea for order. The kitchen garden featured on page 75 is based on an interesting medieval idea about dividing an area into squares, like a chequer-board. In the end, the whole layout and even the design of the raised beds was based on squares, a simple enough principle. But I now regret not being even more rigorous; we used a variety of materials for paving which, given the chance, I would immediately swap for the simple combination of grass and gravel squares that works so well over much of this garden.

Garden design has sometimes almost nothing to do with plants, as the roof of the Bank of America building in San Francisco, designed by Topher Delaney, clearly demonstrates.

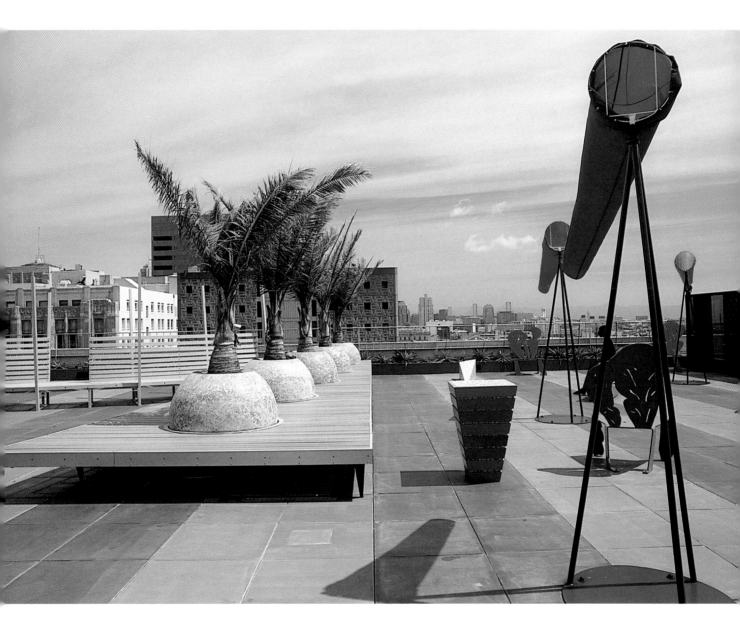

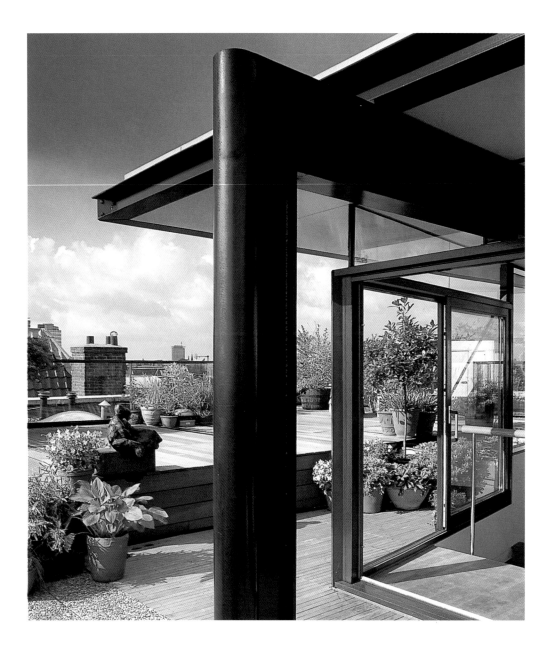

Again the message is clear – keep the big idea simple and keep repeating it. Nature and the passage of time will add the interest and variety.

In our garden, we recently came to a tumultuous decision about the planting of two large rectangular beds in front of the house that had been dumped with a variety of unsuccessful shrubs and perennials for four years. The answer was to rip it all out and plant a hedge of box, twenty metres long, two metres wide and twenty centimetres tall. I don't know if it will work and it will certainly cost a bit, but I am betting that it will look neither anaemic nor indecisive.

ABOVE LEFT The relationship of the architecture of a building to the architecture of a garden is crucial, requiring sensitivity to the context in which the garden is to be made.

ABOVE RIGHT The barrier
between the house and
garden can be softened –
with furniture clothing the
exterior of the building and
by large pots that can be
moved indoors and out.

With a basic shape or principle guiding your ground-plan, you can begin to think of
incorporating some of the more stimulating elements: paths, seating, water features, tubs
and planters, raised or sunken areas. These give purpose to the garden by providing you
with entertainment, walks and places to stop and admire. I think of them as punctuation,
pieces that make sense both of the way the garden is organized and used.

There are more drastic and time-consuming methods of visualization. You could attempt
to construct a model of the area. I know one enthusiast who resorted to the stick-down
felt grass and little plastic trees that are sold in model shops to decorate train sets. His

design was admirable and I recommend his methods. Or you could pilfer little plastic building bricks from your children's toy box. When painted, they are useful, if crude, indicators of how a structure might look, especially if it is constructed mainly of rectilinear walls, raised beds and paving.

Alternatively, I have always found faked photographs very useful devices for transporting my imagination into the future. Start by enlarging some photos of the existing space, preferably taken on a sunny day, on a photocopier, and then buy a gardening

ABOVE LEFT A strong overall design with a simple ground-plan is the short cut to a successful design. This is our hot garden, designed around simply one basic, teardrop-shaped central area.

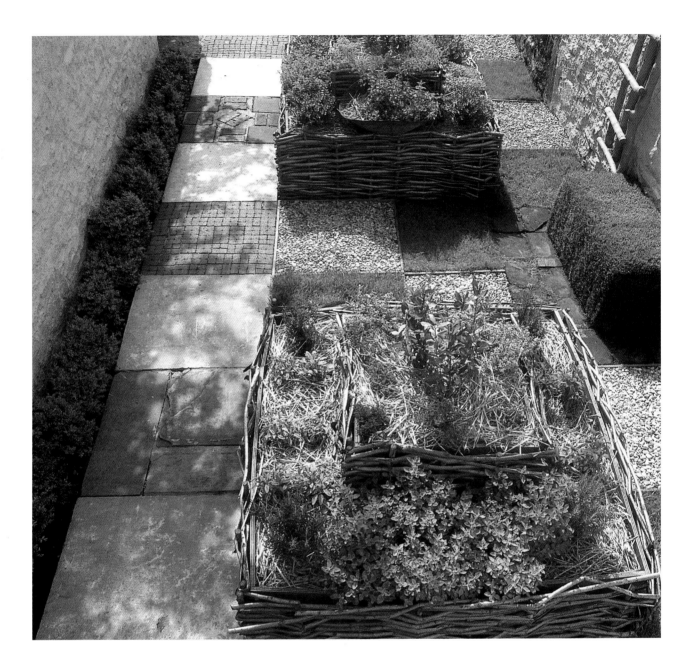

ABOVE RIGHT The ground-plan is the two-dimensional expression of an idea; the three-dimensional objects, such as walls, seating and raised beds, project right out of it here in our kitchen garden.

magazine or two. Rip out structures and objects and hedges and plants that you like from the magazines. It is an easy task to move them around on the enlarged photocopy, trying them in different combinations and adding outlines of other, original elements, in pencil first and then pen. Paste the lot down and then photocopy again. The resulting single image on one thickness of paper will give you a realistic impression of what the garden could look like. I have often used this technique – that is, until I acquired a little digital camera and some photo-enhancing computer software.

Light & Colour

Shade in the garden is almost more important than light, especially in the height of summer. And as gardens are increasingly

being used as extensions of our indoor living spaces, so we humans require as much tender protection from the sun as our

plants. Light and shade are also essential romantic elements, creating deep contrasts, enriching colour and teasing texture

out of plants and materials. But they are also more powerful and significant than that. Although it never strikes us as truly

obvious, light (whether daylight or artificial) is fundamental to our perception. Without it we would be blundering about in

chaos, blind to a visual sensory world. Before design, before aesthetics and colour, there must be light – it is of the

beginning of all things.

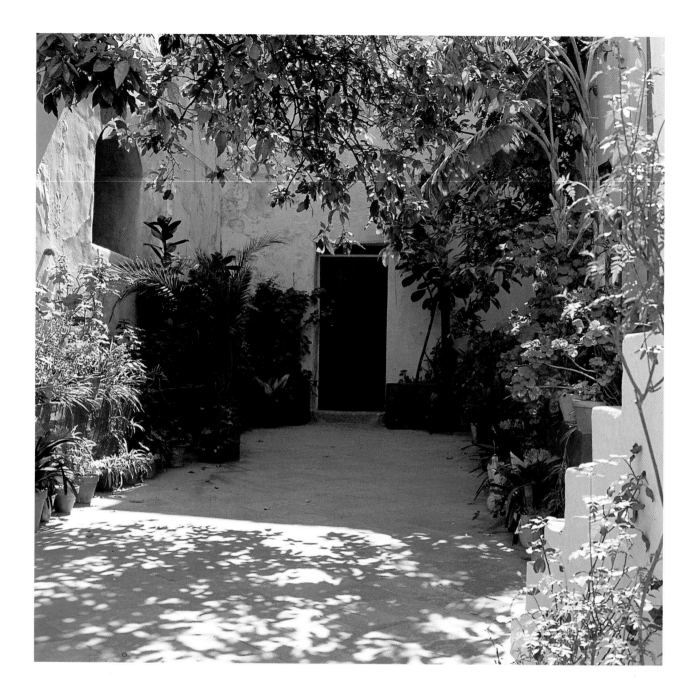

There could be no more absolute beginning than that described in Genesis 1:3-4: 'And God said, Let there be light: and there was light. And God saw the light, that it was good: and God divided the light from the darkness.' The second, less-quoted sentence may seem obvious: that without light there is no darkness and vice versa. But these words can be interpreted quite rigorously, in terms of the fact that light itself is invisible as it travels through the air, only seen when it hits a surface and excites the molecules within it. Light

Pure white, brilliant sunlight in a patio garden in Spain bleaches the whitest of walls and creates appealing blue shadows. The sun can be so intense that it will drain the colour out of almost any surface.

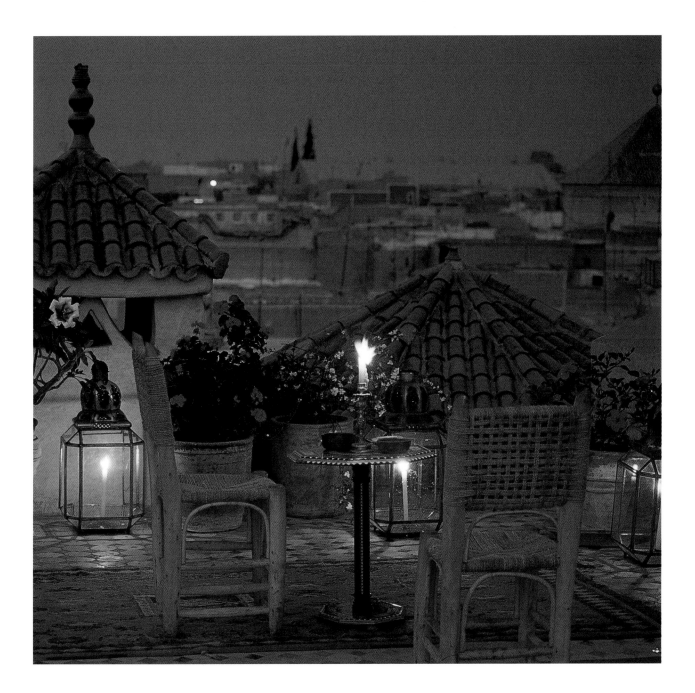

By contrast, the whole landscape in hot countries can change dramatically at night, when a million artificial light sources subtly illuminate the same architecture, giving it depth and colour.

is the slipperiest of substances – invisible of itself, weightless and impossible to grasp. It is made of the same stuff as radio- and micro-waves, merely beating at a different pulse. It moves in straight lines, yet is chimerical in character. We perceive the world only because different surfaces absorb sunlight in various cocktails of colour and reject the hues that they don't want. The reason a leaf is green is because green is the one colour of light that a leaf doesn't need to photosynthesize; what we actually see is the leaf's rejects.

So it follows, as night does day, that if you change the colour of light, the object before you also changes. The flowers on my philadelphus appear white in daylight and yellow under the single street light in our lane. In England, under a cloudy grey sky, they are really not white at all, but a dull bluish grey. I don't ever see them as such a depressing colour, because my mind tricks me with its colour memory: it has adopted the colour they reflect under light on a clear day when I am out enjoying the garden as its touchstone. If

The light of northern countries is predominantly blue, because the cloud layer – particularly if it is thick – filters out many of the other colours of the spectrum.

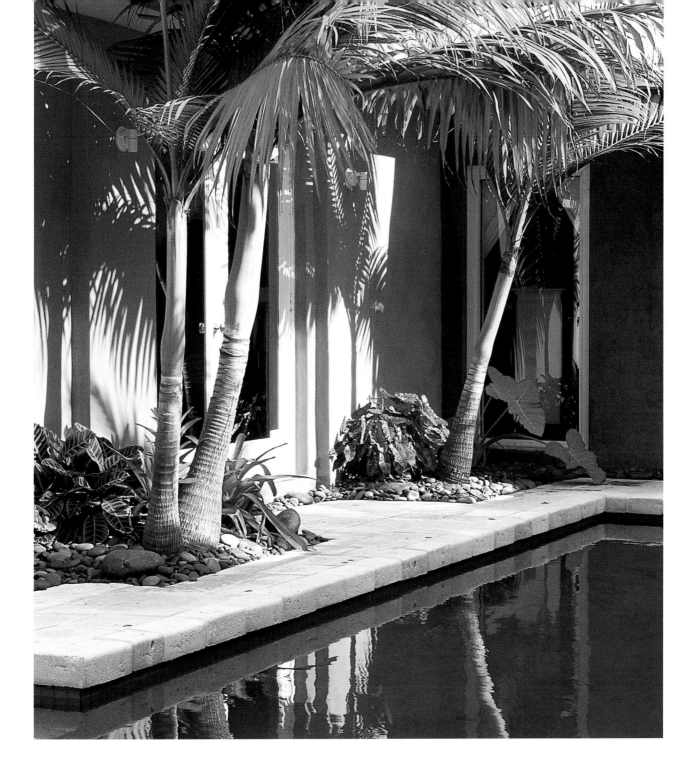

Direct sunlight provides full-spectrum illumination. If the sun is not too fierce, we perceive colours all around the spectrum with equal intensity.

you're suspicious of this phenomenon, ask a couple of friends to identify the colour of their own car after dark under yellow, sodium street lighting. They should have no problem, because although they can't see the true colour, they mentally superimpose their memory of it on what they actually see. Ask them then to spot the colour of a stranger's car, or worse, ask them to find one dark blue, one red and one black car. It's impossible, unless they already know their true colours.

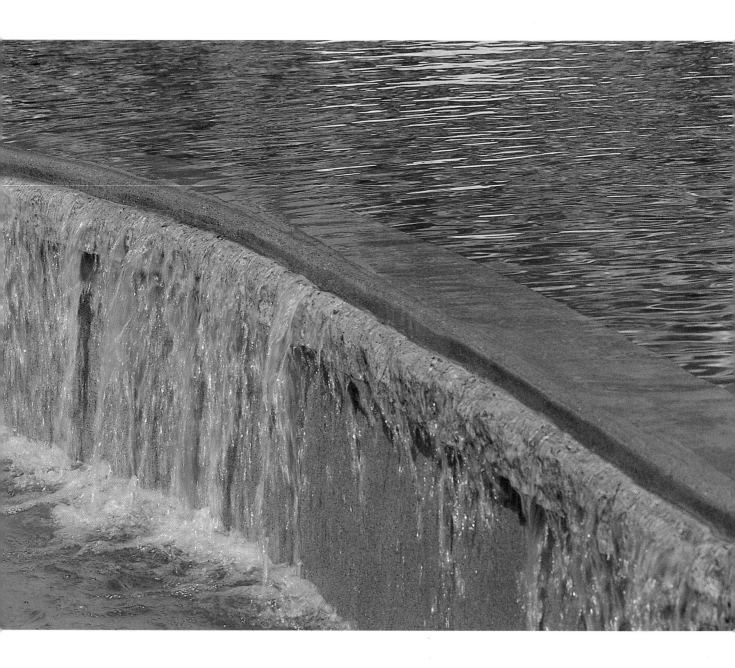

If you combine visual memory with the nostalgia we all feel for sun-kissed holidays in sunny latitudes, you really start to run into problems. We have all stared in rapture at the colours of houses and walls in other countries. The red walls of Taroudant in Morocco or the blood-coloured streets of old Rome, for example, are passionately vibrant backgrounds to their gardens. And we have all dreamed of bringing those colours back to our own homes and gardens. I have fallen in love with the ultramarine blue used by Yves Saint Laurent in his Moroccan garden, the colour that is also used on houses on the Greek isle of Lesbos. But these colours often seem so dull and lifeless when they are

The trick with light, be it natural or artificial, in a garden is to harness and modulate it. There is no better medium with which to do so than water: it captures light, reflecting it off its surface and refracting it through drops and cascades. The combination of winking, bubbling and rippling light, of movement and sound, makes water the essential garden element.

transposed into a garden somewhere further north. Whether used on tiles, in traditional paints like limewash or as components in modern coatings that can be used to paint plant pots and fencing, these colours just don't seem to reverberate in the way they did in the Mediterranean.

We all think it possible to paint our gardens these days; it has become very fashionable to do so. We also expect the exotic paint colour names to somehow transport our homes to somewhere just north of the Equator, even if they are in quite another part of the world. It doesn't always work, because the light in Lesbos and Morocco – and, for example, in their latitudinal equivalent California – is bright, so the eye accommodates the startling contrasts of powerful colours that it reflects – of brilliant white houses and deep inky shadows. On the other hand, in the grey old north, such colour combinations look very sad. The white looks grey and the blue (although it might sit well by itself) appears sullied by the white. The first trick to getting such colours to work may be to avoid this contrast problem by not using them in combination. White alone can scintillate on cottages and houses set into a green landscape, and even ultramarine blue has a place by itself as a garden wall colour.

The second trick is to understand what colours work with different qualities of light. We know instinctively that a northern climate's light is different, that it seems softer, somehow greyer and actually subtler than the brilliant glare of a Mediterranean noon. This description is not only subjective, it also sums up the light's optical character. Indirect light reflected from a northern sky is different in its very substance to Mediterranean light, which may sound strange, given that it all arrives at the planet Earth from the same source. But this makes sense once you remember that light is composed of many different colours (that can be released from white light with a prism) fused together into what we generically call 'white' light or 'daylight'. In fact, daylight can vary enormously in colour (according to the time of day and the amount of dust and moisture in the atmosphere), from the hot orange of a sunset to the pure, full-spectrum light of a midday blazing sun that is just about the perfect, balanced blend of all the different frequencies, producing the truest 'white' light. But even in that moment at midday, a person standing in the shadow of a tree may be lit only from the blue sky above, in an almost purely blue light.

Pure white light, that of the Greek islands or of California, is a middle benchmark on what is called the Kelvin scale, that ranges from 10 to 9,000K. It hovers roughly around the middle, at 5,500K. Below it swarm the hordes of artificial light-bulb types that give a much warmer light. Above white light on the scale lies a vast realm of blue light: 8,500K for light that illuminates you in shadow on a sunny day and 7,000K for the light that you get on an ordinary cloudy day in parts of the world distant from the Equator, such as Britain. It is this vast variety of coloured lights available from 'the big light in the yard' that can transform the garden throughout the day.

The last figure is sobering. It means that for most of the year, northern Europeans are a blue people – until the sun shines. So it stands to reason that the colours that work in this climate, in our gardens, on our buildings and exterior paintwork and in our rooms (especially north-facing rooms) are those that sing a blue song. Equally, the colours that don't – lime green and mid-scarlet red, for example, can look bleak.

The qualities of available daylight can be exploited by a garden's planting. Where I live, the sky is predominantly a soft grey for much of the year, so elements and plants that have a purplish or bluish cast appear rich and intense. ABOVE LEFT The ceanothus in my shady kitchen garden almost hums with colour in summer. BELOW LEFT The cabbage in the vegetable garden has a strong colour even in misty weather. RIGHT Daylight changes dramatically through the day, and by evening bathes the garden first in a warm yellow, then an orange yellow, then a deep orange and sometimes an amber light. The warm colours of the spectrum – the pinks, yellows and oranges – really sing.

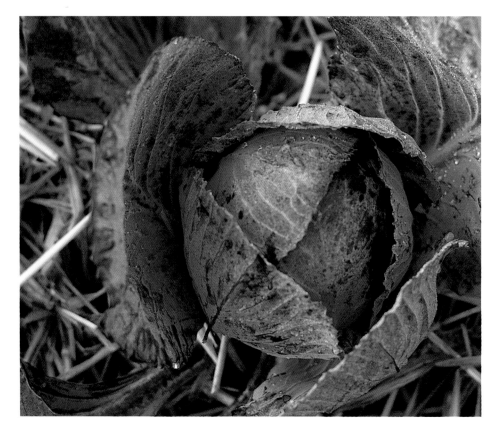

Pure cobalt, or ultramarine, which has a purplish hue, will work undiluted. Prussian or Phthalo blues that veer to the green look better when mixed with some white to produce exquisite, cool pale blues. Purples with plenty of blue in them also look good, as do greens. Oranges and warm yellows are worth gambling with simply because they don't look cold and optically are paler, 'brighter' than other hues. They make the grade literally by bludgeoning their way in. By contrast, complex muddy colours, which are very fashionable in genteel homes, are also excellent in our climate because the blue light brings out the grey, tricking the eye, and producing a pleasant confusion.

And muddiness, or complexity, is the saving grace of a family of pigments that we know collectively as 'earth' colours: yellow ochre, raw sienna, red ochre, etc. These pigments widen the range of decorating colours we can use enormously. This is partly because they derive from clays and hence directly from our environment. This comfortable subconscious association is coupled with an intriguing depth and complexity of associations, because it is the earth colours that tint our limestone and sandstone, marble and terracotta. They are colours with an 8,000 year-old decorating pedigree and are the only truly universal pigments. Yellow ochre is the only yellow I know that when mixed with white will produce a cream colour guaranteed not to take on a sickly cast when painted on a garden wall.

But I'm undermining my own argument here. The earth colours work as well here as they do in Greece or Morocco or California, albeit in perhaps less violent combinations, so it is possible to catch a resonance of that holiday with a dab of burnt sienna and yellow ochre. It is important to remain sensitive to the context of what is being painted, to its material and to the planting that will eventually work with it. Large areas of applied colour in the garden work a powerful effect that can all too often crush the delicate arrangements of the various elements. Decorating the garden is not as graphic as furnishing a room; rather, the garden is open to the elements, buffeted and lit a thousand different ways. It is shaped and gently ravaged by the elements and fights back with growth and newness.

An interior will degrade with time, even under care; in the same conditions, a garden will flourish and develop into its own thing, a living, awesome, moving force. And yet one morning with a paintbrush can knock the exquisite arrangement of texture, colour, form and complexity right off balance. The wrong colour can turn Paradise into Disneyland.

So choose your plants carefully. I always recommend limewash because its microscopic crystal structure refracts light in a very pleasing way. When pigment is added, the resulting paint has all the life and charm of a plant.

Synthetic acrylic coatings, on the other hand, are less successful. At least they are water-borne, which ensures that the minimum of pollution is introduced into the garden, but they dry to a non-porous plastic coating which invariably suggests just that, as though some giant spray gun had enveloped the wall or fencing in a flat and lifeless PVC overcoat. In an attempt to get round this problem, I developed the technique described on page 111. It does not produce a surface with all the movement and depth of limewash, but it does at least breathe some life into the paint and give your walls interest. Or you can consider materials other than paint to decorate your surfaces: glass and mosaic have intrinsically interesting optical qualities, as does gold leaf, sparingly applied.

With thought and care, artificial lighting can have a stunning impact in the garden, particularly when it is magically combined with water. This garden of fountains in Santa Fe, New Mexico, is designed by Martha Schwartz.

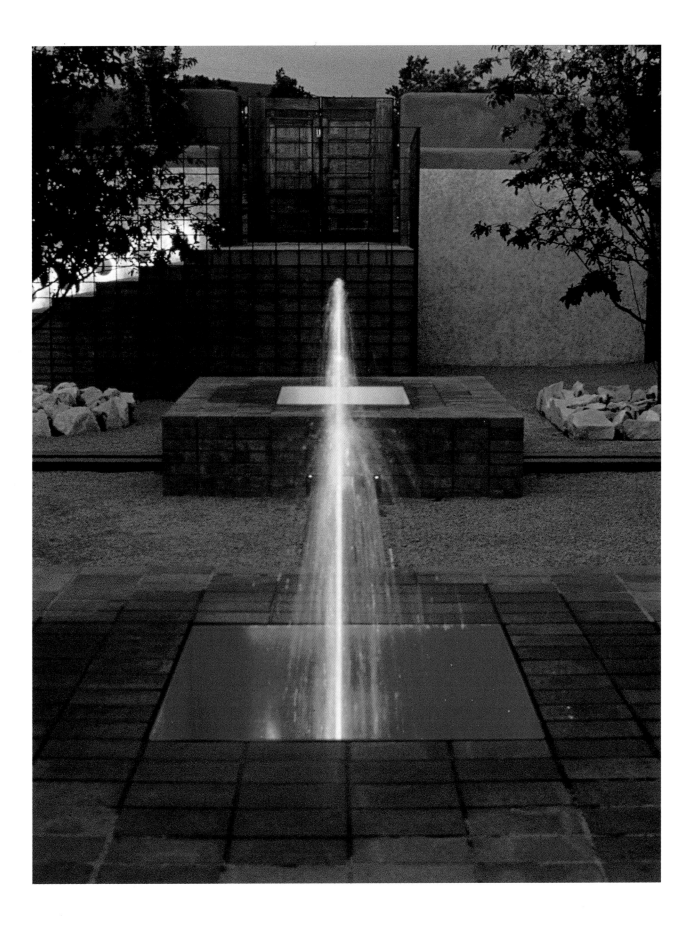

LEFT Colour need not come into the garden purely as a result of planting or painting. Fabrics and furnishings can be stored in the dry and used to upholster a welcoming day-bed or bench, or to make screens, sails, flags and canopies. RIGHT Artificial lighting may be a necessary feature of entertaining in the garden, but it need not be expensive or complicated. The repeated use of candle lamps both reinforces a stylish design and also offers light from several sources, eliminating deep pockets of shadow.

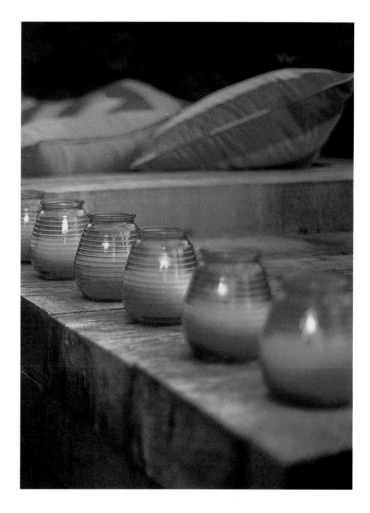

To treat woodwork, I always prefer to use coloured stains wherever possible, or washes of acrylic colour that allow the wood grain and surface to grin through. This is more important outdoors than in, because of the subtlety and complexity of external surfaces and materials. Paints just hit it all too hard if you're not careful. We used several colours throughout the garden; perhaps most successful was the purple applied to the raised beds on page 104. This was what I like to think of as a 'catalytic' use of applied colour, subtly bringing together disparate elements with the use of a common colour, as though picking up on a shared colour of thread in different fabrics and tapestries. Here, the purple was used to relate the bluish-purple-grey stone of the paths to the colour of the hazel sticks used to face the front edge of the beds. The hazel has a cast between maroon, bronze and silver that the stain colour heightens. The assembled elements were satisfyingly unified when the coloured cabbages matured. This arrangement may sound contrived and artificial, but all gardening is really such. And conceits like this can be delightful, bringing real pleasure.

Whim & Fancy

If the mechanics of designing and laying out a garden are humdrum, then their purpose is not. The garden connoisseur

Edward Hyams maintained that there were only two schools of gardening, one based on the Latin-Greek model, all

formality and architecture, and one based on the Biblical concept of Eden, a perfect Paradise garden. Now that tastes have

diversified, it might be possible to enlarge the list to include, say, the Indo-Persian garden, based on principles of

enclosure and the use of water, or the oriental garden, a type that includes Chinese water gardens and Zen pebble and

gravel gardens. Even New Age and Modernist philosophies have spawned their own schools of design.

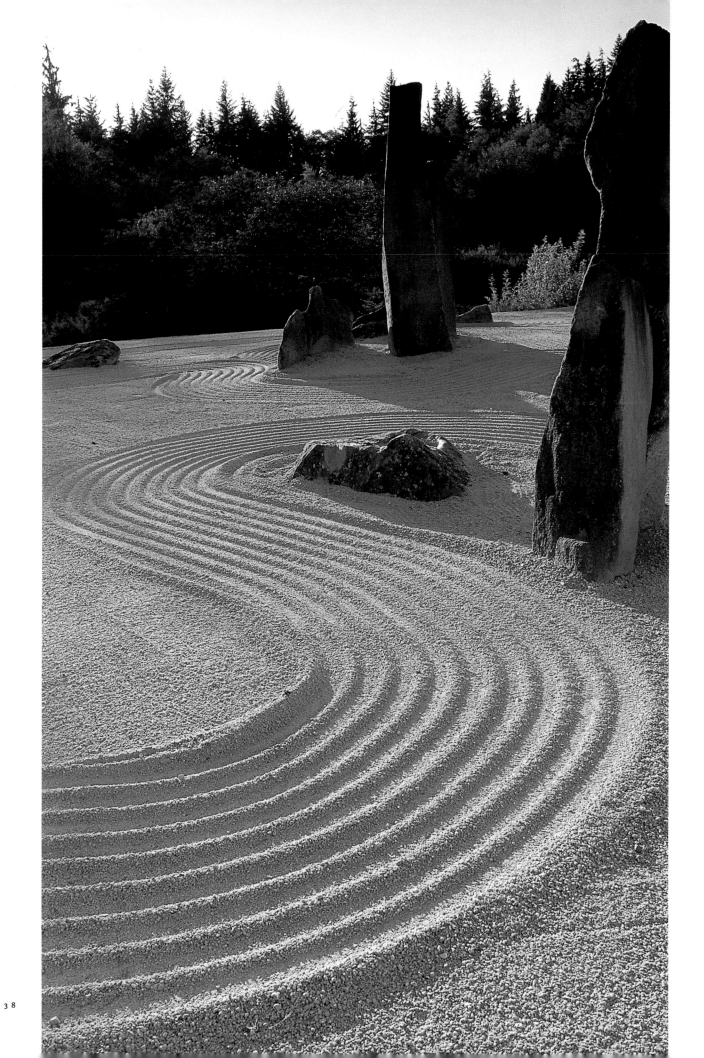

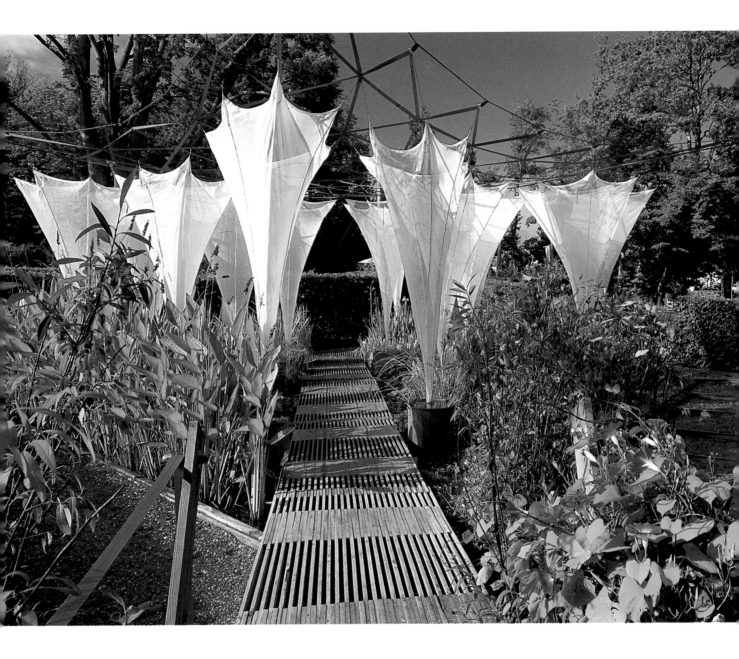

PREVIOUS PAGE The most exciting gardens are those that defy convention and expectation. LEFT Such ideas need not be permanent; the raked gravel in this Zen garden is a deliberate indication of its temporary perfection. ABOVE The sails here are almost as fragile and delicate as the flowers they imitate.

From whichever school of thought its inspiration is derived, it is impossible to imagine a single garden which doesn't kindle something positive in the human spirit. Gardens are not simply about creating fantasy, they are about experiencing a rare and better world and the pleasure it can bring every day. In whichever culture they occur, gardens serve to bring us a little closer to heaven, nearer to a state of grace. They always seem to encourage the best in human beings.

It seems natural that as part of our better nature, gardens should also appeal to our sense of humour and fun. This is something that I can't help feeling the Victorians got wrong,

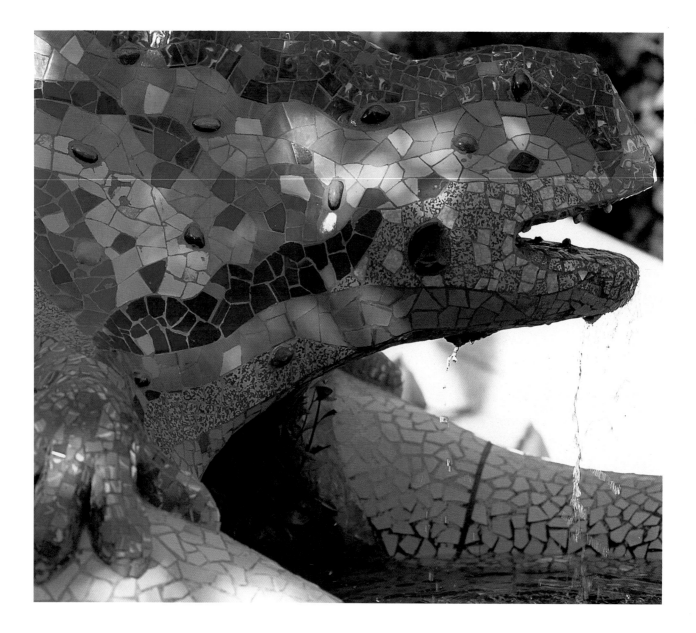

ABOVE Gardens have always been settings for art and sculpture. The Güell Park in Barcelona delivers a cocktail of planting, water and mosaic that is a twentieth-century reworking of classical materials. RIGHT Martha Schwartz's adventurous design for a small garden eschews traditional materials in favour of netting and perspex in an attempt to break free from association with traditional garden sculpture.

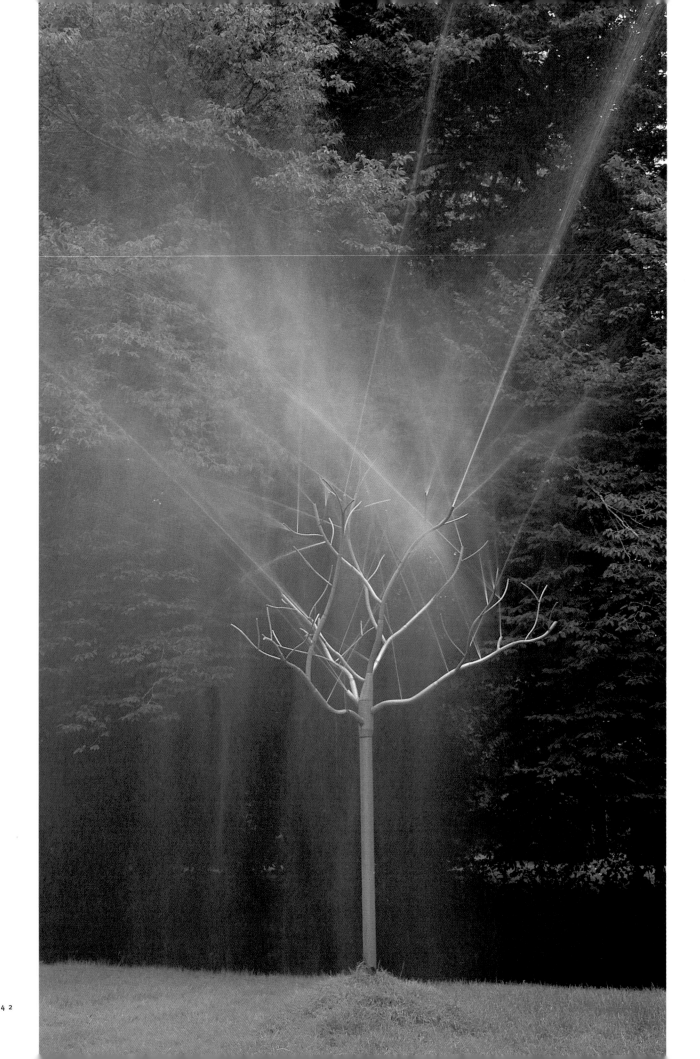

The key that turns the lock of inspiration for so many artists and designers is the one with 'childhood' written on the label. Few of us can doubt or resist the potency of childhood images, whether real – scenes from films and cartoons – or, more importantly, imagined – the settings that we dreamed up when reading a story. LEFT The idea of a magic fountain tree is based on one or two famous historical antecedents and still delights today as it has always done. RIGHT This subtle and clever fish wall is a quieter and even more original idea.

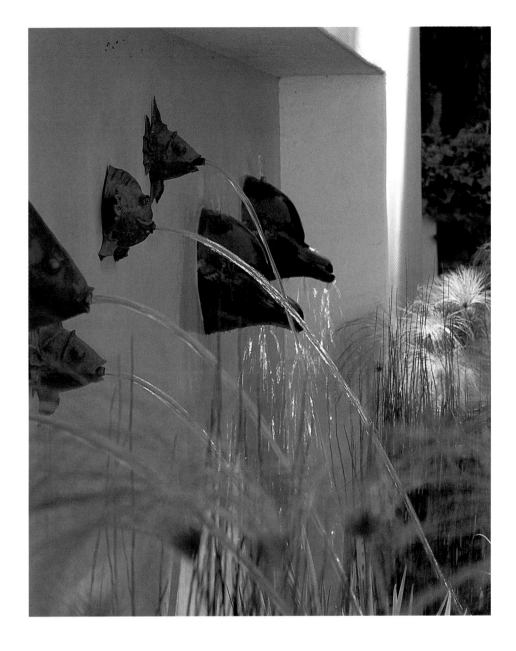

whereas the Georgians, the Stuarts, the Tudors and generations before them got it right. They embraced wit and raciness at the expense of more polite emotions such as charm and elegance. It seems that we have not managed to shake off our nineteenth-century weeds, but are still making the same mistake of shunning humour and joy in favour of more sophisticated appreciations. This is an error committed by so many designers, although it has never, mercifully, affected garden design on the Continent or in America to the same degree. It is as though the British must affect seriousness at all costs in order to convince the rest of the world of our worthiness as horticulturists.

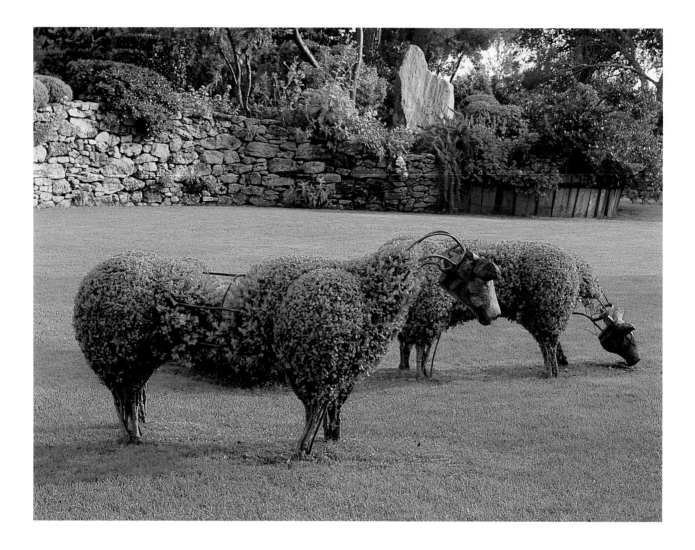

Having made my gentle plea for order, I now ask for wit and delight, two old-fashioned, but certainly not Victorian, words. Others are joy, whim and fancy, and collectively they convey the idea that a garden can develop a light-hearted personality; it can, of course, soothe and heal with its scents and views, but it can also trick, tease and entertain us. Paths, walks, water features, sculpture, accessories, mirrors, hammocks, lights, hedges and fences, mulches and even jewellery can all play subtle and enjoyable games with us in the garden. Two of our project ideas in the book immediately spring to mind. The first is the mosaic mirror described on page 155. The whole point of this piece is that it is not a mirror at all, but just a frame that can be shoved upright into the ground anywhere in the

ABOVE This appealing sculpture is nothing more than an elaborate piece of topiary, but it shows the extent to which a confident imagination can run.

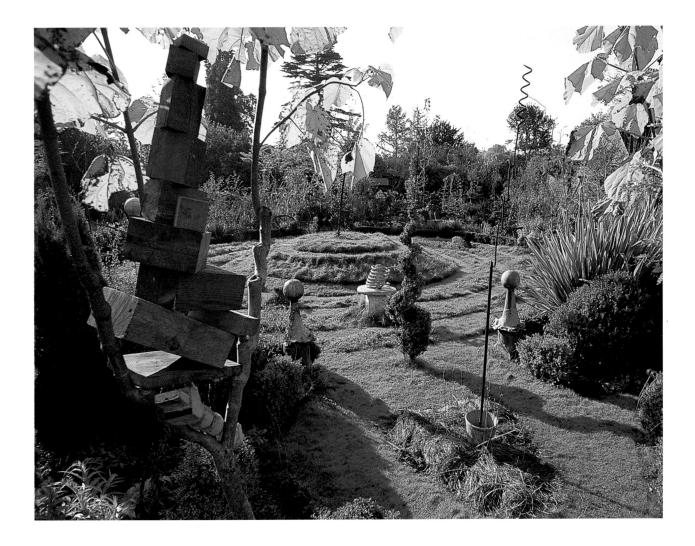

ABOVE By contrast, this
garden has been imagined
and built out of dedication
to one idea, to the fantasy of
one man. Ivan Hicks has
built a 'garden of the mind'.

garden in order to make us look just a little bit harder at what lies behind. Likewise, the mosaic ball on page 154 is simply a visual pun. I got the idea from walking round the garden and every week finding a rugby or foot ball at the edge of a lawn, just under a bush, always in a different place. The mosaic version ought to tinkle subconscious bells with a number of other parents.

A lightness of touch in both materials and design is appropriate. The woven open fencing on page 100, made from hazel uprights joined with willow wands, has an almost fairy-tale quality, not because of the design, which is relatively classical, but because of its use of a somewhat transient material. Moreover, the rough bark and undulating wood give the piece

a rustic jauntiness that fascinates me, so much so that I have used hazel, willow and chestnut poles all over the garden.

By contrast, an example of using pure design at ground-plan stage to achieve a similar end is the layout of the raised beds in my vegetable garden, illustrated on pages 104-5. I was so determined that these beds should not be functional rectangles that I built them around walkways that branched off an undulating central path. This entailed days of extra time cutting timber and forming raised beds that are triangular, rhomboid and even

LEFT There is always room outside for the surreal. What might seem contrived as interior decoration is liberated in the garden. CENTRE A balsa and willow butterfly would seem absurd indoors, yet we entertain it outside.

RIGHT Theatrical lanterns also seem far more at home outdoors. It is as though the restrictions and shackles of conformity fall away in the garden, where creative and fantastical ideas are allowed to work their way out.

segmental in shape, many with curved front edges. They were a nightmare to build, but the end result is as satisfying and enjoyable as I could have hoped. Not that anyone else notices the trouble that I have taken.

The enjoyment of gardens seems predominantly an adult hobby, even a sedentary one. I was told by an eight year-old recently (not one of my own children, who remain diplomatically neutral) that 'views are for geeks' and that what really matters outside to young people is whether there is any privacy to be had.

Children, then, want to extract their own, alternative pleasures from the garden. Just as part of our grown-up enjoyment of outdoors is a liberating and child-like pleasure in being free and amongst nature, so most children seem to flourish in this environment too. The important thing, because of their immense energy, is that they are not enlisted to walk and sit and read and contemplate, but that they are properly catered for. Their desired privacy involves some sort of shelter. The trellis pavilion on pages 126-7 provides mine with

A child-like enjoyment of the garden seems necessary at any age, but incorporating children's needs can be less easy. One answer is to design something sculptural that is vibrant, interesting and totemic for children and adults alike.

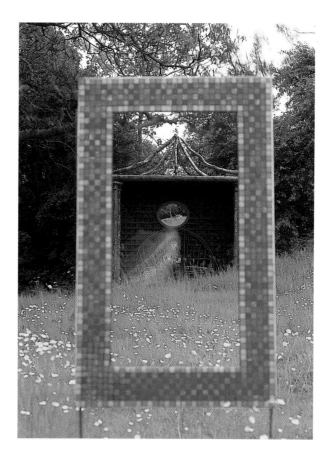

LEFT Some gardens can be designed primarily for adults but incorporate enough that is of interest to children. This garden by Paul Hooper is split into appealing levels. RIGHT Even a simple garden structure like this gazebo can have a dual purpose. It is both a convenient resting and vantage point for adults and a little play space for children.

just this: it is a place to play monopoly on a spring day, to sit and cool off after a forceful swing under the walnut tree. After we built it, at the bottom of the orchard, it served pretty well as a junior retreat from boring adult socializing.

But its days were numbered. I had not anticipated, in any way, the change in the kids' behaviour that has taken place since we built the little gothic playhouse on pages 128-31. As I write this, I am just putting the finishing touches to it, mixing paint for the inside and assembling the steps and playmat area underneath. The whole project has been three or four days' work for two of us, and it has been overrun all day, every day, by the enemy, wanting to make it their own, to build furniture inside and furnish it with cushions and rugs. Its interior measures only a metre by two, but six of them, aged seven to twelve, have been inside at one time for hours on end. They disappear after breakfast to emerge only for lunch; they have possessed it and marked it as their exclusive territory. It is dry inside, although

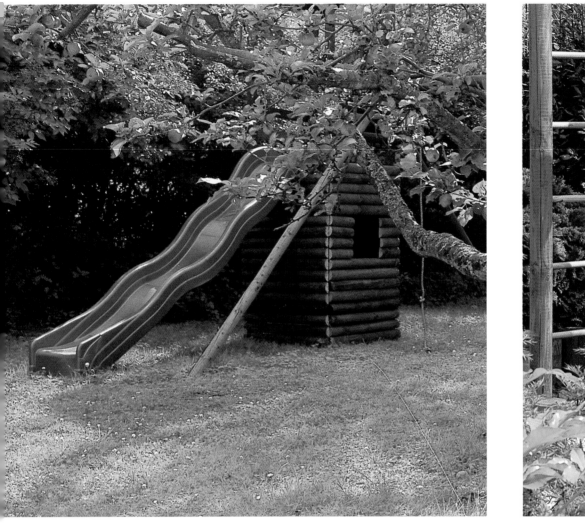

not particularly cosy in January, and still they refuse to abandon it. I can't help feeling that their enthusiasm is not just of the flash-in-the-pan variety: I think, instead, that they prize it because it is a space which is exclusively theirs, which does not form part of a larger adult whole. And I also think that something as rustic and homemade as this fits into their own imaginings, just as it does ours, of what a magical house should be – all bark and brush and not a piece of brightly-coloured PVC in sight.

Incorporating children's features can be difficult, especially in the space of a small garden. LEFT The solution here is to build a slide and a swing into and around the existing features of shed and trees.

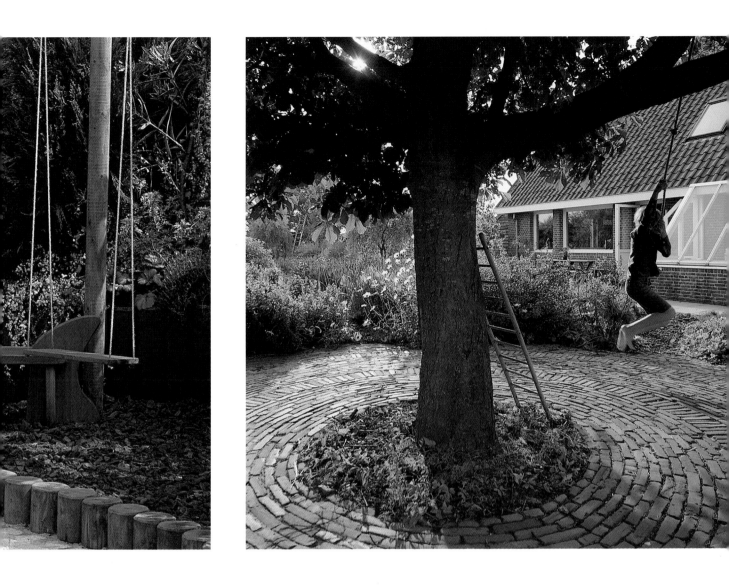

CENTRE A climbing and activity centre is homemade from timber, an alternative to manufacturers' plastic.
RIGHT The living wood of a splendid old tree is used as a basic structure for rope, ladder and platform.

Making any garden a totally safe and child-friendly place is a difficult task. I have laid rubber flooring down, the kind used in playgrounds. I have also drained our large pond, bolted mesh grilles from our blacksmith over the lead water cisterns and built the little fountain on page 147. This is all in an attempt to prevent our smallest from drowning, since apparently only three inches of water is deep enough. I even dug a small soakaway with rubble under the mosaic paddling pool in the hot garden and fitted a bathroom plug and

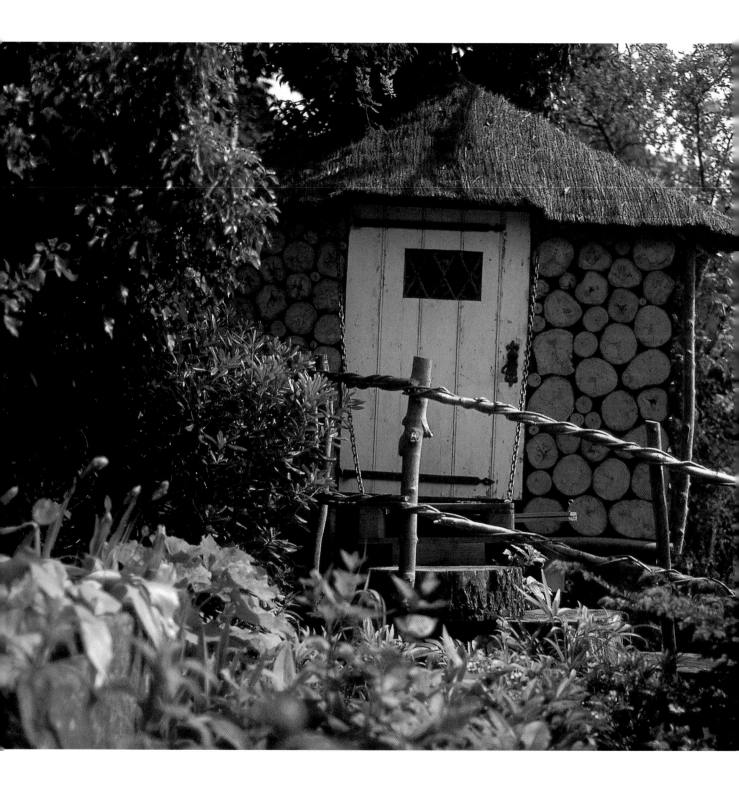

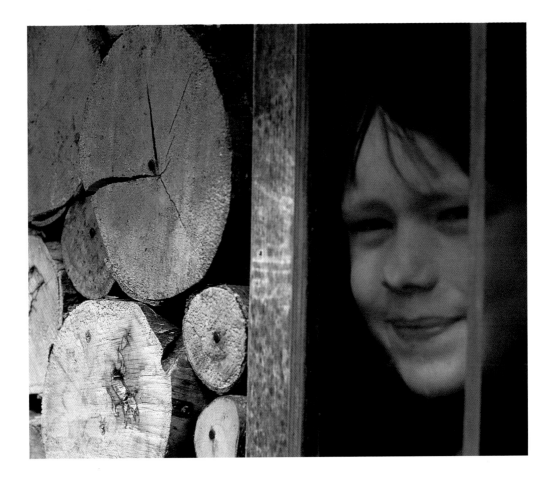

The ultimate fairy-tale fantasy, our children's play-house that has become a piece of garden furniture that adults are not permitted to colonize.

waste pipe so that we could let the water out and ensure that it did not refill in wet weather. I also discovered that the glass mulch used on pages 156-7 to face the fountain is no sharper or more dangerous than ordinary gravel.

It would be very foolish to encourage any reader to build their own play furniture without also encouraging them to memorize their local government regulations about child safety and use of materials. Clearly, you and your children are safer if you buy a good quality, branded climbing frame or swing. But using half-sleeper timbers, I easily built an oak sand pit to go with the playhouse. You can even customize manufactured products, with paint, with foam padding and with rubber matting. With a little imagination, a lateral solution often emerges.

Creating the Garden

The second part of this book is devoted to practical projects in the garden that offer the means to translate your designs and ideas into reality. Many are easy, some are challenging and a few, such as the shell fountain on page 158 and the children's playhouse on page 128, will demand several days' intensive work (although the satisfaction of having made something of value will more than make up for the effort you spend).

The projects are organized into five sections that deliberately reflect the areas of home interior decoration that we most comfortably recognize: floor coverings, wall decoration, furniture, accessories and lighting. Exterior decoration can use many of the principles of interior decoration, but reworked to suit its more organic context. We are all, after twenty years of books and magazines, almost fluent in the language and ideas of interior design, confident in how we handle fabrics and paint, and these skills can, amazingly, be translated into the garden to produce an exciting and original outside environment. Since good design is always ergonomic (I think of it as being polite to human needs and human frailties), and since we nowadays spend more and more time dining, drinking, entertaining, relaxing and playing outdoors, I can't think of a more appropriate way for garden design to go. A simple transference of interior concerns into the garden can help us arrive at more recognizable – and sometimes better – solutions when designing the outdoor space.

You may be reading this book in bed, lounging on the sofa, or even sitting in a deck chair, but it is certain that you will not be poring over it with your steel-toed boots on, shovel and chainsaw at the ready to destroy and re-build your garden in one mighty flash of activity. Very few of us are blessed with a superabundance of enthusiasm for do-it-yourself activities, even fewer of us for heavy gardening. Those that are, those rare models of radiant zeal, are so exemplary, so super-human in their energy, so far-removed from our own experience of life as a daily, draining slog, that their presence in our lives just serves to dishearten us further. I have

a friend who is just such a whirlwind, a powerhouse, a dervish of creativity, that I stand humbled in her presence. I cannot compete, I just don't have the stamina. Instead, I revolt and sink deeper into my imaginary comfort sofa, bury my head further into the pages of my glossy magazine and feed my sluggishness with metaphorical chocolate.

If I feel this way, how can I possibly expect anyone else to be different? What unique proposition can I offer to persuade you that laying a path or building a turf bench will improve your life, make you happy or bring riches beyond your wildest imaginings? After all, it might just be the case that you get more enjoyment from reading this book and looking at the pictures of other people's hard-won achievements than you will ever get from doing-it-yourself. Of course, I can't find any life-changing solutions to tempt you with, but I can, scrabbling around the bottom of the barrel marked 'human endeavour', come up with a few basic incentives.

To begin with, this book isn't simply a catalogue of ideas. The projects that follow are designed to stimulate you into attempting something similar, but not necessarily exactly the same: a project that perhaps fits your own 'big idea', your own theme that you might want to superimpose on your garden. By looking at the pages of inspirational photographs that accompany each project, by looking at other books and gardens even, you will begin to see what is possible, how a trick, a material or a technique can be translated a thousand different ways to suit the personal vocabulary of a garden – its setting, climate and, above all, its owners.

All of the projects and many of the more atmospheric garden schemes were built at my home in Somerset, where we had tremendous fun designing and executing them. Two specific areas here, the hot garden and the kitchen garden, were planned to fit spaces measuring only sixteen by thirty feet, the size of many town gardens, so that they are adaptable to a large number of settings. Nearly all of the projects featured are appropriate to gardens of any size and can be stylistically reworked to suit all styles of garden, whether contemporary, traditional, formal or wild.

The personal nature of design and gardening, of creating objects and spaces and atmosphere, is the great key to excitement and adventure. If all you do is copy the grass bench on page 132, you will be proud to have achieved a great deal, but if you keep the technique and change the design to suit yourself, then you will have made it your own and created something entirely original.

This, I think, is the ultimate incentive I can offer, and it is the reason why I write books. Within all of us, no matter how humdrum our everyday lives, there is an unlocked potential for creativity, for expression. It is part of every one of us, as naturally so as a nose and two feet and, I believe, as useful and as necessary. From the age of ten or eleven, most of us were told that we were 'not particularly good at drawing' or 'slightly tone deaf'. Even if we were not dismissed in this way, it was patently obvious in such activities as art and music that we were not the most gifted in the class, that we were even clumsy. So it is no great surprise that we grow up with a lack of confidence in our expressive abilities, a suspicion that our faculties are very limited and a fear that whatever we attempt, even in the decoration of our homes, will be mocked by our neighbours and delicately ignored by our friends.

I say, forget all that! Every human being has the potential for expression, for the extraordinary. All that is required to achieve great things is commitment, belief and a little guidance. I have already talked about the value of commitment to big ideas and how not to get side-tracked. A trust in those ideas will bolster your resolve and belief in yourself and what you are capable of, and will provide you with the confidence to try anything. This book simply offers a little guidance to help you along the way. For most of my adult life, I have been involved with teaching, always in the belief that people have a right to learn, not simply a 'right to have a go' and that ideas and techniques should only be taught if they are really workable. I think what follows in this section fits the bill. If you are serious about finding and giving vent to that creative side to your character, achieving something lasting and impressive and having fun building an interesting outdoor environment, then read on, learn a little and then have a go.

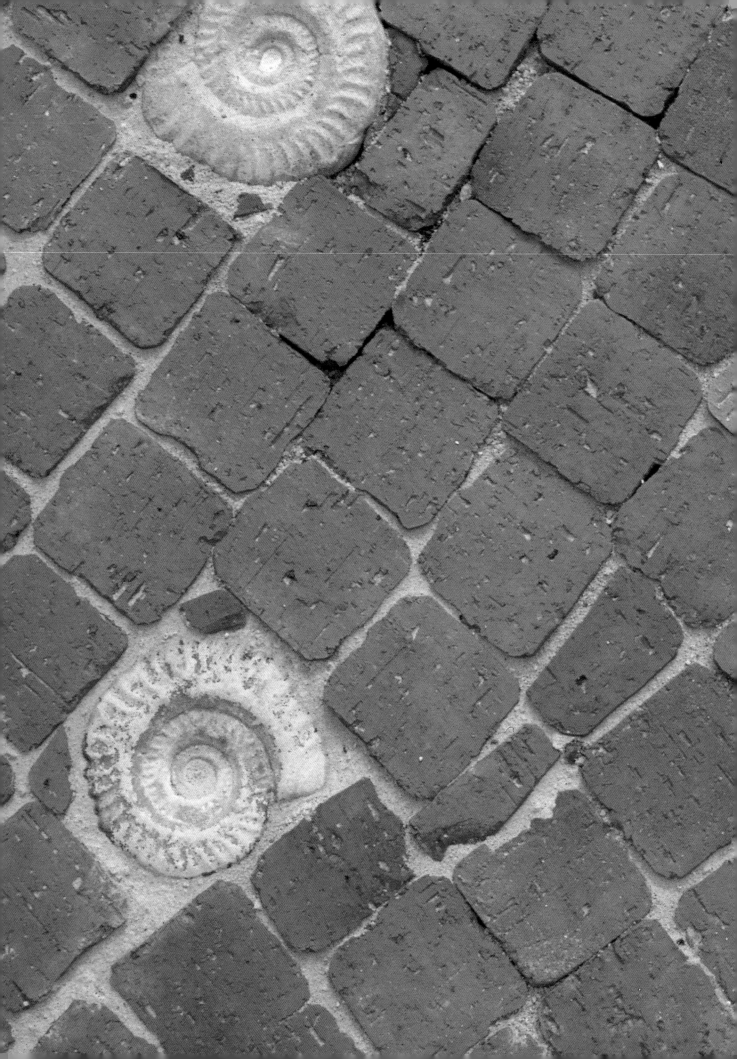

FLOORS

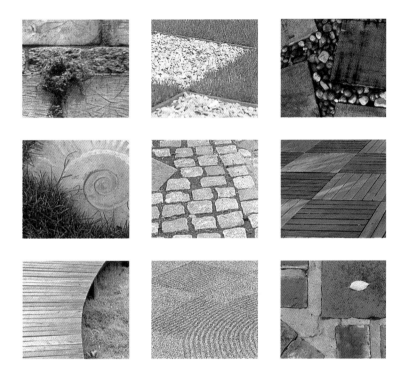

JUST AS WE LAY CARPET, RUGS AND BLOCKWOOD FLOORS IN

OUR HOUSES, SO THE GROUND BENEATH OUR FEET OUT-

DOORS MERITS THE SAME CARE AND ATTENTION. MOREOVER,

BY EMPHASIZING THE PATHS AND FLOORS IN OUR GARDENS,

WE ARE DRAWING ATTENTION TO AN OVERALL GROUND-PLAN

– THE VITAL KEY TO A STRONG AND EFFECTIVE DESIGN.

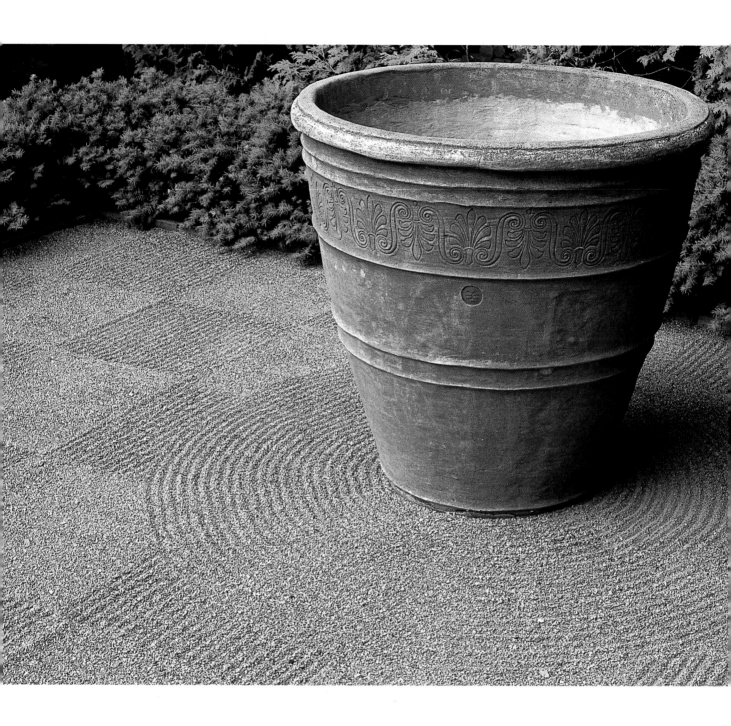

GRAVEL FLOORS Apart from the soil itself, gravel must be the easiest available material for making exterior floors. It provides instant paths when poured over hardened earth and forms a textured contrast to the planting of the garden. It also gives year-round access to different areas and in formal garden designs – both traditional and contemporary – gravel is an essential defining element of the ground-plan of the whole plot. To prevent weeds from invading your paths by growing up through the gravel surface, either lay down a woven plastic membrane underneath or first dig out the ground to a depth of about 10-15 cm (4-6 in), lay some rubble, scalpings or coarse stones and roller them flat to provide a surface for the loose gravel.

The joy of working with gravel is that it is fluid: it fills gaps, goes round corners and over bumps in a way that no interior flooring material can achieve. RIGHT Irregularly shaped objects like these sliced logs and dark pebbles can be incorporated and then softened by selective planting straight into, or through, the gravel. LEFT Another such stylistic principle of traditional Zen gravel gardens is the raking on the surface of geometric patterns. BELOW RIGHT All these same elements are present in a more formal path, but in a different arrangement: the edges of the path are softened by planting and the insertion of stone cobbles acts graphically to break up the path and provide gentle steps up the slope.

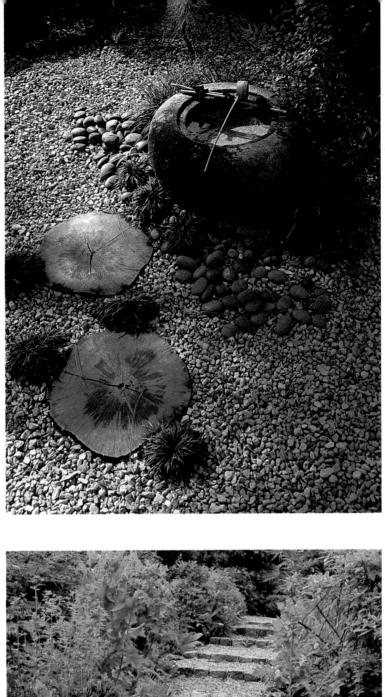

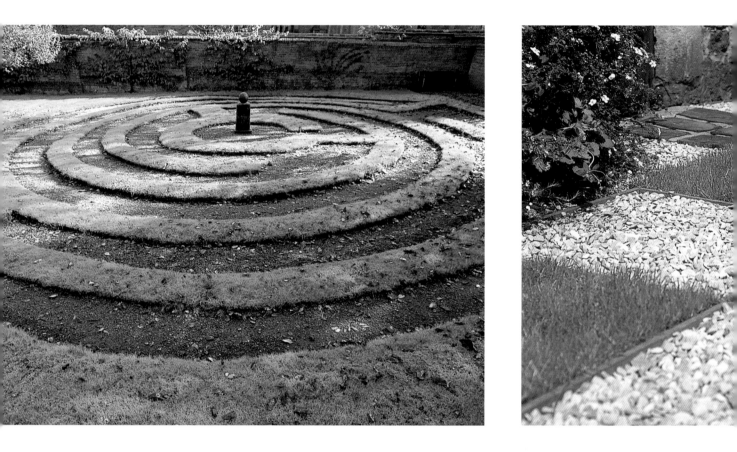

GRASS FLOORS I find that grass provides me with the most exciting opportunity for play
when designing a garden. I don't mean traditional rectangular lawn, but the use of grass as a
sort of green gravel that can be cut and manipulated in a similar manner. It can be treated like
a carpet, curved and stretched and used together with other flooring materials to really define
a ground-plan. It offers a green, soft and natural alternative to other, harder landscaping
materials, whilst still giving a strong structure to a garden. Grass can be used to great effect as
a contrast to both hard areas and taller and more fluid planted beds, and it can guide visitors
between one garden room and the next, between views and vistas.

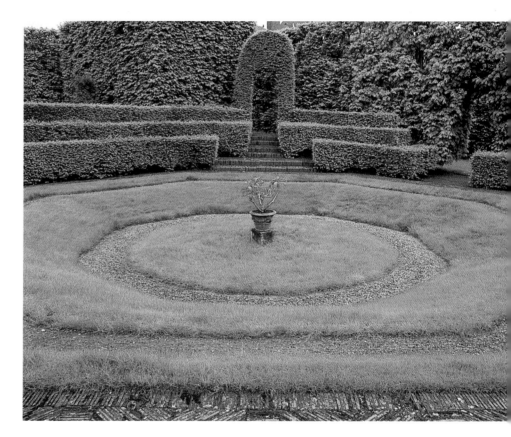

LEFT Grass, camomile or thymes can be planted between paving stones or gravel paths to bring a heightened contrast to a graphic layout. CENTRE My choice in our kitchen garden was to alternate squares of paving, loose stones and turf to make a chequerboard – drawing on a medieval idea in which herbs would occupy every other square. RIGHT I think the most dynamic combination is that of turf and gravel, or simply bare earth. The textures are similar and allow the creation of very fluid forms.

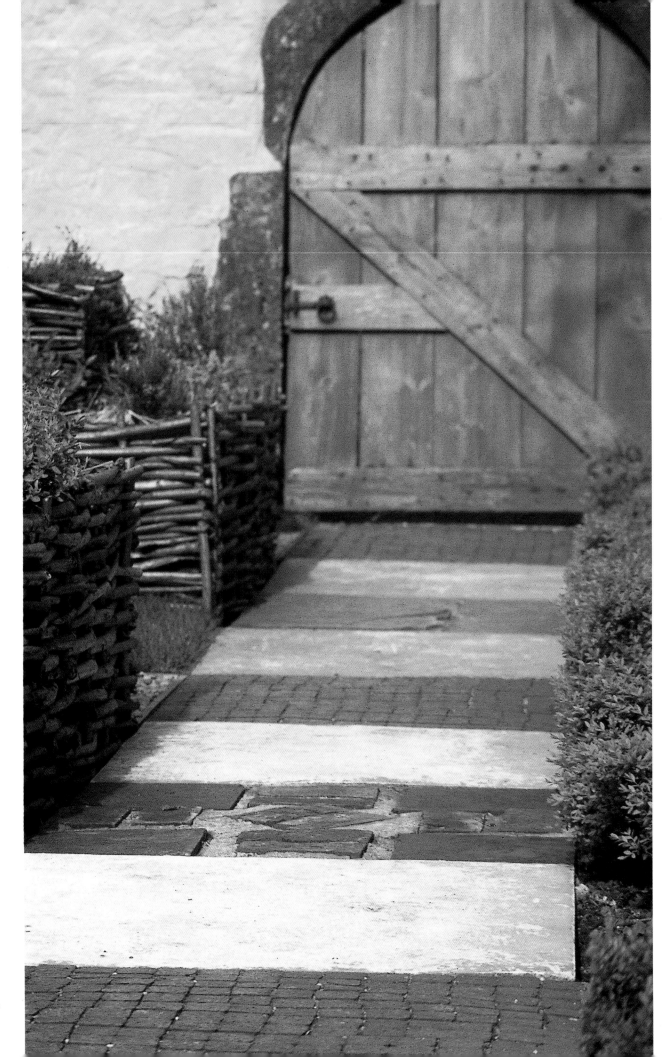

LEFT If you're careful, and if you have a strong overall design in mind, you can incorporate a variety of paving materials into a single scheme. This is what we did in our kitchen garden, using the squared floor-plan as a grid into which we could drop different materials, such as the bricks and stones leading to the garden door. BELOW LEFT AND RIGHT Alternatively, you can create patterns within patterns to add complexity to the main elements of a design.

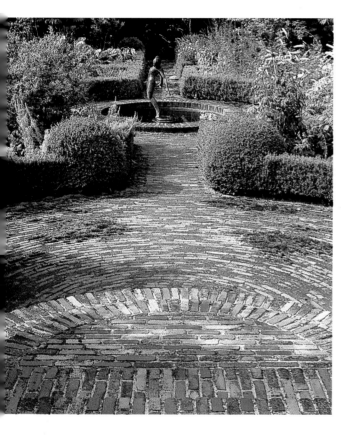 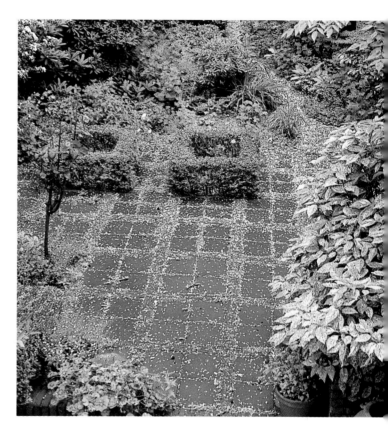

PAVED FLOORS These bring a graphic rigour to any garden because they are built of single, repeated elements. As a result, you can use them to fill large areas where gravel would give just too amorphous a shape and be visually unexciting. Paving stones also allow shapes and patterns to occur within the texture and design of the entire area and really come into their own for large, formally described, hard landscaping. The patterns chosen – be they herringbone bricks, square slabs or even crazy paving – set up a pleasing rhythm across a hard surfaced space. The brick floor that I laid in our rose walk (see page 78), for example, had to fit into a long rectangular shape, so I deliberately designed a curved pattern within the straight contours to introduce some tension and to make the area appear wider and more enticing.

WOODEN FLOORS Timber has a tactile and friendly appeal outside, just as it has indoors, but deep suspicions of its suitability as a garden flooring material still persist. There is no doubt that it has a much shorter life than any other hard surfacing material, but I am a great fan of oak, a hardwood which will last for decades, especially if it is bought in thick, chunky sections. Most sawmills will have off-cuts and the cheaper grades of oak for sale at knock-down prices. And even softwoods will last as long as twenty or thirty years outside if they are treated (avoid pressurized wood, as arsenic leaches from it) and kept off the bare, damp earth.

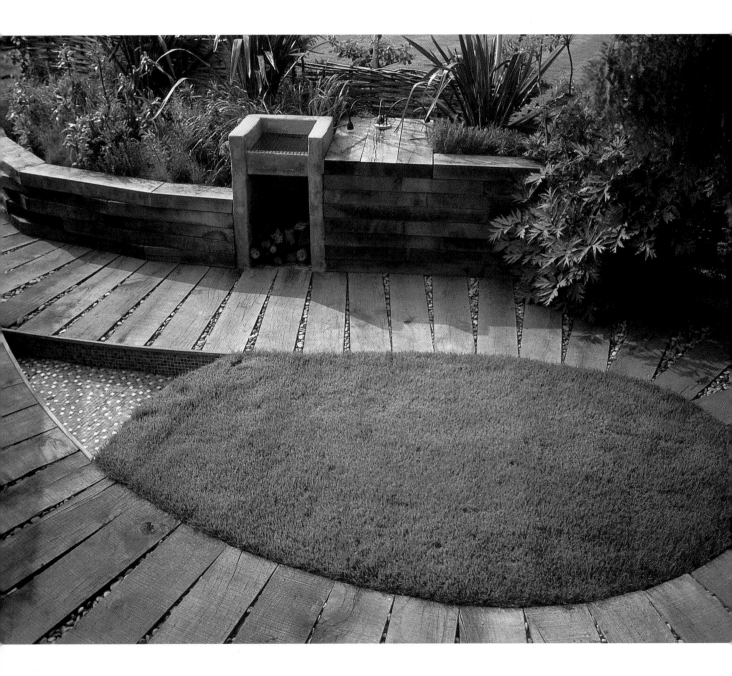

LEFT The floor, walls and furniture of my hot garden are all built from lower grade oak cut in sections of about the same width and depth, but half the length, of railway sleepers. They make a beautiful and solid floor, which in six months greys to a silvery finish. ABOVE RIGHT By contrast, a semi-wild garden demands a more rustic approach: these steps are simply built from half-logs and almost disappear into their surroundings. BELOW RIGHT The supremely architectural approach is to build paved superstructures, such as bridges, out of timber.

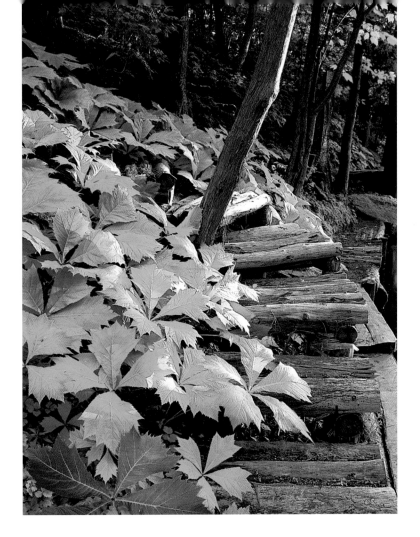

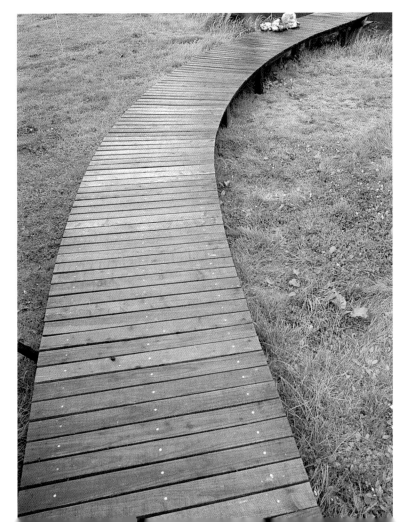

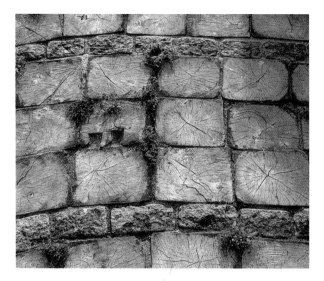

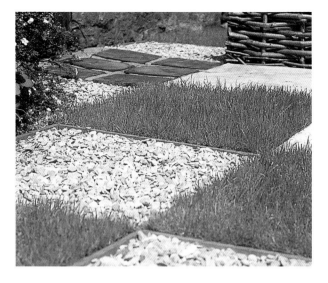

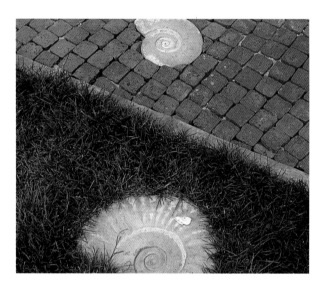

DESIGN YOUR PATHS as part of your original ground-plan, so that their outlines are in place early on. You need to figure out where and how you want to move through the garden and where you may want to slow down or stop, to take advantage of a pleasing aspect, perhaps, or to rest on a bench. The widths of the paths – and particularly their patterns and textures – will be influenced by these decisions. Grid-like patterns suggest the crossing of two paths or an area of stasis; lines, whether in multiples or simply as path borders, help to move you along; curves suggest lazy meandering and the flow of energy through the space; while radiating patterns around a fixed point draw you in and hold you there.

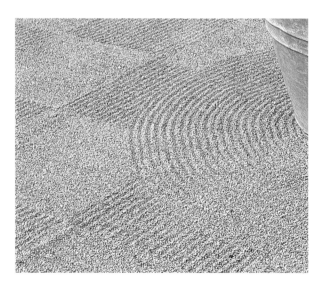

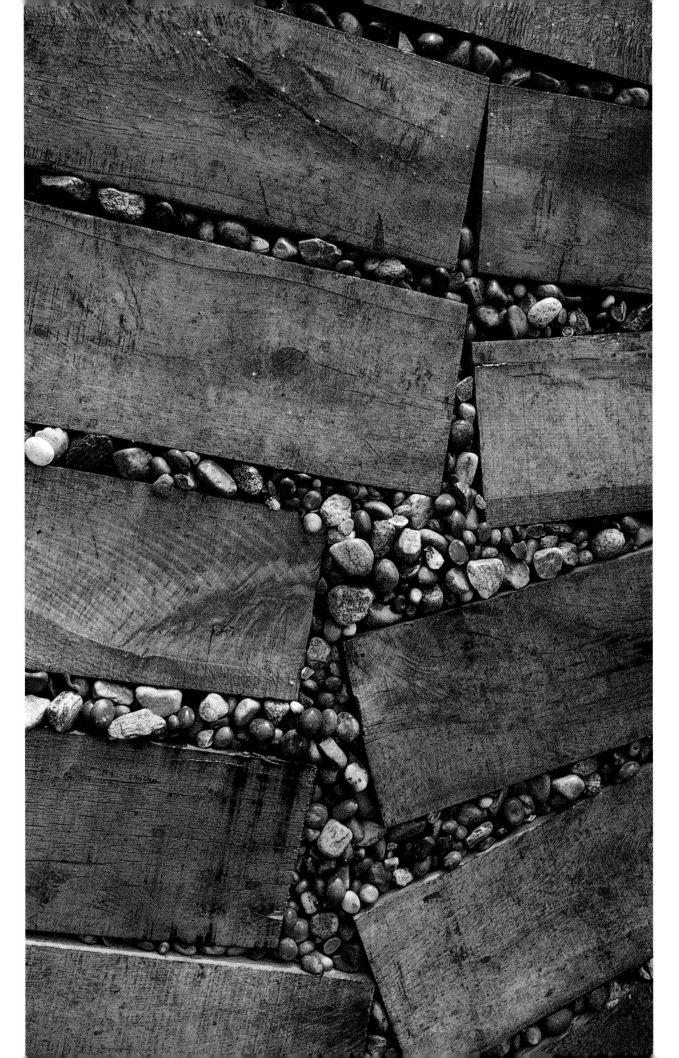

raked gravel floor

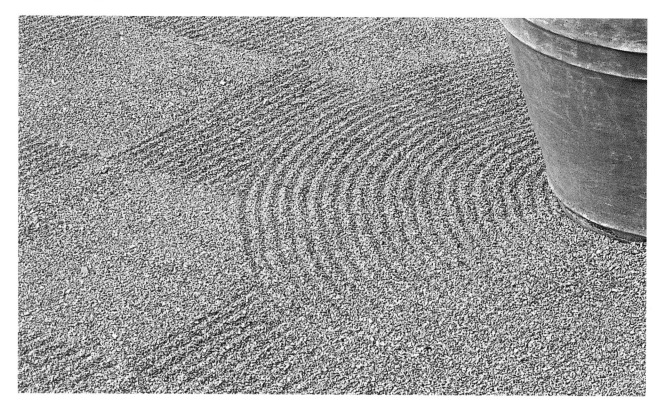

This is the easiest of all exterior floors to lay, but perhaps the most difficult to maintain properly, especially if you intend to sweep and rake it to the fastidious level of perfection required for Zen gardening. This will clearly not be possible if you intend to employ gravel for a well trodden path, but in a purely decorative area, raked patterns may repay the effort involved.

Meanwhile, I can offer three hard-learned tips about gravel: first, when laying it around your house, use the large, coarse variety that will not easily get trodden indoors; second, buy gravel by the lorry load, or half load, as it is staggeringly cheaper this way than in bags; and third, use a traditional besom broom, not a yard-brush, to sweep gravel, as it will separate out the leaves and dirt from the stones.

The trick of its preparation is to ensure that you meet two essential requirements: a good solid bed to underpin the gravel and something to prevent weeds from growing through it. In order to achieve both in one sweep, dig down to a good 10-15 cm (4-6 in), lay a bed of scalpings, fine hardcore or stones, roller them level and then pour a couple of inches of gravel over the top. If you want a formal path or terrace, the area should first be edged with timber, edging tiles, stainless steel, or another boundary. If you want a meandering gravel path through long grass or a flower border, it's often sufficient to lay the gravel directly over the earth with no boundary edging. Just stamp or roll the earth to a hard layer first and perhaps then lay down a woven plastic 'mulch mat' (bought off the roll) which will keep the weeds at bay and prevent the stones from mixing with the soil and eventually becoming incorporated.

fixed stone pavers

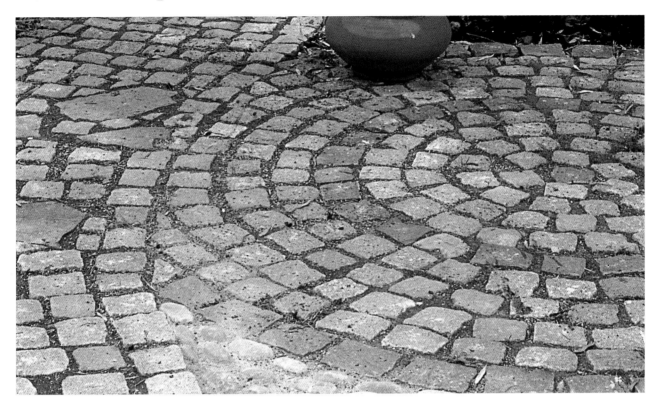

Small pavers can be laid out in patterns and those with a fluid design are especially desirable for areas of flooring that have curved or lop-sided shapes. The careful following of a natural line or form in the execution of a design is called *andamento*, a term commonly used to describe the flowing arrangement of mosaic pieces that breathes life and movement into the work. Curving patterns on a floor are always less easy to undertake than tedious geometric ones, but they pay dividends with their natural and gentle appearance. It is sometimes difficult to know whether to lay such a floor on sand or on cement. Generally, large paving slabs that have an uneven surface, or a mixture of paving materials to be widely spaced, will need a cement backing of some kind to stabilize them. Otherwise, most paving can be laid onto sand, provided that there is some form of retaining edge to keep everything in place.

The fluid and uninhibited lines of the floor here, made up of a variety of different materials, means that irregular gaps appear between the blocks. There is always a danger that the gaps will be so large that sand alone will not do a proper job of grouting between the pavers to keep them in place. It is possible to strengthen a sand grout with lime or cement to make a very weak mortar, as I describe in my brick floor project on page 78. Here, a strengthened grout can be prepared in powder form – a dry mix – say, one part cement to nine parts sand. The mix can be shovelled and brushed into cracks. It does not need to be vigorously wetted with a hosepipe: it is usually sufficient to rely on the mix absorbing moisture from the atmosphere to enable it to set.

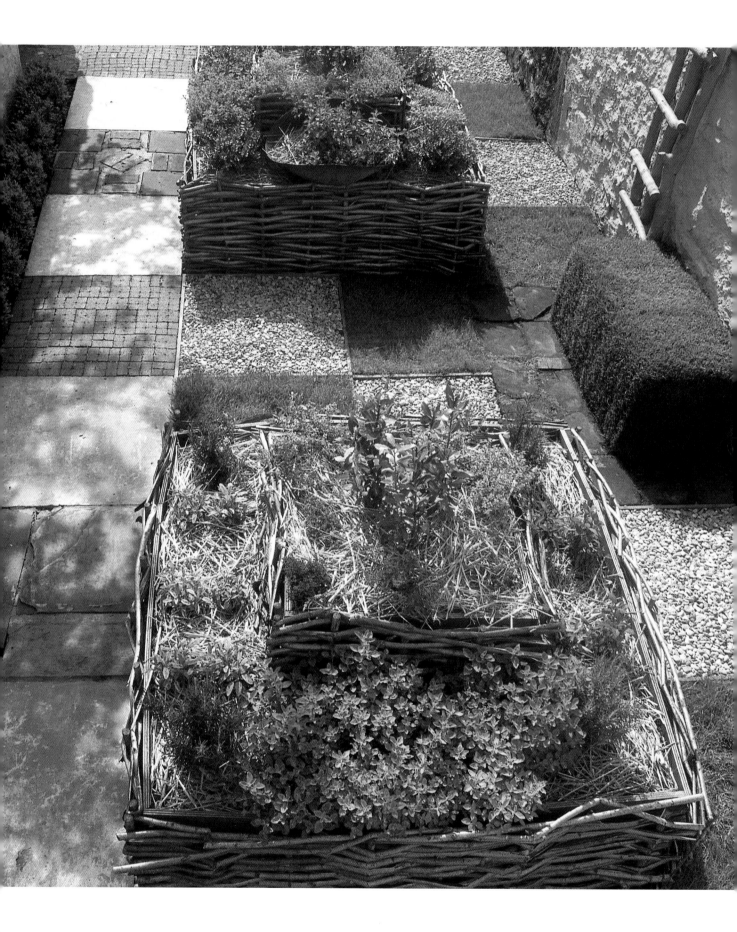

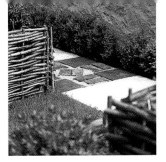

a medieval kitchen garden

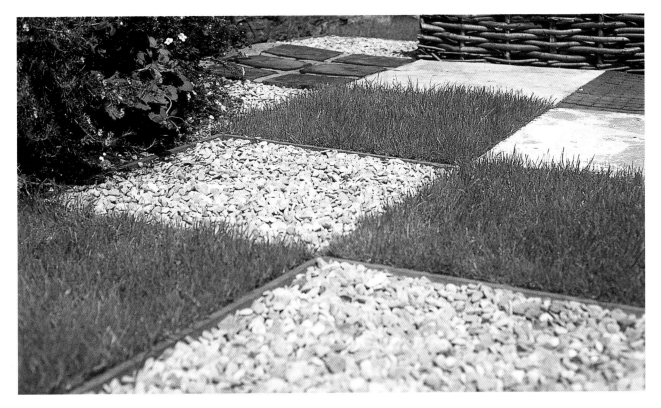

You should consider turf simply as another outdoor flooring material, not just because it is green, but also because it is cheap, easy to use and flexible. This is the kitchen garden at home, an essay in very simple forms and colours: its predominant shape is the square, the planting is all herbs and the colouring is controlled by the yellow-ochre limewashed walls (see page 110). The inspiration for the overall design came from an account of a medieval garden that was divided into squares (no doubt considerably larger), some for flowers, some for shrubs and herbs, but every alternate one laid to grass. One day I shall design a garden with larger squares that could cover an entire acre with the same chequerboard pattern, but in the meantime this adaptation will do.

The concrete blocks were poured *in situ*: we first dug out the area of each block, laid a square of scalpings within a square timber frame and used a white cement concrete mix to fill. The gravel squares were similarly dug out and back-filled with scalpings before being dressed with 5 cm (2 in) of cream gravel, poured into a timber frame.

It is important to remember that the areas between the man-made materials will host living plants. So, having trampled the area in hob-nail boots and finished all the hard surfacing, I dug the remaining exposed earth quite deep and incorporated lots of manure, not so much for its nutritional value, but because it holds water well. The earth was then firmly flattened and finished with a 2.5 to 5 cm (1 to 2 in) layer of fine, silty soil. For seeded grass, the soil level should be flush with the floor, but for turf should be lower to allow for its thickness.

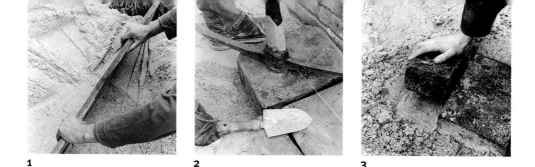

1 2 3

a blockwood floor

Laying a wooden floor outside may seem foolhardy, as it is not the most resilient of materials. Yet without blinking we will put up a wooden structure in the garden or lay down some timber decking. The difference with a floor is that it is not an open structure, but something in permanent and full contact with the soil, and so it is prone to rot, fungus and infestation. These problems certainly apply to softwoods, but my choice is always for well-seasoned hardwood, especially oak. I have used it for raised beds and for built-in furniture (see page 134) and it weathers extremely well, especially if you lay it on a bed of sand to help the area drain. The oak used here is from old recycled beams that has hardened over two centuries.

Materials: To execute such a floor, you will need a large quantity of sharp sand to lay under the wood, a string line and spirit-level, a mallet and perhaps a little cement (standard 3:1 mix) to put as a border around some of the exposed floor edges.

1 Dig out the area the floor is to occupy to a minimum depth of 20 cm (8 in), to ensure free drainage. Fill with coarse or sharp sand or fine grit as a bedding layer to a depth of 10 cm (4 in) and level off with a long piece of timber. **2** Using the spirit-level and a string line, lay the blocks out on the sand and tap them firmly with a mallet as you go. This beds them down, removing any air gaps and compressing the sand beneath.
3 Other flooring materials can be added in rows or patterns. I laid black granite Yorkshire cobbles every third row. Once happy with the layout, brush fine, clean sand into the gaps. For planting in-between the blocks (perhaps with herbs), use a mixture of clean sand, grit and potting compost in equal proportions.

patterned tile floor

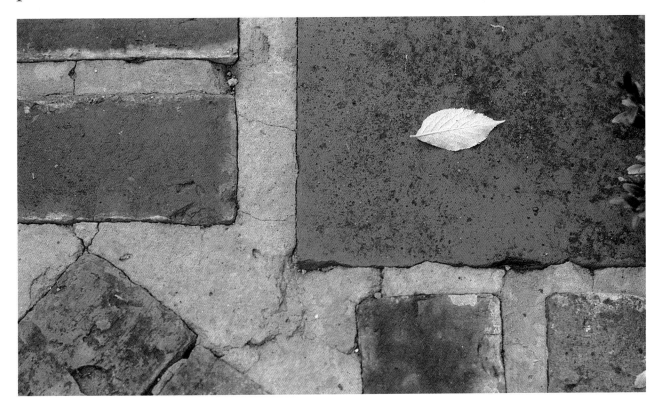

Fired earth – terracotta – is an incredibly versatile material that finds its way into the garden in so many ways: as plant pots, edging tiles, bricks, quarry and roofing tiles. Given its longevity and practicality, it is not surprising to find paths made from recycled terracotta. You can jumble tiles and bricks together and the delicacy and pattern of their common material will homogenize into one charming path or terrace that will work in almost any garden – classical, romantic or contemporary – and with almost any colour. However, schemes based around blue can be made particularly cold and lifeless with too much terracotta in them. This floor uses small bricks and blocks set closely together, and is a variation of the technique used for the blockwood floor opposite, adapted here for odd and irregularly shaped elements.

The most rigid support for your floor is a bed of scalpings or small stones a good 10 cm (4 in) deep. Lay out your design, using old bricks, tiles or even broken, glazed pottery and set your level across the whole area using a string line (see page 184). Make a good solid mix of three parts sand and one part cement (see page 184), incorporating any odd bits of broken terracotta or stones, and build little plinths between 2.5 cm (1 in) and 12.5 cm (5 in) deep. Carefully lay the bricks and tiles – dampened with water – onto these plinths and check all round with a spirit-level. When the cement is hardened, back-fill the gaps with more cement (a white cement and sand mix gives a clearer colour). Roofing tiles should be cut into strips 5 cm (2 in) wide and set instead on their edges into a bed of wet cement as an effective emulation of Roman clay tile flooring – appropriate in a medieval, Tudor or Edwardian garden.

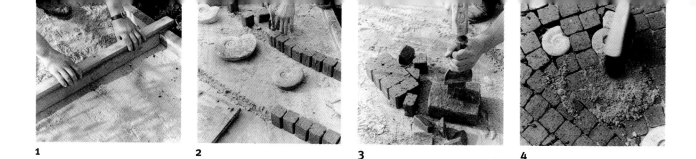

1 2 3 4

a decorative brick floor

The blockwood floor represents a first step in the skills required to lay a floor outside. This paving project is altogether more ambitious, although really no more difficult, simply more time consuming. The results, however, are more than worthwhile: laying out a large design is exciting in itself, and the finished work will have a tremendous impact.

Materials: You will need an area dug out to a good depth, say 20 cm (8 in), and filled with rubble, sand or scalpings; more sand to lay the floor on (just enough to get a smooth level); some old bits of timber; a rake, brush, chisel and lump hammer; and some gloves. I also edged the area with timber boards screwed to timber spikes, set into the soil to form a firm border to the path.

1 If the path is narrow enough and has side boarding, nail the old bits of timber together to make up a level, as shown, to smooth out the sand to exactly the right depth. This forms a bed for the bricks. Otherwise, use a spirit-level to get the sand flat. 2 If the design is complicated, start by scratching it out in the smoothed sand with a stick. Then put in a key line, points or features and start to infill. You can use all kinds of flooring materials; I include some terracotta fake ammonites.

3 The bulk of the design is executed in excellent little machine-made pavers that come in a six-pack for easy laying. I split them with a chisel and broke up individual ones to fill gaps and corners. 4 Once the decorative elements are laid, carefully grout the floor by sweeping fine sand into all the cracks. Hose down with water to help the sand penetrate, and repeat the process as necessary. Adding one part cement to nine parts sand will stiffen the grout, but is not absolutely necessary.

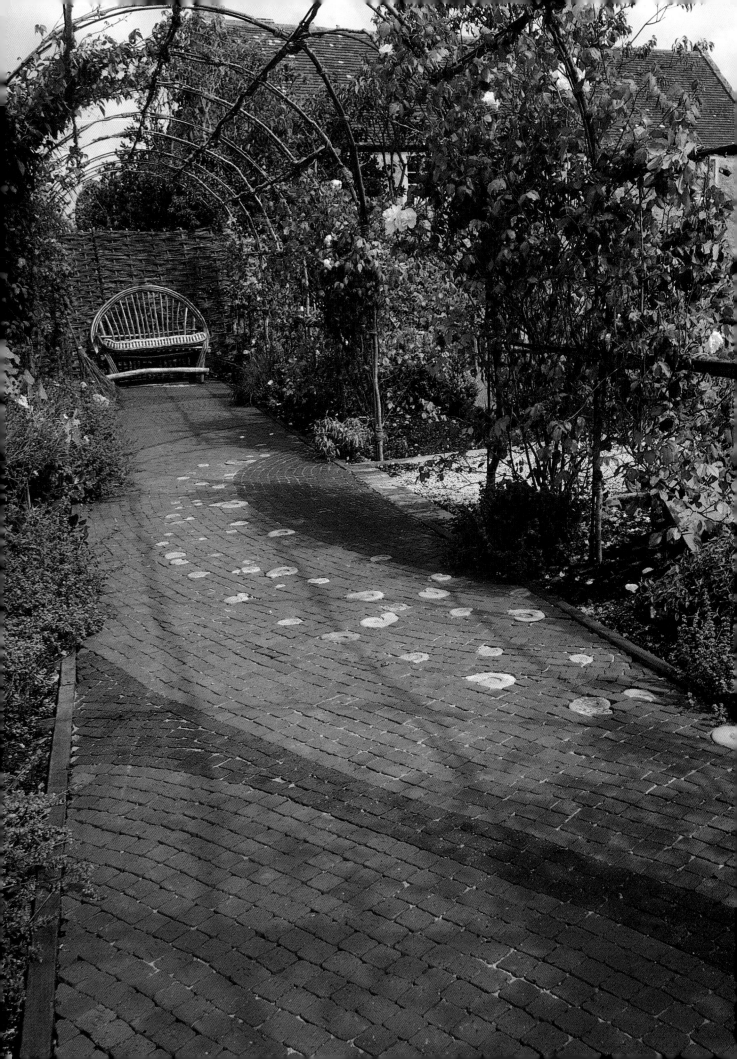

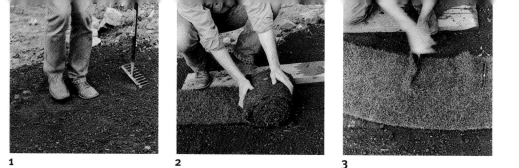

1 2 3

cutting a grass carpet

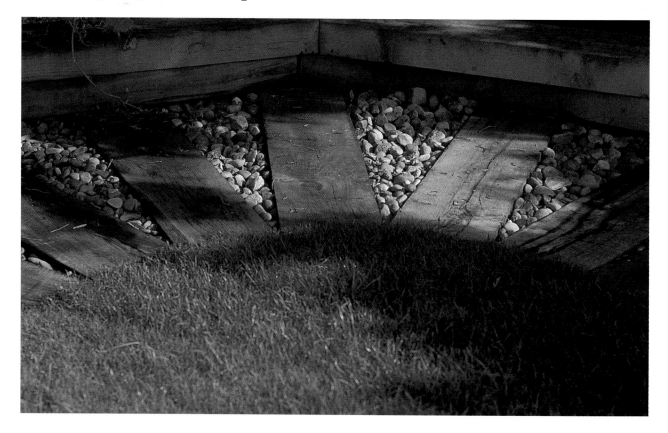

There is a fashion for relegating grass and lawns to the fourth division of gardening and replacing them everywhere with hard landscaping. This is a shame and reflects, I suppose, the current trend for rejecting carpet in favour of wood-strip flooring inside. And yet grass is a miraculous carpet that is self-renewing and self-adhesive. I love it for its colour, its texture and the sensation underfoot. It is cheap and has an important design contribution in the garden because it can link disparate areas. It can provide a common theme, so we should never underestimate it. This project isn't so much a finished design, but rather a demonstration of how flexible grass is as a design material.

Materials: To lay grass in this way you will need the usual tools – a rake, shovel and some good quality turf – and you will need to prepare the ground well, as all good gardening books tell you. You will also need some stout scissors and a bread knife.

1 Prepare the ground as usual, stamping and raking the soil thoroughly and repeatedly to get it compacted, level and to a fine tilth. This pays dividends later, when you come to lay the turf. Add grit and a little clean sand to lighten heavier soils.
2 Mark out the pattern on the soil with sand and begin rolling out the turf to flow along the lines of sand. Butt the turf edges together as tightly as possible so that the joins do not show.
3 Make fine shapes with a bread knife or scissors, treating the turf like a sculptural material. Cutting triangles out of an inside edge and butting up the edges will help a curve to form better.

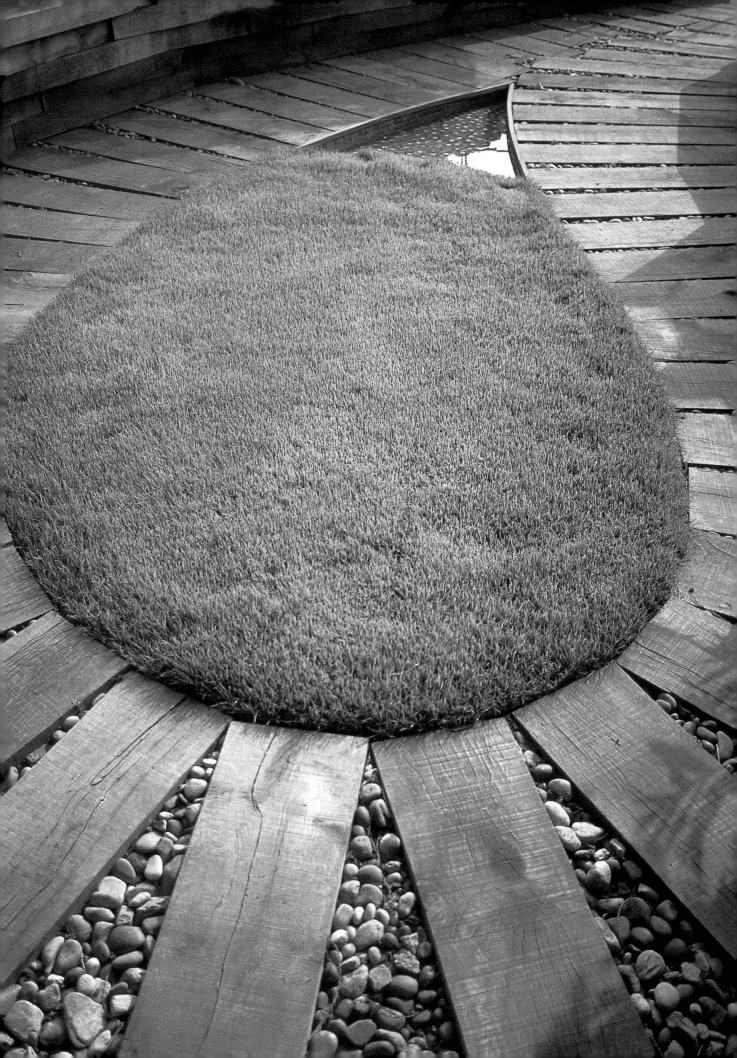

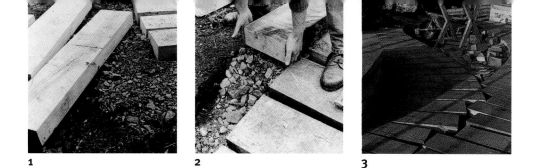

1 **2** **3**

railway sleeper flooring

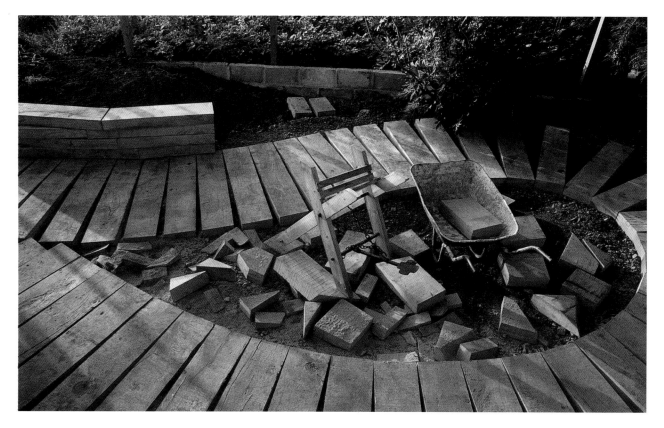

Reclaimed railway sleepers are tough and weathered and are ideal as a garden flooring material. They are ridiculously easy to use and altogether too tempting to ignore. The fact that they are so thick means that when they are laid their sides interlock to some degree, making a very stable structure. But if you cannot get hold of sleepers, or if you want to experiment with lighter colour tones, you can use cheap grades of a variety of new woods.

Materials: Oak, cedar and chestnut are all appropriate woods for this flooring project, as are recycled railway sleepers. The slabs shown here are cut from cheap 'c'-grade oak. Instead of using grout, I filled the gaps between the wood with Cornish pebbles.

1 Start by digging out the area of ground for the floor to a depth roughly corresponding to twice the thickness of the wood – about 25 cm (10 in) in our case. Back-fill with rubble, then with a layer of finer stone, and level off to provide a flat surface. **2** Carefully lay the blocks directly over the stone, building up corners and edges underneath the wood with hand-fuls of small stones to ensure that the blocks are absolutely level. **3** Space the blocks liberally to allow for filling with some form of loose grouting, such as pebbles, gravel or stones, that will become part of the overall design. Where possible, inter-lock the blocks to form interesting patterns – here we came up with a pattern that looks like meshing teeth!

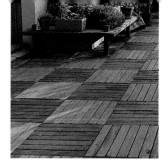

wooden decking

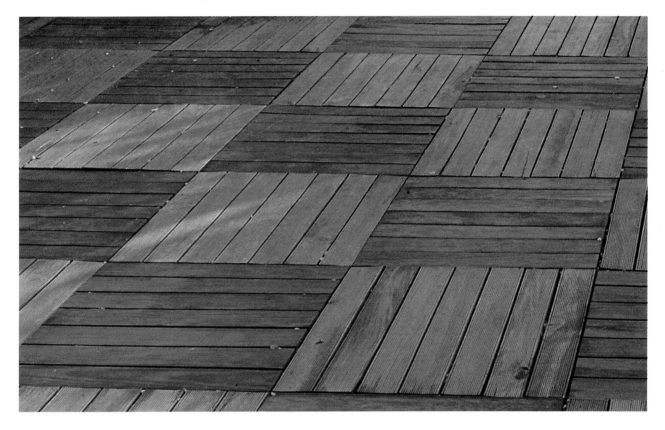

There are often inhospitable places in the garden, perhaps dark corners where few plants will flourish, that can be made friendly with a quickly made floor. The decking squares in this roof garden were simply laid over the existing, unattractive flat roof and occasionally 'spiked' together with nails or screws. On a rougher surface, you might need to level the area with a frame of timber 5 x 5 cm (2 x 2 in) by placing chocks and wedges of gash timber underneath the decking. Once the flooring tiles are nailed onto it, nothing's going to move. The whole process is ridiculously easy, because every nail you put through a flooring board strengthens the whole structure.

Using this principle, it is not difficult to make your own wooden decking out of sawn timbers, 2.5 x 10 cm (1 x 4 in), nailed onto a frame 15 x 5 cm (6 x 2 in). In fact, I recently made a bridge across a stream this way. I laid some old railway sleepers either side of the stream and then simply placed two large timbers, each 8 x 20 cm (3 x 8 in) across the gap, about 75 cm (2 ft 6 in) apart. For the surface of the bridge, I bought a special type of decking timber that has a grooved topside to prevent you slipping on its surface. It comes about 2 cm (1 in) thick by 8 cm (3 in) wide in ten foot lengths. I sawed the timber into lengths of about a metre (3 ft 6 in) and just laid them across the two long timbers to make the surface of the bridge. The only fixings I used were 20 cm (4 in) nails, one at each end of each decking strip. Miraculously, the combined effect of all these nails made the entire structure amazingly sound.

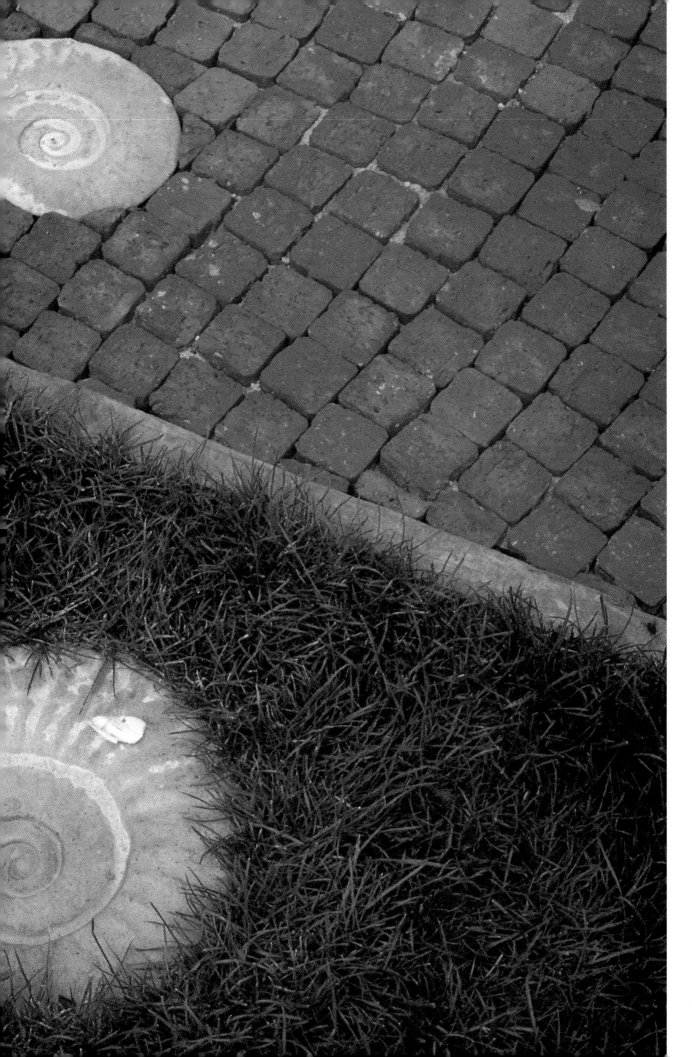

W A L L S

IN THE DESIGN OF AN INTERIOR SPACE, WALLS CREATE THE

SINGLE BIGGEST IMPACT. THEY PLAY A SIMILAR ROLE IN A

GARDEN – AS A FOIL TO PLANTING, AS ASSERTIVE PANELS

OF COLOUR AND TEXTURE AND AS OPEN, DECORATIVE

FRAMES. THEY ARE THE KEY COMPONENTS OF STRUCTURE

AND DESIGN THAT GROW OUT OF THE GROUND-PLAN.

SCREENS In the garden, screens are not just for separating areas and offering privacy, they are also key structural devices. They act in a similar way to walls, but ones that are very simple to erect and that can offer the ambiguity of translucency where brick or render might seem too unyielding or might cast too much shadow. Another advantage of

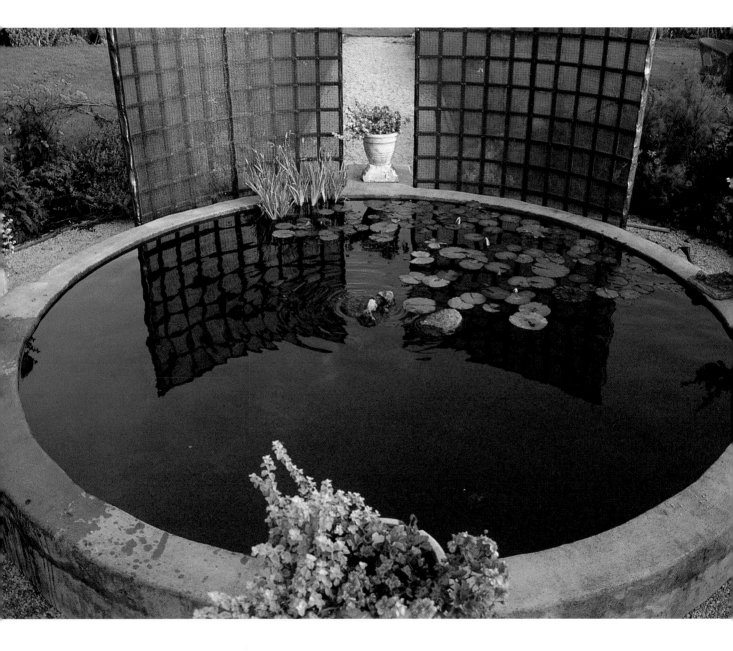

screens is that they can be moved around and re-used as the garden develops and at different times of the year. They should be thought of as highly flexible pieces of furniture that have a powerful effect on the way spaces are created and used.

RIGHT In conjunction with more permanent walls, screens also take on a less flexible identity, but can be a useful means of softening the massive intransigence of masonry. BELOW RIGHT Their real strength is as translucent dividers, playing two extremely useful roles: that of supporting climbing plants and that of controlling and articulating space, even creating an instant garden 'room'. LEFT These roles combine to offer the garden designer an opportunity for instant height and structure, the ground-plan made 3-D, as it were. These screens are covered with green shading fabric, which gives them some solidity, and finished with the fine netting usually used to protect soft fruits. In the short term, they are fully formed topiary. In the long run, they will become hedges of climbing plants.

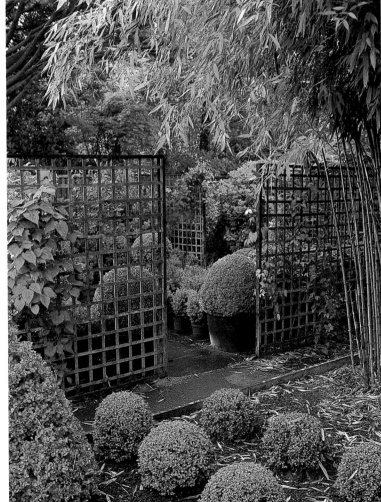

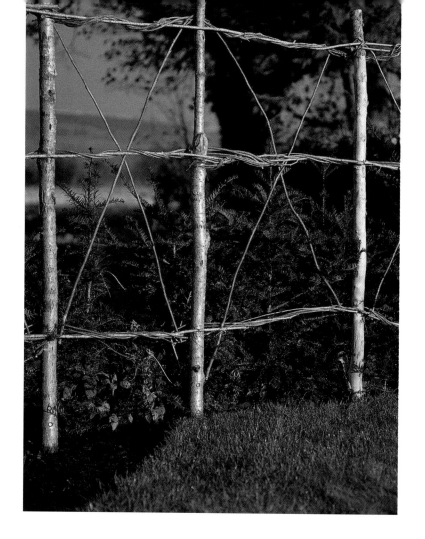

ABOVE LEFT A combination of coppice woods used together gives a pleasing balance of textures and scale.
RIGHT The structure comes into its own when covered in planting.
BELOW LEFT The prime requirement for a hurdling wood is that it is pliable. Willow is supremely easy to weave but relatively short-lived (hurdles may last fifteen years at most). The hazel used here and chestnut (much used in France, for example) will weave when split in half, giving chunkier, longer lasting hurdles.

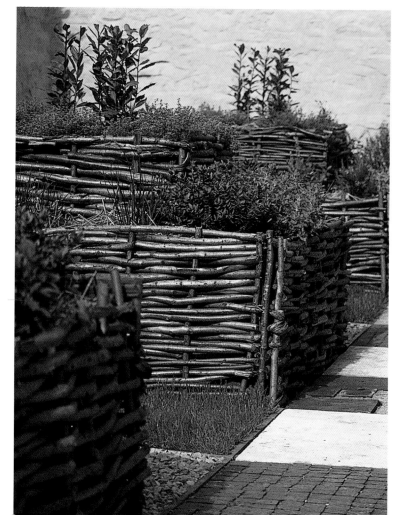

COPPICE WOOD This is thin-section wood that has been cut straight from the hedgerow, or coppice, with the bark on, and to me is the most appropriate, most complementary and most appealing material I could hope to enjoy using in the decoration of my garden. Coppice wood is used for the lovely garden art of hurdling, the making of temporary frames or fences. Unlike

processed timber, it has not been straightened, planed and stripped of its identity. This is wood with its clothes on, part of the fabric of the outdoors – honest, pleasantly bent and at one with the intentions of the gardener. Nothing could harmonize better with the planting in a garden and no material could be subtler in furnishing the outdoor room.

PAINT It won't build you a wall, but paint will transform an existing one. Paint is the quickest, most reliable and cheapest way of introducing colour to the garden, and the outdoor context means you can get away with much stronger colours than you can indoors. Those that work particularly well with foliage are drawn from a subtle palette: blues, especially pale sky blue, lavender blue and ultramarine; orange; warm yellows such as yellow ochre; red ochres and oxides and particularly the bluish pinks that red oxide yields when mixed with white; dark greens that blend into shadows; bronze colours; lead colour and silvers, particularly the greyish silver of old zinc; and gold – in the form of mosaic and gold leaf.

Solid paint colours nearly always require some breaking up in the garden, perhaps because their unmitigated, sheer, flat perfection is at odds with everything else in the natural world. But some hues are so powerful under daylight that their brilliance overcomes any monotony in the surface. LEFT The Moroccan blue of Yves St Laurent's garden is actually a shade of ultramarine which defies the eye. ABOVE AND BELOW RIGHT Other, softer colours, particularly earth pigments such as yellows and red ochres, require the gentle distressing that comes with age, or the pleasing undulations of a stone wall, to add personality.

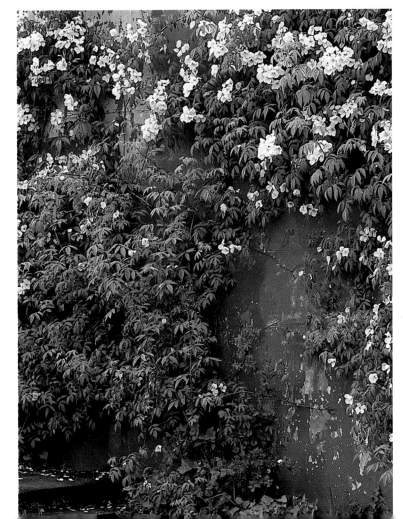

 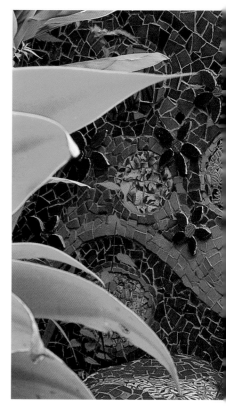

APPLIED DECORATION This is not something that needs to be restricted to the interiors of our houses. You may not be able to wallpaper your garden fence, but there are techniques and materials that are not only suitable for, but are positively desirable in, a garden. It is only outdoors that the shimmering clarity of mosaic or shell work, both of which rely on the play of light and shade for effect, can truly be appreciated. And the setting outside demands colour, a richness of materials, pattern and drama on a scale against which we might feel uncomfortable indoors. The garden can accommodate flights of fancy, even the unashamedly kitsch, in a way that feels alien if you encounter them inside. Even the most minimal of gardens can benefit from a touch of the theatrical on its walls.

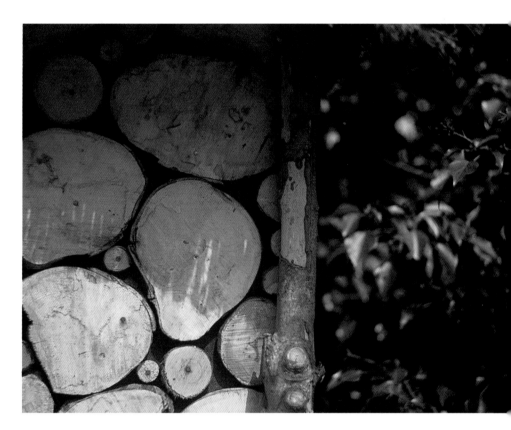

LEFT The simplest of approaches can be highly effective, especially in sunlight. The detail of the glass fountain in our garden shows the seductive twinkling surface of nothing more than recycled glass gravel pressed into some render. CENTRE The mosaic in Margot Knox's extraordinary Australian garden is altogether more carefully done, a painting in stone, tile and ceramic in the tradition of mosaic, but which owes more to the fabulous, fluid creations of the Spanish architect Antoni Gaudí. RIGHT Equally quirky are the log ends that I used to cover the children's house, described on pages 128-31.

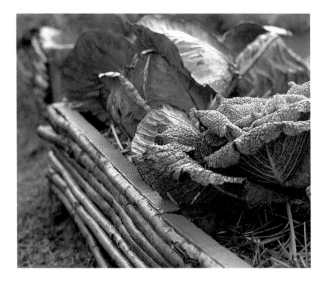

A GARDEN WITHOUT height is one that is immature, that hasn't had time to grow into its own. It is also a garden that has no soul, no seasoned character and no sense. It is like a building without walls or ceilings, just the floors in place, and which therefore cannot rightly be called a building at all. Similarly, our outdoor spaces cannot be gardens without the vertical, for the simple reason that for us to relate sensibly to them, we need things at and above head height. We are vertical beings, and we need our spaces to be in proportion to us and to follow the same basic design. To help you to achieve the vertical without waiting ten years for your hedges to grow, here follow some ingenious techniques.

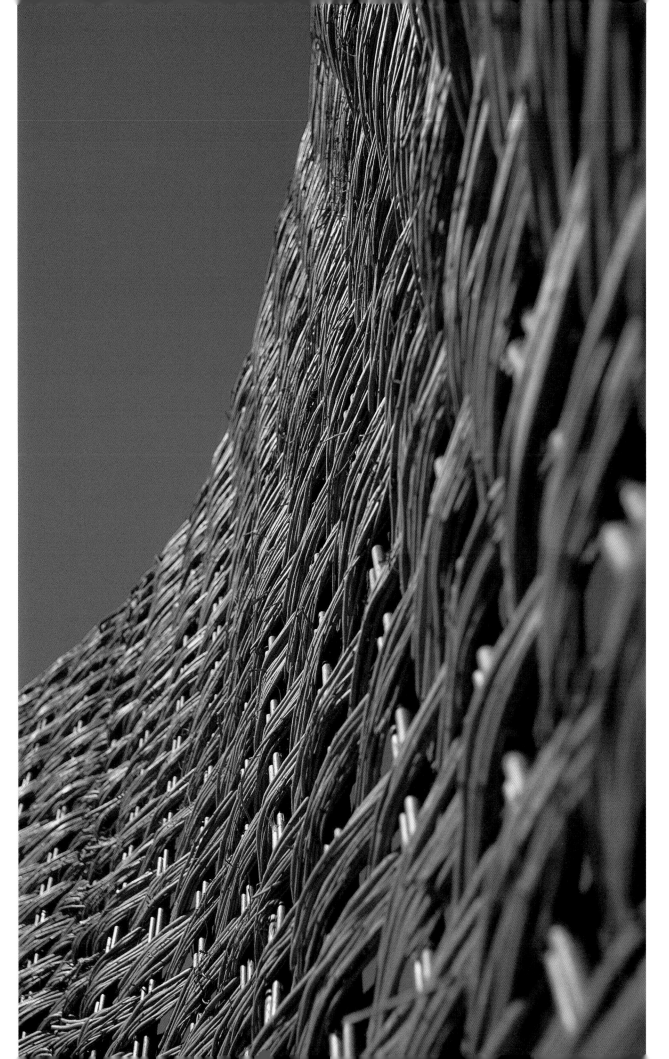

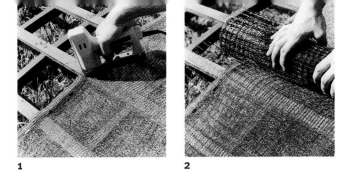

1 2

green screens

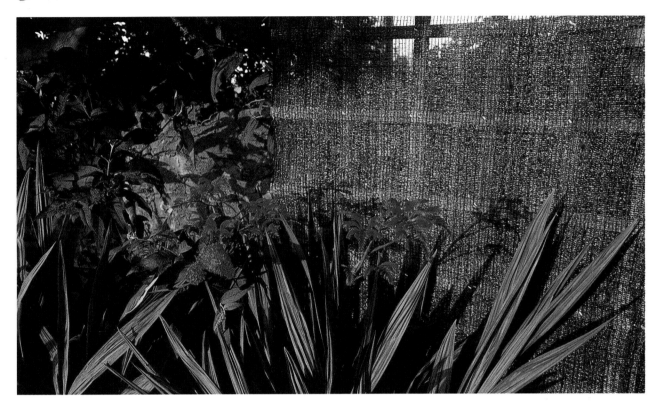

Instant height, especially instant height that is green, is the great object of desire in any newly planted garden. Whether in the perennial border, in a hedge or in the shrubbery, tall planting is prayed for, lusted after and admired as a mark of maturity and good plantsmanship and design.

The beauty of a structure like this is that it behaves just like a big, shaped hedge, offering screening and privacy. It provides a formal shape against the often informal outlines of plants. Since it is covered with fine netting, it is also a perfect climbing frame for ivies, clematis, honeysuckle, solanum, morning glory – any climber you care to plant next to it. And although it can be made of standard trellis, it is much, much nicer.

Materials: Apart from the trellis panels themselves, you will need a staple gun, a quantity of fine strawberry netting and some greenhouse shading, which can be bought off the roll at garden centres. I also painted the trellis first with a dark green outdoor wood paint/stain to improve its colour and durability.

1 If you are forming a shape from plywood rather than using bought trellis, use marine ply, as it is much more durable. Jig-saw out and stain/paint the structure or trellis green with a proprietary garden product. The dense netting is used for greenhouse shading and is bought from good garden centres. Stretch and staple it onto the frame. **2** To turn the trellis into a practical climbing frame for plants, staple fine open netting, of the type used for covering soft fruit plants, over the top.

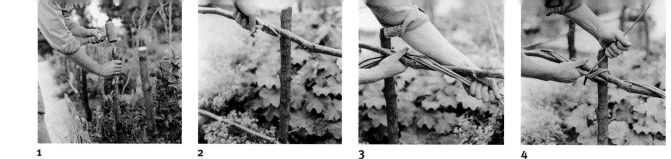

1 **2** **3** **4**

coppice fencing

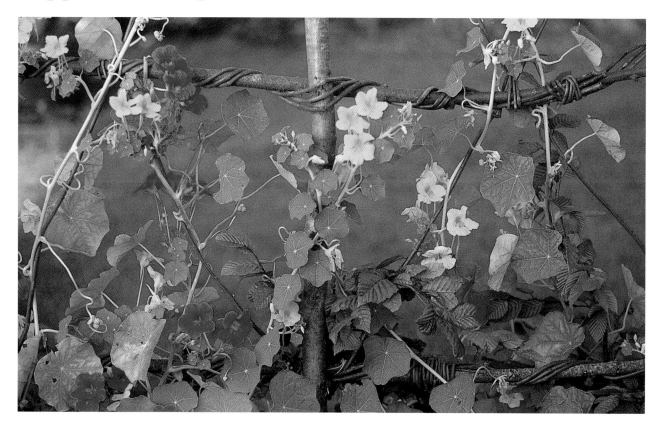

This project is delightful to look at and, just as importantly, delightful to execute. You will either need access to timber from coppice wood or you must make friends with an under-woodsman or small timber company. You will need 5-7 cm (2-3 in) diameter uprights made of any hardwood that will survive some years in the soil: ash, sycamore, hazel and, especially, oak will do, but chestnut is my firm favourite. The laterals can be of any coppice wood, and they can be quite spindly. Hazel is good for this job because it grows straight and is pliable.

Materials: You will also need some thinnish galvanized wire, stout gloves and a bundle of willow withies (flexible stems about 2 m (5 ft) long) for the decorative ties. These can be bought mail order from a willow hurdle manufacturer.

1 Cut the posts 50 cm (18 in) longer than their eventual height, put a point on them with a hatchet or billhook and knock them well into the ground. I space them every 60 cm (2 ft). If the top of the post starts to split, hold a block of wood on it and hit that. **2** Tie on the laterals with wire, or screw them in if the lateral is large enough. Snip the wire and tidy the ends away in the joint. If need be, saw the tops off the uprights. **3** Take two or three withies, well soaked to increase flexibility, and weave them, as one, round the lateral. I find two winds for every 60 cm (2 ft) about right, with a third to take in the joint between upright and lateral. **4** Ends and joints can be made bulkier and wires hidden by wrapping a withy around them.

withy knots

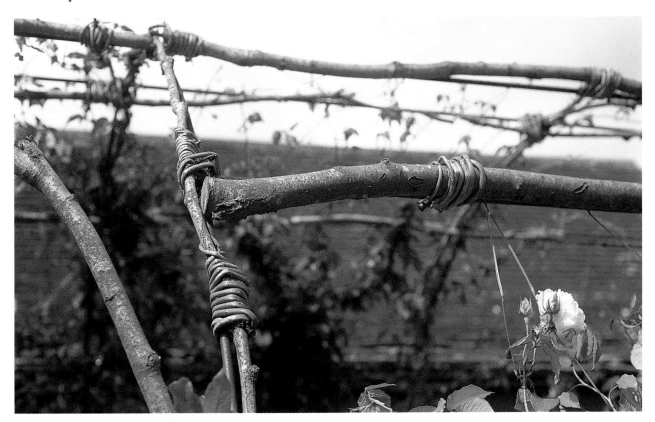

This fencing technique uses more of the material I love, coppice wood. I adore its combination of flexibility and sturdiness, its rough hands-on-ness, the openness and light ruggedness of the structures that coppice wood makes. There is an appeal in the pliability of hazel and chestnut or in the way a willow stem, or withy, will bend and kink like a piece of rubber tubing. Masonry walls break up a garden with an almost brutal aggression, but trellis persuades and gently eases both you and your eye around the space. The more open it is, the more gently it persuades. And the more natural the material, the more it seems integral to the garden itself rather than part of some manufacturer's range.

Of course, it isn't simply sufficient to bang a load of sticks together and expect them to look good. I use stout uprights, thinner laterals and then finer willow withies for the details. The knots, pictured in various guises at the top of the page, are also executed in willow, usually over a wire tie underneath. It's important to use them fresh, when they are at their greenest and most pliable, and they must not be allowed to dry out and turn rigid. After a year or so, the willow knots will weaken and desiccate, becoming brittle, so you need to identify a nearby and cheap source of willow ties. If you have a willow growing in your garden, you can prune the longer shoots from the current year's growth in the autumn and use those. You could even learn the arts of coppicing and pollarding (both of which involve the annual cutting of hardwoods back to a bole or stool) and become an amateur under-woodsman.

1 2 3

hurdle edging

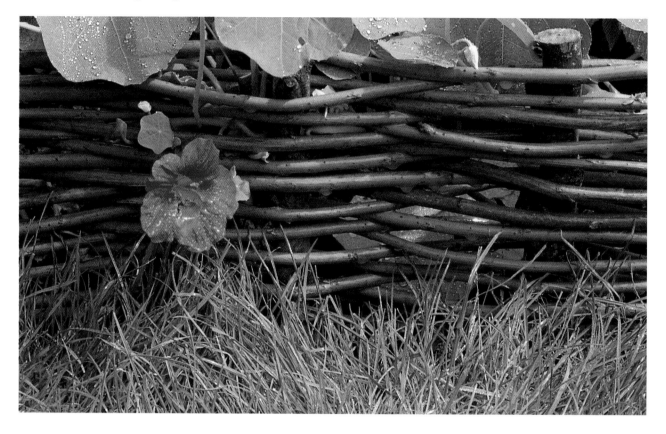

An extension of the use of coppice wood to build structures and fences is the art of making hurdles. It may at first seem a diffi-cult exercise, but it is immensely satisfying, a basic activity of the primitive homemaker or shepherd with a modern purpose. I use small hurdles woven *in situ* for containing differences in levels between planting beds, as lawn edging and as low retaining walls. On a larger scale, you can construct screens and sturdy raised beds like the split hazel ones of our kitchen garden (see page 106). Hazel is stronger and long lasting, but tough to manipulate.

Materials: You will need a mallet, a rough saw and some strong garden secateurs. Plus your willow withies (at about 2m (6 ft), longer than tree-grown willow stems) and some lengths of 2.5 cm (1 in) diameter wood; hazel, chestnut or willow will do.

1 Start by banging the wooden lengths into the ground at 30 cm (1 ft) intervals. Once in, they need to be as tall as the fin-ished hurdle height. **2** Grab half a dozen or so withies and, starting just before an end of the hurdle, weave them round the end upright and then through the other uprights, as though they were one fat strap. Repeat with more handfuls of withies to build the hurdle up in layers, alternating the weave with each layer. Try always to finish a handful with the ends point-ing inwards and never to finish a handful at either end of the hurdle – always in the middle. **3** Finally, trim any loose, pro-truding ends or frays with secateurs to give a neat, clipped finish to the hurdle.

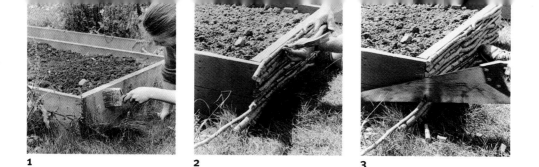

1 2 3

decorative raised beds

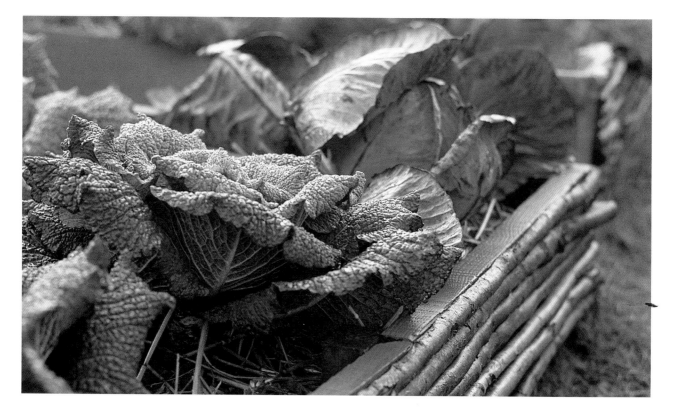

I like the idea that in the garden you can find chairs, tables, mirrors and all kinds of furniture. So it seems appropriate to elevate the humblest of utilitarian providers, the vegetable raised bed, for inclusion in this list of indoor/outdoor living accessories. And why not? Vegetables are important decorative plants in their own right. Some gardeners even seamlessly meld vegetable and floral beds together. In our garden, the vegetable beds are separate but visible and form an unavoidable part of the walk round the entire space. To make them as attractive as possible, they are not only unusually shaped into triangles and segments to follow a curving grass path, but they are also treated decoratively as part of the structural design of the whole garden, blending by virtue of their material and their colour.

Materials: For this project I used some purple paint/stain for the timber, local stone (called scalpings where I live) and 2.5 cm (1 in) diameter hazel rods, some 5 cm (2 in) nails, a hammer, drill and hand saw.

1 We started by painting the timber around the outsides of the raised beds with two coats of purple paint/stain to accentuate the purplish-grey colour of the local stones used to cover the ground between the beds. **2** You can split the hazel rods yourself with a billhook if you're very enthusiastic and prepared to have your patience tested, or you can buy them ready split. Drill each end with a fine, say 4 mm, bit and nail through this into the wall of the raised bed (not drilling first will result in the wood splitting). **3** Trim off the ends at each corner with a hand saw.

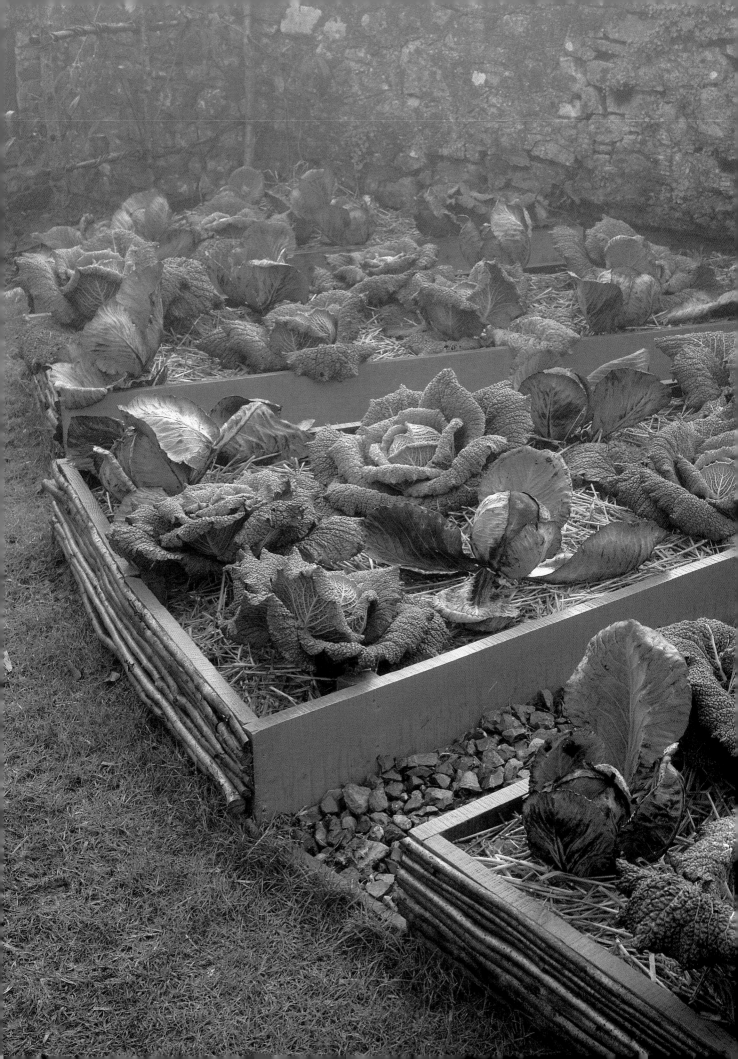

large-scale hurdling

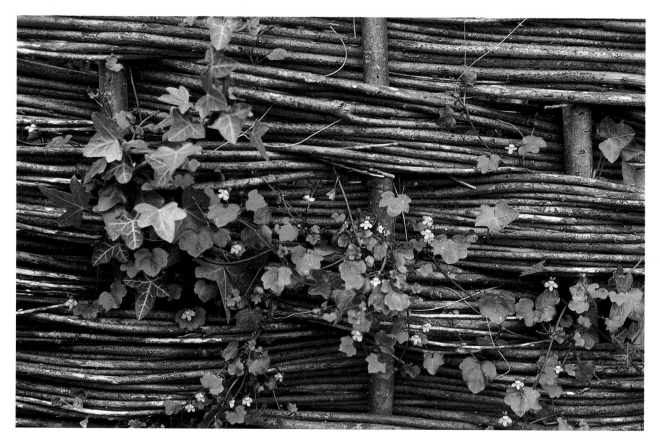

If the delights of working with wood and withies have become an obsession, then you could consider making your own full-size, two-metre high (six feet) hurdles for fencing or for covering up an ugly building. Remember that hazel and chestnut, though heavy to work, will last for fifteen to twenty years, whereas willow is more likely to last ten, fifteen at most, before literally falling apart. You can protect all these woods with an exterior acrylic varnish, which will provide a plastic surface layer, or with a mixture of linseed oil and white spirit (I recommend a fifty/fifty ratio, with the addition of ten per cent beeswax polish to keep it soft), which has a more penetrative action. This should be done in the second summer after their erection, once the wood has given up all its moisture and become noticeably brittle.

Another measure to help prolong the life of your hurdles, especially those of willow, is not to move them and to ensure they cannot be moved. This means drilling, screwing and firmly tying them to strong timber stakes or to a wall. It also means not leaving them unsupported along their bottom edge, because they will sag miserably. A block-work wall or stout timber is the answer, on which the uprights of the hurdle can rest. Some of my one and a half-year old hurdles in the orchard are now heavily deformed and weakened by lack of support and by the action of wind and rain. Those screwed into a frame are still proud and alert.

1 2 3 4

exotic materials

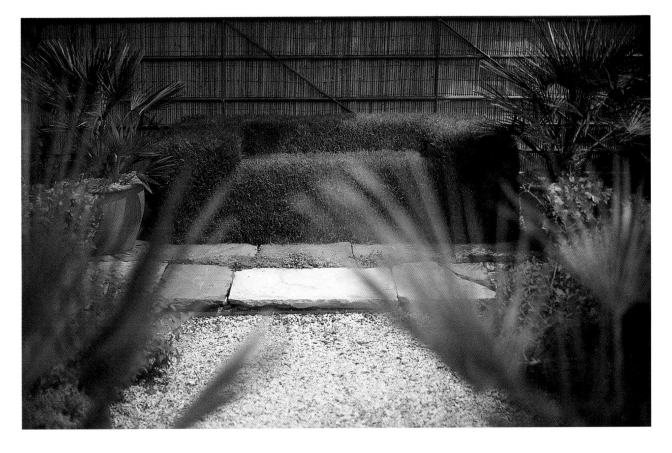

Fencing need not just be made from native hard and soft woods. In a contemporary or minimal space, it's desirable to add a harder edge. This low wall behind the turf sofa in my garden is a recycled agricultural field gate made from galvanized steel that has turned a cool grey over a couple of decades. We wired a roll of bamboo screening onto the back of it to make what I consider to be a rather beautiful screen, which is back-lit at night.

I've experimented with a variety of screening materials that you can buy on a roll and which make excellent wind-breaks and privacy screens when tied onto gates. Birch matting (1) makes a tough, serviceable and almost entirely opaque screen. Its rich brown colour and coarse fluffy texture are not quiet and tidy, but I am impressed with its serviceability. Peeled reed (2) by contrast, is flimsy and just doesn't cut the mustard 700 feet above sea level. I have to admit that the canopy we made from it for the hot garden is now in pieces, the edges smashed by the wind and the wire (which holds it all together) rotted by a week's worth of rain. It has been replaced by a facsimile canopy of split bamboo (3, also used for the field gate screen above) which is just as jolly. Bamboo is such a familiar garden material that it seems pedestrian, but it proves its worth by its simplicity and durability. The most opulent colours, however, come with dried willow (4) which is open and richly textured.

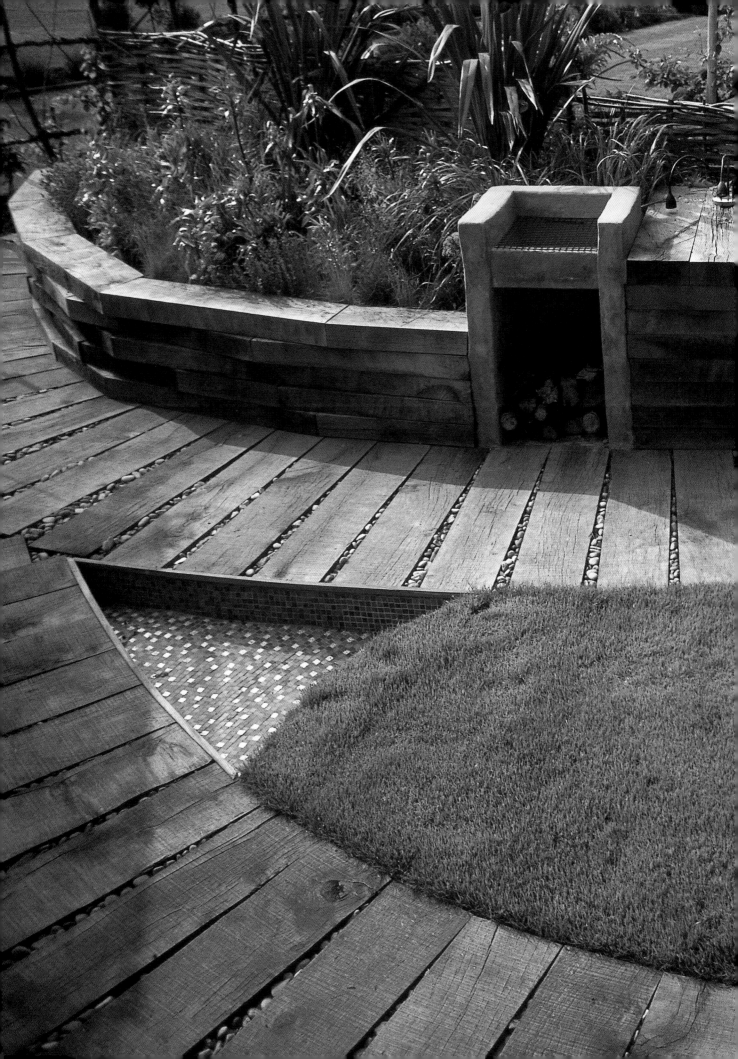

1 **2** **3**

oak walls

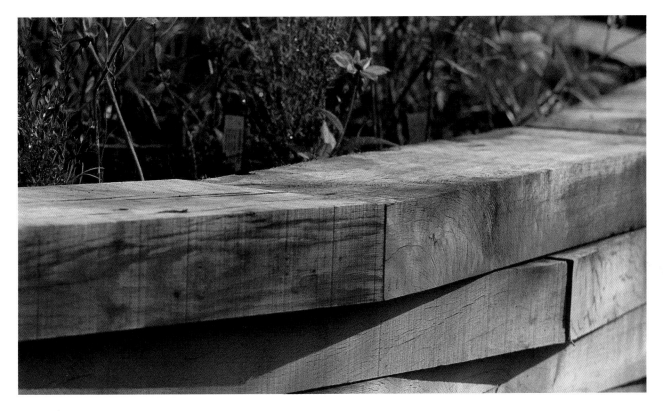

Reclaimed railway sleepers are the *sine qua non* of garden landscape materials. A week cannot pass without a television presenter using them to deck, pave or wall his way through a hapless victim's back yard. I count myself guilty. The maddening thing is that they are excellent value for money, recycled and effective because of their sheer weight and consequent stability. They are ideal for flooring, for raised beds and for built-in furniture. But I have discovered an alternative in a cheap grade of oak, less usable for other purposes, that comes in sections 10 x 25 cm (4 x 9 in) – about the same dimensions as sleepers. The comparative advantage of sleepers is that they are hardened with age, but new oak, once air dried, is tough, too, lasting for decades.

Materials: You will need the timber, rubble or stone for the footings (see page 184), some long nails or screws (an electric screwdriver is useful) and hammer, and a chainsaw with experienced handler.

1 Start by laying a scalping or stone bed (see page 184). Get a local sawmill to cut the timber into manageable lengths. Build the walls as though out of giant bricks, staggering the joints. A curved wall has much greater strength than a straight one but, in any case, do not exceed a height of 1.25 m (4 ft). Secure with long nails or screws at intervals. **2** Cut and trim the joints with a chainsaw. Take all the correct precautions: wear safety clothing and follow best practice. **3** The same timber can be used to make the floor alongside, following a similar, curving arrangement (see page 82).

1 **2** **3**

limewash

Limewash may be a crude and ancient coating for exterior walls, but it is also the most noble. It's success and enduring appeal lie in two miraculous qualities: its affinity with walls, especially those built with lime mortar (because it bonds without any additives and breathes moisture); and its chemical nature, a calcium compound that dries by changing its composition, taking on a matt, crystalline quality. Limewash can be used on render, stone, brick and even terracotta and should ideally be applied in four or five watery coats. It needs to be protected from the elements while it 'dries' or carbonates.

Materials: You will need protective gear – rubber gloves and goggles – for mixing the wash, since it is caustic in its wet state as calcium hydroxide. A drill with a mixing attachment is useful, as is a strainer and a large, lidded coffee jar. Limewash comes as concentrated lime putty in tubs or as dried calcium oxide powder for mixing with water.

1 Start by adding a few spoonfuls of lime putty to a large bucket of water. Mix it carefully to a skimmed milk consistency. **2** You can add colour (earth colours are best – I used yellow ochre) by first mixing the pigment thoroughly with water in a coffee jar. Tighten the lid, shake it vigorously and then strain into the limewash through a muslin or a fine sieve. Admix the colour thoroughly, preferably with a drill and mixing attachment, keeping the revs low. **3** Then brush on the wash with a vigorous motion, 'pushing' it into the wall. It may seem weak and transparent, but it will dry to a much whiter, opaque coat. Clean up splashes immediately, as limewash can scorch plants and burn skin.

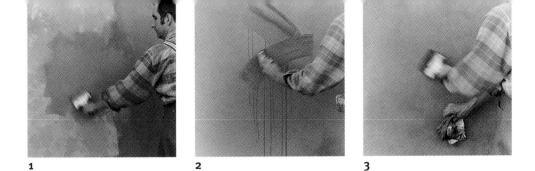

1 **2** **3**

acrylic paint

Limewash may be a prince among paints, but its colours are limited and its application tricky. The problem is that its poor relations can look so synthetic and lifeless by comparison. I developed this technique to give exterior acrylic paints a bit of life and surface interest. Acrylic paints, like their cousins, emulsions, are water-based suspensions of plastic polymers that knit together as the paint dries. In fact, acrylic polymers continue to do so long after the paint is dry. Because of this stamina, acrylics can be used on all kinds of strange surfaces outdoors and in: masonry, wood, quite a few plastics, concrete, even metal if it is primed appropriately. This versatility makes it hard to resist, and this technique for giving it a finish of broken colour makes it even more versatile.

Materials: You will need a stout wall painting brush, some rags or a sponge, pots for paint mixing, acrylic base coat, a litre or so of matt acrylic varnish and artists' acrylic paint or colour pigment.

1 The surface must be cleaned, sealed and primed appropriately. A wall, for example, should be brushed down and given a coat of stabilizing solution. When dry, brush on a coat of the base, pushing it well into the wall's surface to help it bond.
2 When thoroughly dry, make up a wash of 1 part acrylic varnish to 5 parts water and tint it with either some darker artists' acrylic or with pigment, mixing well. Brush it out over as large an area as you can manage without it drying. **3** Start to move the paint about with the brush as it dries, dabbing at it with a sponge or rag to give a random, broken colour effect.

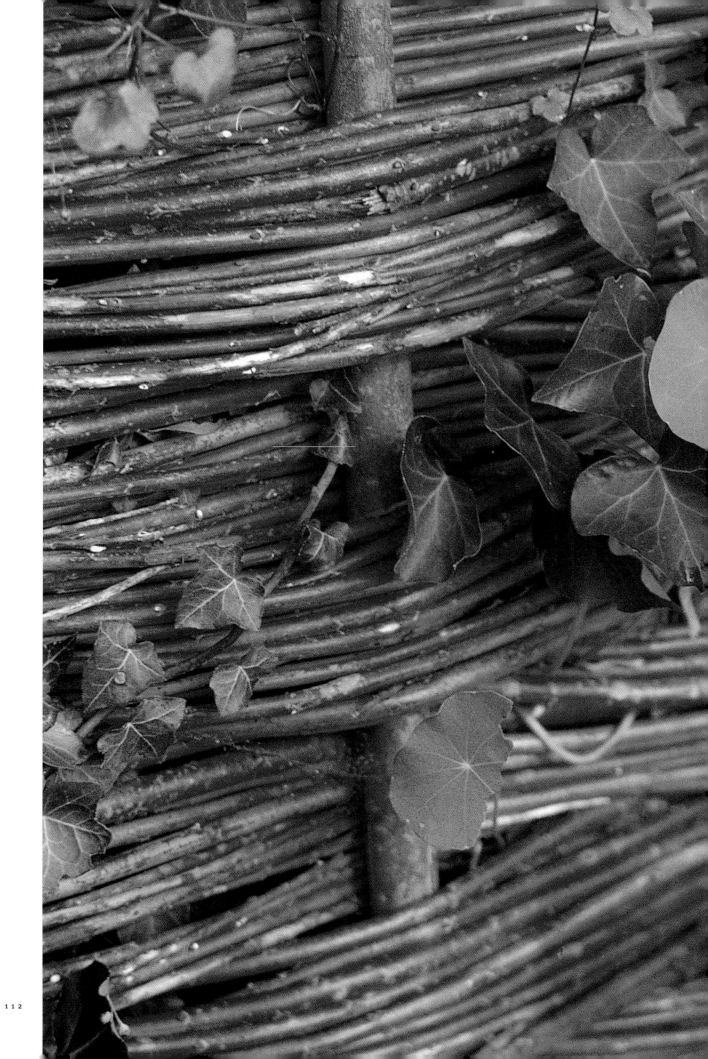

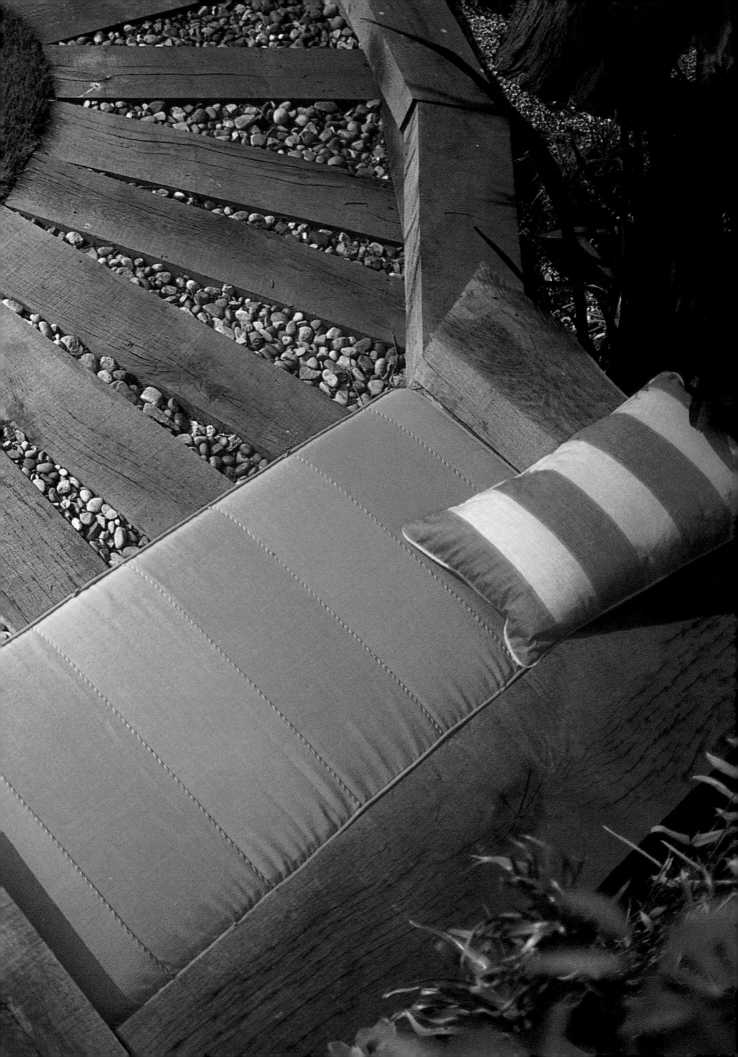

FURNITURE

TO THOROUGHLY ENJOY YOUR GARDEN, YOU WILL WANT TO

USE IT AS AN OUTDOOR ROOM WHENEVER YOU CAN: TO

COOK, EAT, READ, SIT DOWN, RELAX AND PLAY IN.

FURNITURE OUTSIDE WILL ENABLE ALL THIS AND IT WILL

ALSO ACT AS PUNCTUATION IN YOUR DESIGN, CREATING

PAUSES IN THE WALKS YOU TAKE AROUND THE GARDEN.

ABOVE LEFT Building a structure in the garden need not be an ambitious enterprise. Nesting-boxes, kennels, dovecotes and even rabbit-runs all provide an opportunity to experiment. RIGHT The rustic, gothic play-house that I built for the children (see pages 128-31) is really a simple piece of carpentry and just an overblown nesting-box. Its success relies on its eighteenth-century appearance, but such exactness isn't essential. BELOW LEFT A tree-house is much more straightforward, yet it smacks of romantic adventure, of Robinson Crusoe or Tarzan. In fact, it's in a garden in Mauritius.

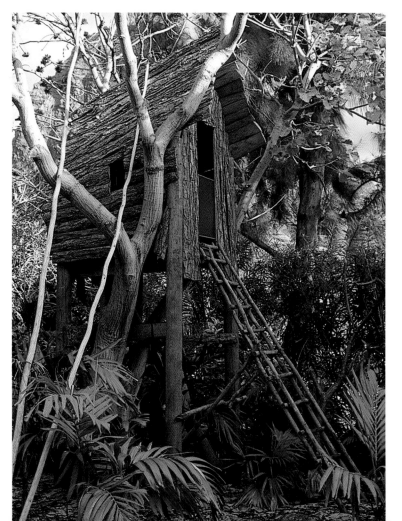

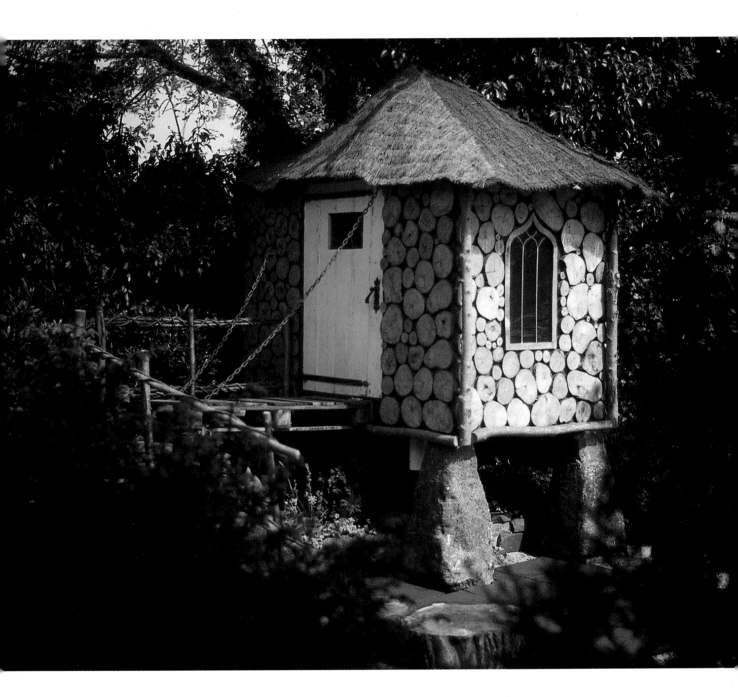

ARCHITECTURAL STRUCTURES At its grandest level, garden furniture can develop into entire structures, the equivalent of the built-in cupboards of an interior. Within the broader, more open areas of a garden, there is always room for a man-made folly, a play-house for the children or an arbour to offer refuge from sunshine or rain. Such features constitute theatrical centrepieces in the garden, major elements of punctuation in the overall design. These little buildings are not only inviting and delightful to look at, but they also represent a gesture of reconciliation to nature and to our simpler, primitive past when we lived in closer proximity to the outside world.

HIDING PLACES Because gardens have no ceilings and their boundaries – walls, fences or hedges – are nearly always wider and vaguer than the solid walls of any indoor room, they will accommodate big furniture, big structures. So big, in fact, that you can create rooms within rooms, entirely or partially enclosed spaces that offer privacy. Call them arbours or hideaways or follies, but they are really just play-houses for grown-ups. I refer often to their use as punctuation in a design, by which I mean that they are visually hard and assertive structures when seen against the more fluid outlines of planting. In any garden, but particularly a young one, furniture can provide height, focus and drama.

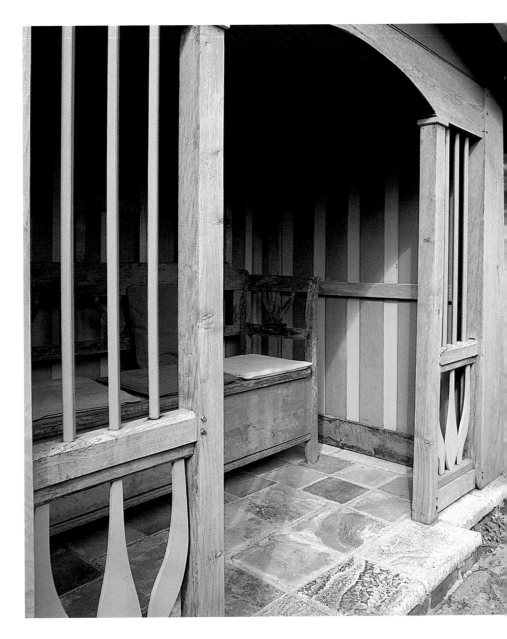

LEFT At their most delicate, structures like the frames in John Wheatman's garden in San Francisco provide poise and order in a relatively unstructured planting scheme. CENTRE At the opposite end of the scale, both in detail and theatricality, the permanent 'tent' is in the grandest decorative tradition, somewhat at odds with most modern gardens. RIGHT Mirabel Osler's oak retreat strikes a more modest and rustic note: it is built by a craftsman and at least nods, through its style and honesty, to the outdoor context which provides both its setting and its origins.

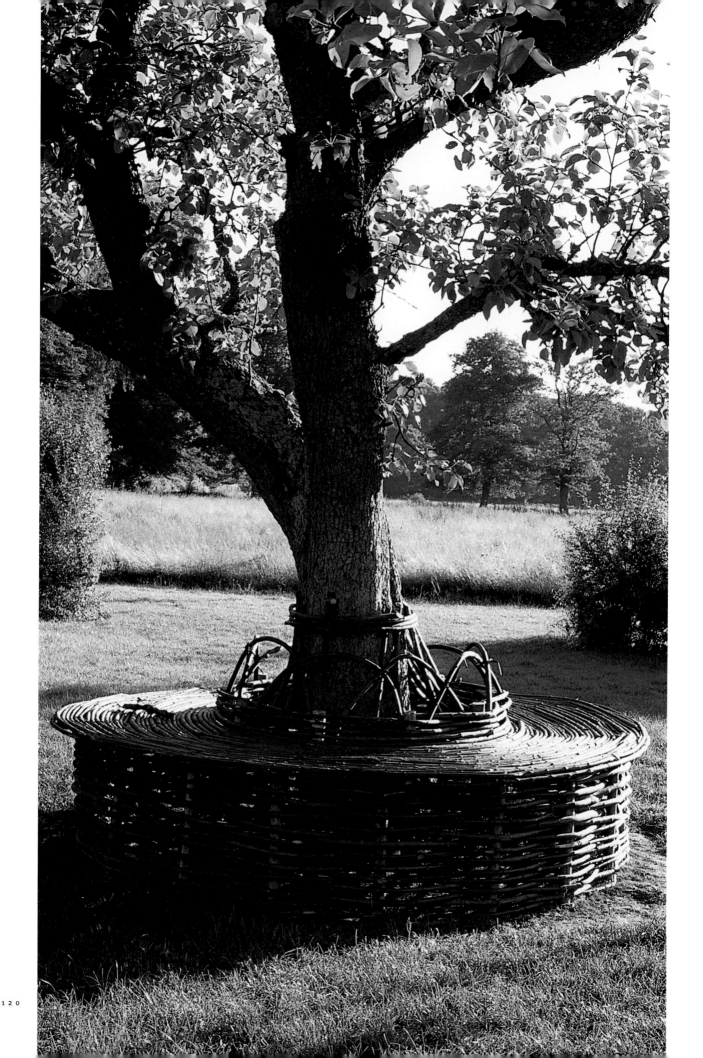

SEATING One way of handling the design of large features and furniture is to incorporate into their design materials that have sprung either straight from the location, or that look as though they could have. For instance, you don't need to live on a farm to have a bench made from coppiced hazel; you can dress an urban garden with hurdles and a log bench and it will work by virtue simply of being made of natural materials that have undergone a minimum of processing. They need only be sawn into lengths, bent a bit and nailed together to produce beautiful and practical pieces of furniture.

LEFT Deep in the Berry region of central France, the owners of the Prieuré d'Orsan have recreated its strikingly modernist looking medieval gardens and built any number of seats, benches and features from coppiced chestnut - which is actually cropped a hundred miles further to the south. CENTRE Lon Shapiro's work matches cut and worked timber with topiary to help it integrate into its setting. RIGHT Artist Paul Anderson uses old gnarled reclaimed oak to make substantial pieces suggestive of redundant agricultural fixtures.

EATING OUTSIDE Food always tastes better when eaten outside – perhaps the setting brings out the Neanderthal in us. And there is no more amenable way of cooking than on a barbecue in the open air. The backyard as a place for entertaining is an exciting and flexible extension of the kitchen and dining area indoors and is an idea that still works even if you're not interested in gardening and flowers. What helps is a sense of enclosure (another Neanderthal instinct) so that guests feel secure and don't disperse in all directions.

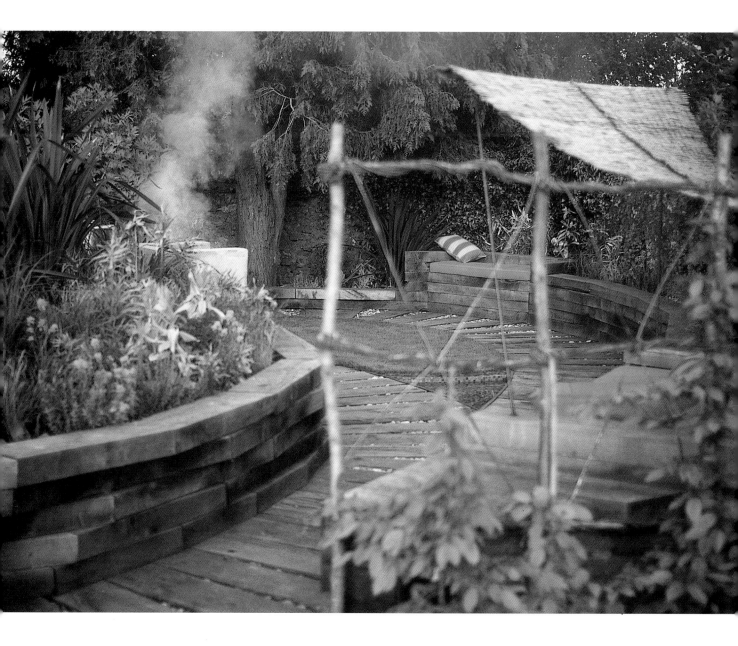

Ideally, in anything but the smallest of gardens, you should divide off an area not too far from the kitchen that has a view, is reasonably sheltered and ideally one that catches the evening sun. LEFT I built our enclosed hot garden on a site that catches the last evening rays, but which also, unfortunately, is fifty yards from the house. But make sure your seating areas are not wildly exposed. BELOW RIGHT Shade is crucial in any garden, not only for plants, but also for people, and even a low wall will help, as in this contemporary garden by Isabelle Greene. ABOVE RIGHT Here the furniture is cleverly built around and into the planting.

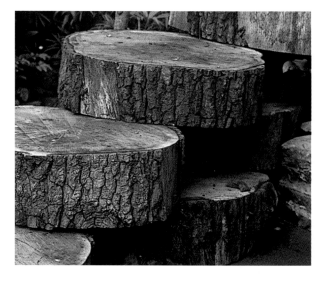

DESIGNING AND BUILDING our own furniture is not something many of us would be prepared to do for the interiors of our homes. There are too many skills required, too many hours to be spent. And yet outside, it all suddenly becomes easier and more desirable. You can build a very passable garden bench from a few logs and some nails, because nobody is going to look for dove-tailed joints or veneer. And even the most sophisticated of projects can use elementary tools and fixings, and elementary skills. Making your own garden furniture is desirable because there is such a limited choice of manufactured pieces on the market. So make your own mark.

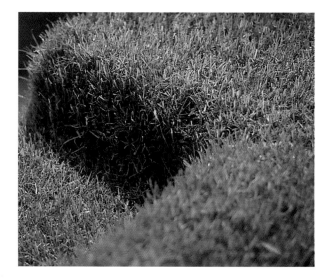

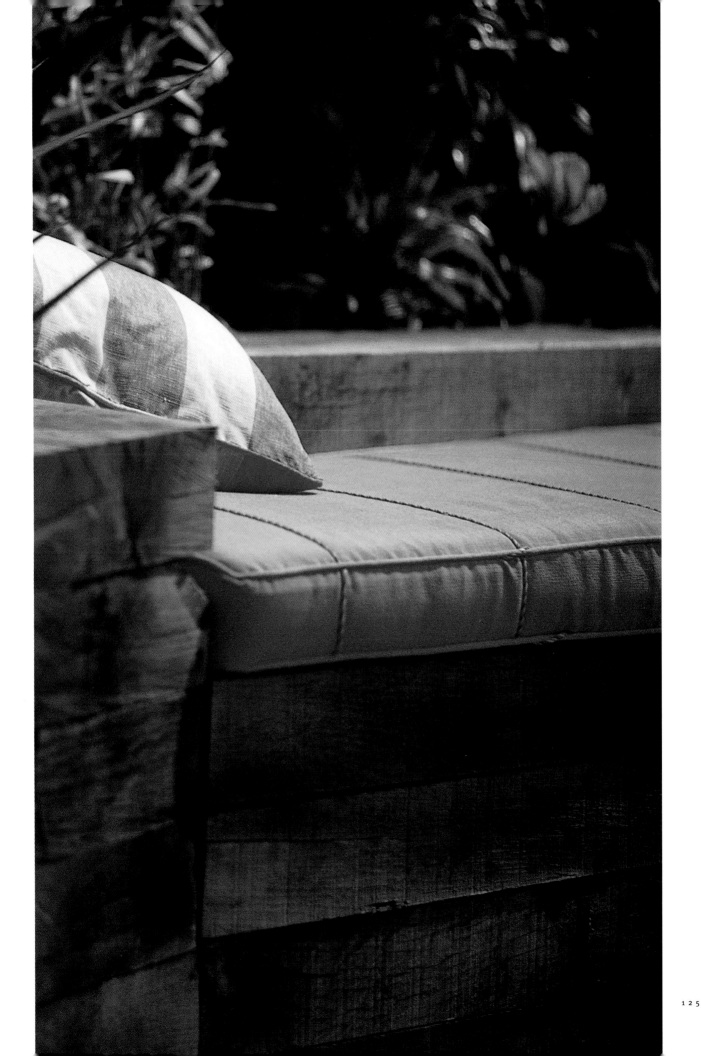

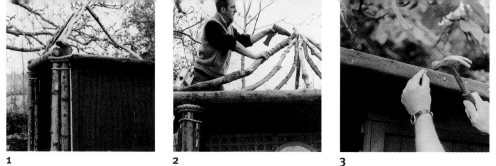

1 2 3

rustic pavilion

This is a piece of eighteenth-century frippery in the then popular tradition of 'rusticated' classical buildings. It is also true to period, a piece of pure façadism: just a simple, open shed with a decorative front stuck on. This is not architecturally pure, of course, but a great wheeze in the garden, particularly where a theatrical flourish is required, as here at the end of our orchard. We customized the design with the façade, the window and the elegant hazel sofa, made by Mark Christensen.

Materials: You will need to find rustic timber, old rope, plywood (for the mirror), exterior paint/stains, and roofing felt. You will also need clout nails, plenty of 10 cm (4 in) and 15 cm (6 in) screws, a good jigsaw and a cordless screwdriver.

The building rests on a bed of rough gravel stones, for drainage (see page 184). The trellis and fencing panels were first painted different colours. **1** Then the trellis is nailed onto the larch-lap fencing panels, which are erected and screwed together – two panels for the rear wall, one panel each for the sides. A long timber wedge is nailed each side on top to help tilt the roof (another larch-lap fencing panel with a generous overhang). The columns are each made by screwing together three pine trunks, then screwed to the front end of a wall. Two, parallel, trunks are laid across the top, screwed down into the columns and against the edge of the roof. **2** Rope rings are nailed round the columns as detailing and curved branches screwed together to form a mock pediment. **3** The roof is covered with roofing felt, nailed on with clout nails; decking tiles are laid straight over the gravel. The window is cut out of plywood, screwed on and then the wall behind jig-sawed away.

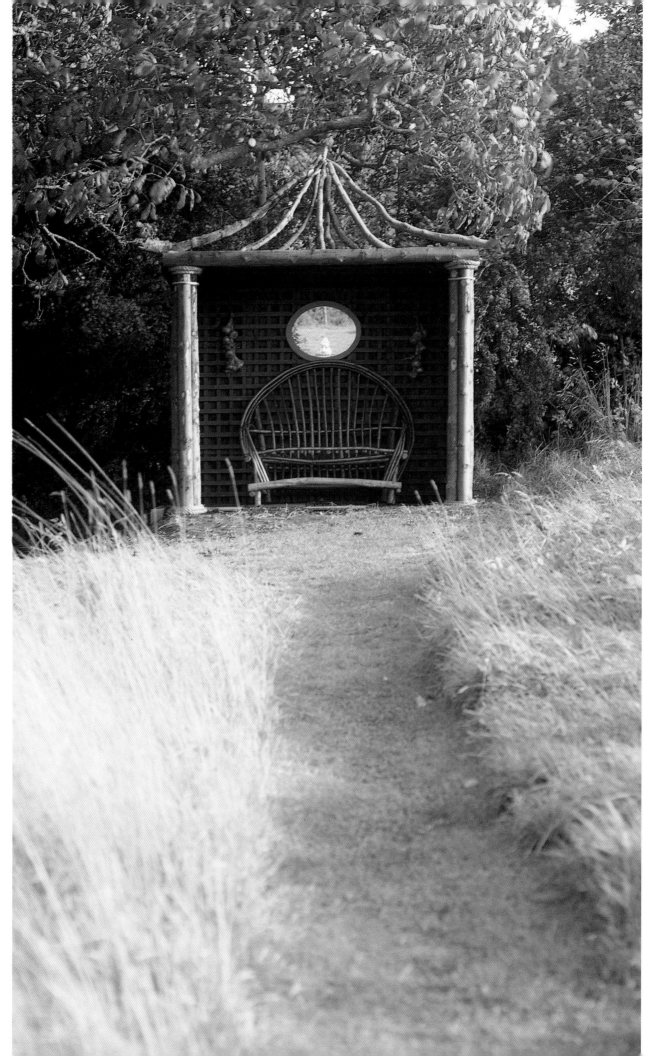

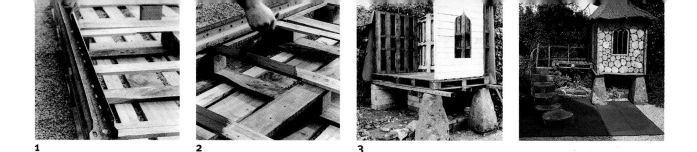

1 2 3

eighteenth-century play-house

While in eighteenth-century rustic mood, I should dwell a little on a children's play-house that we built. It is not a tree-house, since my clients' brief was that it should be accessible to all ages, down to toddler. It is positioned at a modest height above rubber matting, but it still requires steps to arrive at the entrance and it has a drawbridge. Its position against the trunk of an ancient tree, however, does grant it the authority of a minor tree-house.

It wasn't quick to build, taking two of us three days to complete, but it was enormous fun and built mainly of old pallets. I have been told by many wearied experts that pallets don't last five minutes in a construction, that they rot and disintegrate. In fact, they are perfectly serviceable for building if used and protected properly. Provided you mess around with them, trying them in different positions together, and choose strong, undamaged ones, you will find that pallets almost build the walls for you.

Materials: You will need the usual range of woodworking tools, especially a good jigsaw and cordless screwdriver/drill. Plenty of long screws and nails are necessary, some pallets, some waste ply or old board, a recycled old door, an offcut of perspex, some large seasoned logs that you can saw up with a chainsaw (or get an expert to do), roofing felt and perhaps some remaindered odd building blocks or bricks to build up a plinth. I sat the house on two lengths of old steel framing left over from a warehouse shelving system, built the steps from old logs and put on a roof made from odds and ends of birch matting.

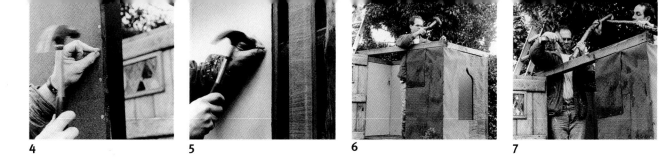

4 5 6 7

1 The base of the house is made of two pallets side by side, joined by screwing the lengths of steel to their undersides. Use a grinder or hacksaw to trim the steel ends flush.
2 I then treated these pallets with a child and plant-friendly timber preservative. **3** The 'foundations' are two old saddle-stones from the now demolished grainstore of the farm. However, I recommend that you build your own version directly onto the ground to minimize the risk to your children's safety. The walls of the play-house are also constructed from old pallets and I use three to sit happily on the base, leaving the fourth wall to come flush against the side of the structure. We even found a pallet with a solid face from which we could jigsaw the window at the end. **4** The pallets are nailed or screwed into place and the roofing felt fixed round the outside of the structure, using large, flat-headed nails or a staple gun. **5** Meanwhile, inside our house, the walls are boarded with some old 4 mm board to provide a comfortable, flush finish, and then some small lengths of old floorboard are nailed down underfoot. The long wall that has to sit flush against the side of the whole structure is made from two pieces of 18 mm ($^3/_4$ in) ply screwed well into the structure and running down the sides of the exposed base pallets for extra rigidity. **6** A solid frame of 8 x 5 cm (3 x 2 in) timber is nailed around the top of the whole structure to tie it together, after which the structure is as safe as houses and able to support the weight of the door that is cut down from an old one. **7** The roof is simplicity itself: eight branches pruned from a fruit tree are each screwed at one end into the timber frame and at the other end all gathered at the apex and wired together.

8 9 10

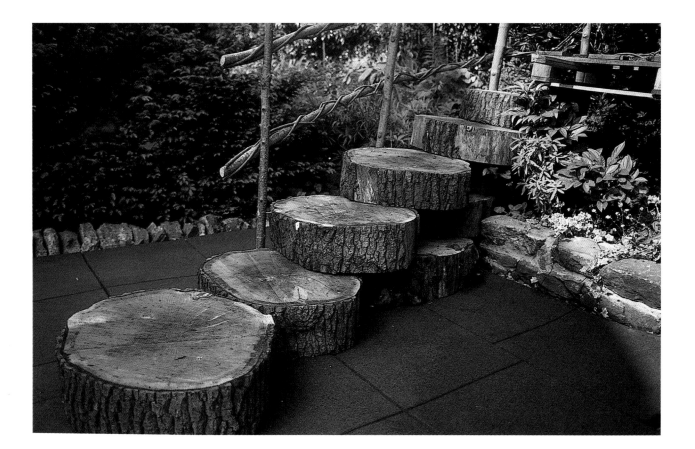

8 The roof structure is also covered in sheets of roofing felt, stapled onto the branches. This leaves only the decorative details: the window frame and perspex are jigsawed from plywood and siliconed together, while stick-on fake window leading is carefully applied to make the glazing bars. **9** The birch matting roof is hammered, wired and bodged on and the log-section steps piled up and nailed together securely. **10** We sawed up a good couple of dozen logs like loaves to make 2.5 cm (1 in) slices and then varnished them to keep their colour, so that the little house looks as good and fresh as the day it was made. The decorative log slices are then randomly screwed onto the walls.

It is easy to explain the charm of quaint little houses like this one and their appeal to even the most hardened, the most architectural, the most contemporary and minimal of us. We like them because they remind us of our own childhoods, not necessarily of our own play-houses or our own adventures, but their decorative fancy belongs in children's stories and fairy tales, in our past imaginings. Inevitably, then, they will always fascinate and charm us, but, of course, they may also disturb and perplex us (fairy tales always have some gory twist to the plot). They can awaken all kinds of unexpected emotions and thus become much more complex that they at first appear. Thankfully, the more predictable reaction to a little gothic play-house like this is that of delight, of the pleasure of seeing our own children in turn play happily in them for hours.

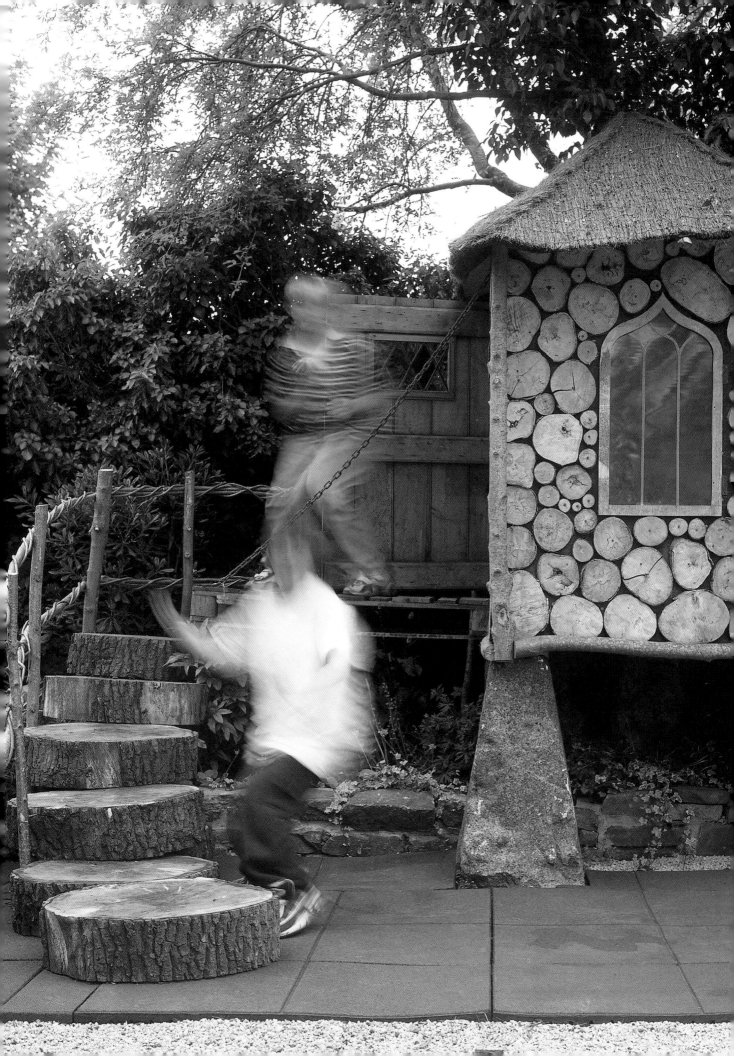

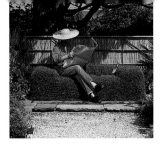

grass bench

About three years ago, I read a beautiful and scholarly little book by Sylvia Landsberg about medieval gardens that included delightful written accounts of grass benches and seating. The idea of building one just wouldn't go away and I have now constructed several (failed) versions, each time refining the technique of getting grass to grow on a vertical surface. I think I finally have it cracked, but should caution that a turf seat requires quite some maintenance: frequent cutting and daily watering during the drier months, just as you would a planted container. However, the result makes it all worthwhile. To turn the corner and find this great green, furry sofa easing itself over the little stone terrace is arresting. I like to stretch out on it after lunch, my head resting on one of the arms, feet up, cradled in this living piece of furniture. I wouldn't know where to start to build an indoor sofa, but this project is proof that building furniture for the garden is so much easier.

Materials: For the basic structure, I used a dozen or so redundant or damaged plastic milk crates. You will also need chicken wire, stout galvanized garden wire and pliers, sackfuls of compost, a box of hygroscopic garden gel of the kind you put in containers, several large bags of garden container moss, plastic pegs (the type used for pegging down horticultural fleece) and, of course, the turf. After much experimentation, I can tell you that the best type is that grown through plastic netting for added strength. Since you can buy a variety of seed mixes, always choose one with plenty of deep rooted varieties, such as *poa pratensis* (meadow grass).

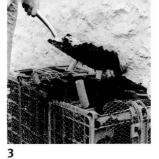
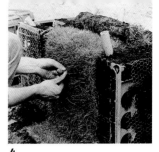

1

2

3

4

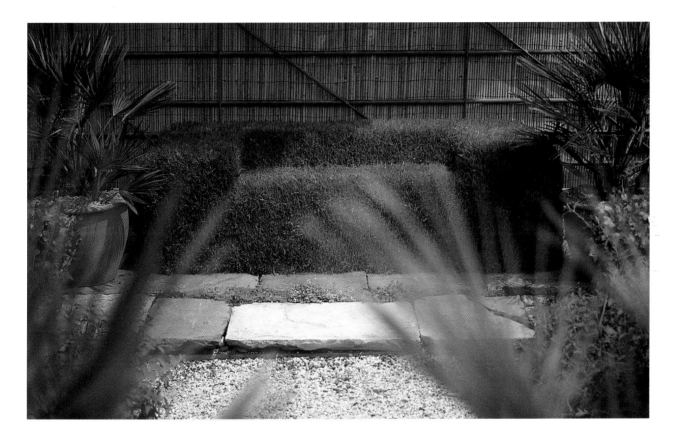

1 Start by making a finished shape, by tying the crates together with the stout wire. Be especially careful always to present the most open side of each crate to the outside face of the structure. **2** Next, cover the entire structure with chicken wire and tie on with more wire. Place short lengths of plastic water pipe through the wire, one every foot or so, to act as irrigation tubes carrying water down to the heart of the sofa, leaving them proud, to be trimmed back later. **3** Then comes the job of gently filling the entire shape with a mixture of compost and a little leaf mould if you have any, to retain water and structure, and the hygroscopic silicon gel, which is mixed in at the manufacturer's recommended ratio for hanging tubs and containers. Mix them all in a wheel barrow, then gently pour them into the voids inside the crates. Do this carefully to avoid leaving air pockets inside the finished shape and regularly

tamp down the compost with a stick pushed through the mesh. Fill the frame up until the compost is bursting at the sides, give it a good watering, leave for a day and then add more compost to finish at the required level. **4** Water again to help build up the reserves of the sofa/bench and then start to turf. The best method I have come across yet is to roll the turf down from the top, trapping behind it a good inch thick layer of moss and securing both layers tightly against the mesh behind with the plastic pegs (the bigger and the more barbed the better). Avoid problem air pockets by stuffing the voids with moss and compost mix and check all surfaces for really good adhesion to the frame. Water again, water every day for a month or so, and pray. And don't even attempt this kind of project at any other time of year except spring, because the turf will not survive.

summer seating area

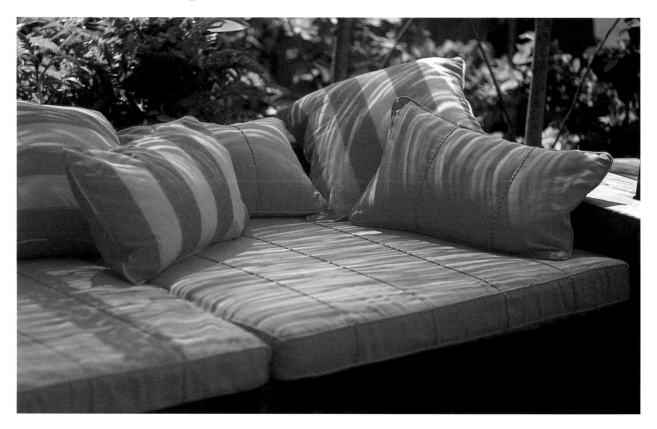

The idea for this seating arrangement is unashamedly borrowed from designers Michael and Lula Gibson, who some ten years ago constructed an entire garden of raised beds and built-in furniture out of railway sleepers, long before they became fashionable. Lying comfortably above the damp earth of their garden on cushions, amongst towering plants and flowers, was a very satisfying experience. I could not resist experimenting with the idea for our hot garden, using new oak rather than old sleepers.

Materials: You will need to be equipped with a hammer, 10 cm (4 in) and 15 cm (6 in) nails, a sharp chainsaw with an experienced handler (or acquire all the necessary safety kit and training) and the wood.

First, I decided on the height of the seating and built up the front wall accordingly. The side walls and sections of the back wall are built up with off-cuts nailed together for added stability and set firmly onto the soil. The seat itself consists of 1.25m (4 ft) oak beams laid from front to back (day bed) or side to side (bench) onto the off-cuts. Finally, a low back support and arms are built up using one more layer of oak over the seating level. These are nailed through at forty-five degrees to firm the structure, and the ends are chainsawed off flush with the front edge of the wall. With the addition of covered foam cushions, the result is something so solid that if feels as though it is carved from stone, but comfortable and magnetically appealing on a Sunday afternoon.

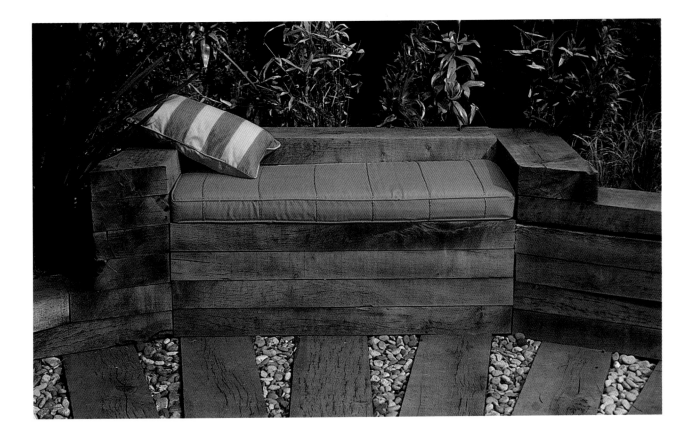

Railway sleepers are, of course, recycled and are the most environmentally friendly material for garden furniture, but because they are soaked in creosote or pitch, they become as hard as iron over the years. They are also, inevitably, a dark, impenetrable gloom colour. New oak, on the other hand, is softer, easier to cut and of a greenish-cream colour that quickly, over the course of one season, turns to a silvery grey. The black tannin present in the timber washes away, allowing the wood to bleach in the sun and take on a delicate bloom.

In areas where the timber is unlikely to come into contact with the soil, a softwood, such as Douglas Fir, could be used for outdoor furniture. Chestnut is a hardwood alternative to oak because it survives happily in damp conditions, although it will not last quite as many years. If the

hardwood comes from a local, sustainable source where replanting programmes are in operation, you can quell any environmental qualms you may feel. The consumption of such timber can even have a beneficial effect, as young trees absorb more carbon dioxide from the atmosphere in their first twenty years than during the rest of their lives.

Whether you choose hard or soft wood, I am firmly of the opinion that pressure-treated timber, used for dry applications in the construction industry, should not be used in the garden, particularly near food crops or children's play areas. Over thirty separate studies have shown that wet or damp treated timber will leach chemicals out into the soil or onto the hands. The chemicals used in treating the wood usually include copper, chrome and arsenic, the last being particularly soluble in water.

an outdoor kitchen

Set into the walls of the hot garden is a barbecue, quickly assembled out of old bits of masonry and rendered over. It includes one essential feature – a food preparation table built into the raised bed wall beside it. In fact, it is built of concrete blocks with a concrete paving slab placed 25.5 cm (10 in) from the top. Its bones are incredibly motley and ugly, but a creamy render covers them all. All, that is, except the area where the charcoal sits, where the bricks are left exposed inside, because the intense heat from the charcoal would otherwise cause the render to pop and explode.

Materials: You will need some old bricks, breeze or concrete blocks, one concrete paving slab – which defines the outside measurement of your barbecue – and mortar for jointing and rendering. A gauging trowel and spirit-level are also indispensable.

Begin by laying a foundation for your structure (see page 184) and then lay a first course of blocks or bricks using mortar (a standard 3:1 mix). Build to the required level, inserting the concrete slab as the bed for the barbecue. All building work above should be executed in brick to withstand the heat. When the mortar-work is dry and solid, render the whole thing with a standard 3:1 mix, wetting the surface of the blocks as you go and applying a good thick 1 cm layer. Don't render the bricks immediately surrounding the fire. You could form the odd nub of render, or insert a half brick here or there in the block-work, to support the metal cooking grill, or even a shelf below. Drilling through the concrete slab in a few places will enable water to escape from the square recess in winter.

ACCESSORIES

CLUTTER MAY BE THE ANTITHESIS OF GOOD DESIGN, BUT NO

HOME OR GARDEN SHOULD BE JUST AN EMPTY STAGE-SET. WE

HUMAN BEINGS WILL ALWAYS DELIGHT IN ART FOR ITS OWN

SAKE, IN THE DECORATIVE AND SCULPTURAL IN OUR LIVES, IN

OBJECTS THAT HAVE NO PURPOSE OTHER THAN TO DIVERT.

DECORATIVE ELEMENTS Of course, garden decoration need not be traditional in design. I suspect that the repro' period look has now been quietly dropped by most garden enthusiasts in favour of more innovative elements. I certainly have a natural instinct to recoil at the sight of yet another pair of reconstituted stone urns badly cast from a rather ordinary Victorian original, or when I come across the umpteenth 'Three Graces' concrete bird-bath. Sculpture need not be as unimaginative – or as expensive.

The two great joys of decoration, and I include sculpture here, are that it need serve no purpose other than to be looked at, or touched, and that you can make it yourself. LEFT These jars came from a reclamation yard in my nearby town and are Portuguese fishermen's pots covered with coral-like worm-casts. I simply filled them with coloured gravel. CENTRE The wire and pebble sculptures of Cheikh Gonzalez and Isabelle Ropelato are simplicity itself, yet very effective. RIGHT Any object, or group of objects, made of glass will survive beautifully outside.

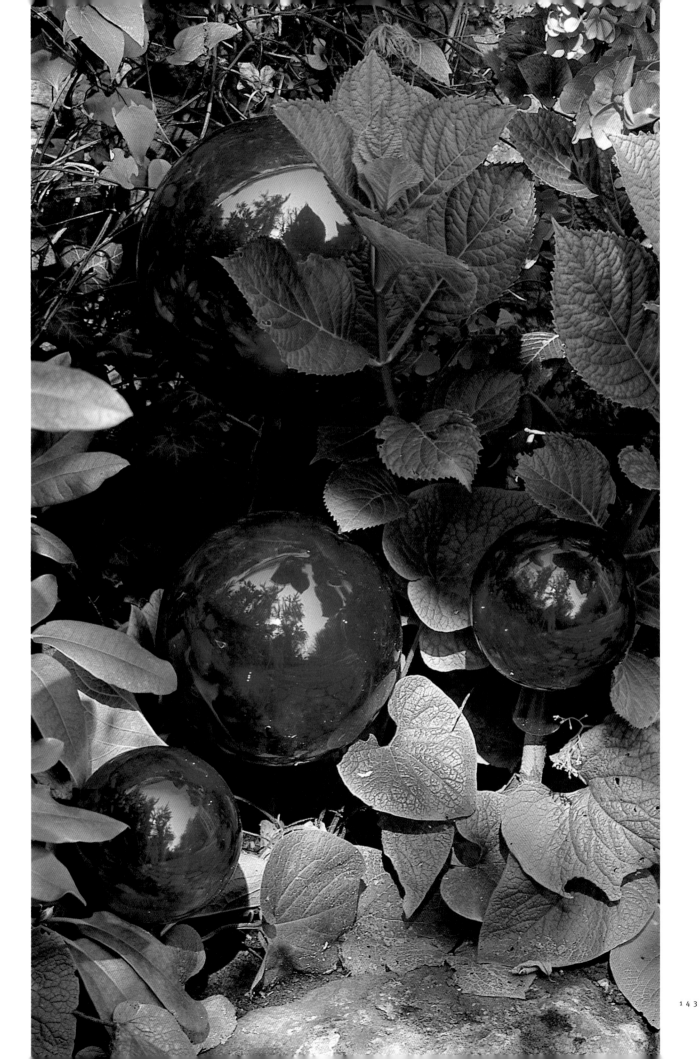

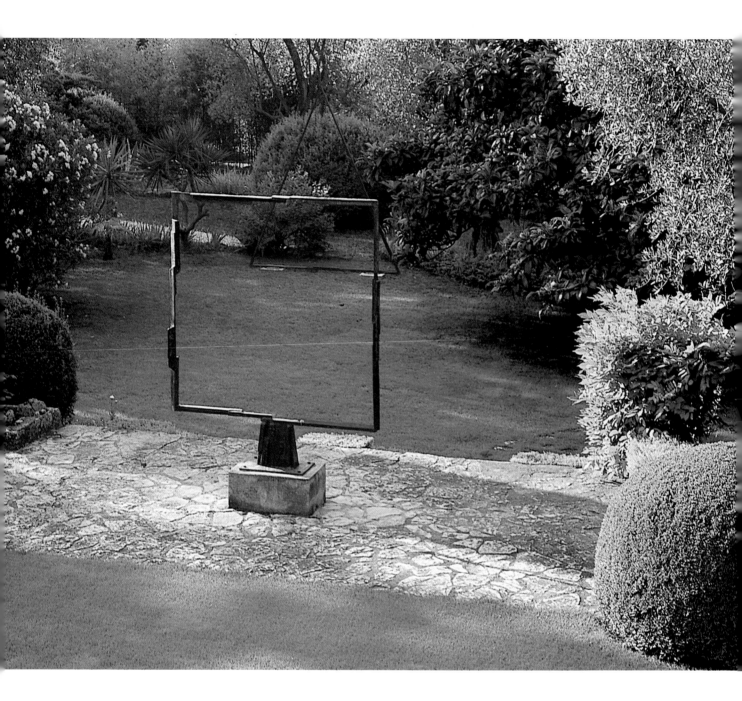

FRAMING THE VIEW But accessories can also serve important functional roles, as water features, plant containers and, less commonly, as frames. The need for a picture to be framed should never be underestimated. I do not mean that it should be literally encrusted with gesso and gilt, but that in the general complexity and confusion of our visual field, especially outdoors, our eyes need to be drawn to specific details and then held in one focused area.

LEFT This simple frame is really just a sculptural form that almost jokes with the concept of a 'view'. ABOVE RIGHT By contrast, the portable mosaic frame that we made for our garden has a surreal quality, its size and thickness demanding that it should contain a picture or mirror, which, of course, in one sense, it does. The window at the rear of the rustic pavilion behind carries the eye into the distance. BELOW RIGHT An ancient device is this literal *oeil de boeuf* formed in the hedge of the garden at Prieuré d'Orsan in France.

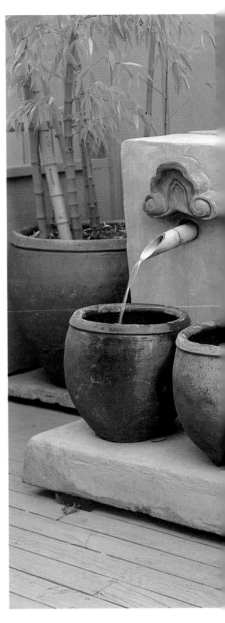

WATER FEATURES The importance of water in a garden is paramount. I have constructed six separate water features at home in the form of fountains, ponds, rills, spouts, even a mosaic padding pool, in order to spark that extra life into the place. Moving water is fascinating to watch and to listen to: the 'white noise' it creates has a relaxing effect and establishes an aural focus, literally blocking out external noises like that of traffic. Water has no intrinsic architectural or decorative style to it. It can be classical, minimal or anything in between. It is simply the moving, gurgling, living element in a garden feature or sculpture.

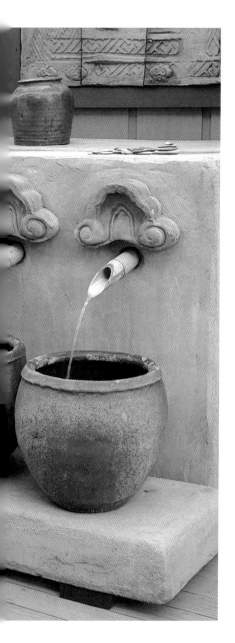

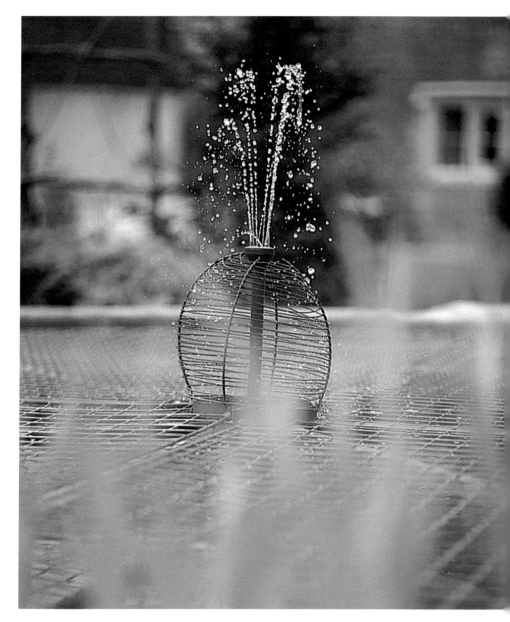

LEFT The lead spout set into a stone lion mask is one of a pair in our garden fixed to a simple stone slab. CENTRE The same engineering design, a spout, can be adapted to any style, as this bamboo garden illustrates. RIGHT Simple, contemporary designs work even better; this fountain at home sits in the middle of a raised circular pond that has been sheeted over with galvanized mesh – originally for child safety – which established a very modernist look. The wire 'sculpture' in the middle is a galvanized cover for a drain vent pipe and the fountain is made from the plastic bits that came with the pump siliconed into a length of copper plumbing pipe.

NEW CONTAINERS The most functional garden accessories are containers. They work both
practically and aesthetically, as organizers for your planting, adding height and colour, and as
decorative objects in their own right. I confess to having used terracotta pots quite frequently
over the years, but they do break and splinter and their colour is unremitting. I prefer a recycled
galvanized water tank or a painted half oak barrel any day.

ABOVE RIGHT Re-using old containers originally destined for another purpose can be very satisfying; this old copper boiler sits at the end of a lavender walk in our garden. LEFT Alternatively, you can disguise existing containers. I eschew paint because it is obvious, so our mandarin orange tree pots are hidden by collars of birch matting. BELOW RIGHT The really correct approach is to buy or build purpose made containers, such as animal feeding troughs, that can be repeated around the garden.

SOME MAY FIND that creating a garden is an awesome task, beyond their capabilities. Others may relish getting stuck into some hard physical labour. Whatever your view, there is no doubt that garden design needs to be executed with a broader brush than that used for any interior. Trellis can be rough at the edges and paths a little uneven. But any garden will also require some careful detailing. Garden accessories and features work as points of focus amid the wider generality of the great outdoors – we always examine them in closer detail. And having dug, laid, built and planted, it might come as something of a relief to be able to work on a tighter, smaller scale in the making of beautiful objects.

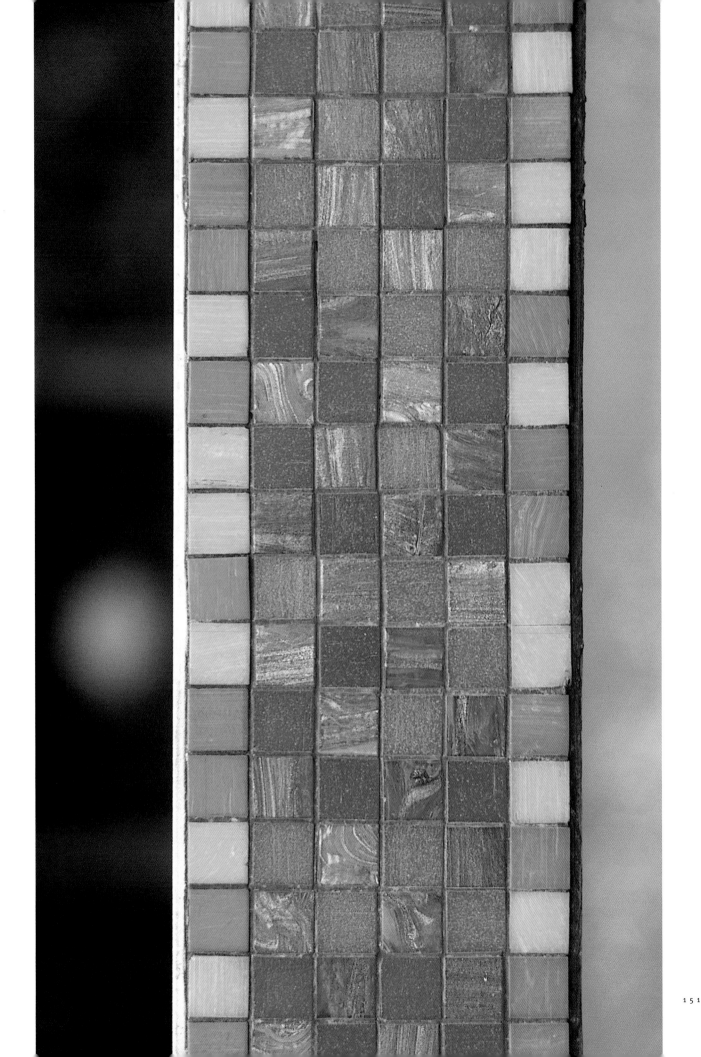

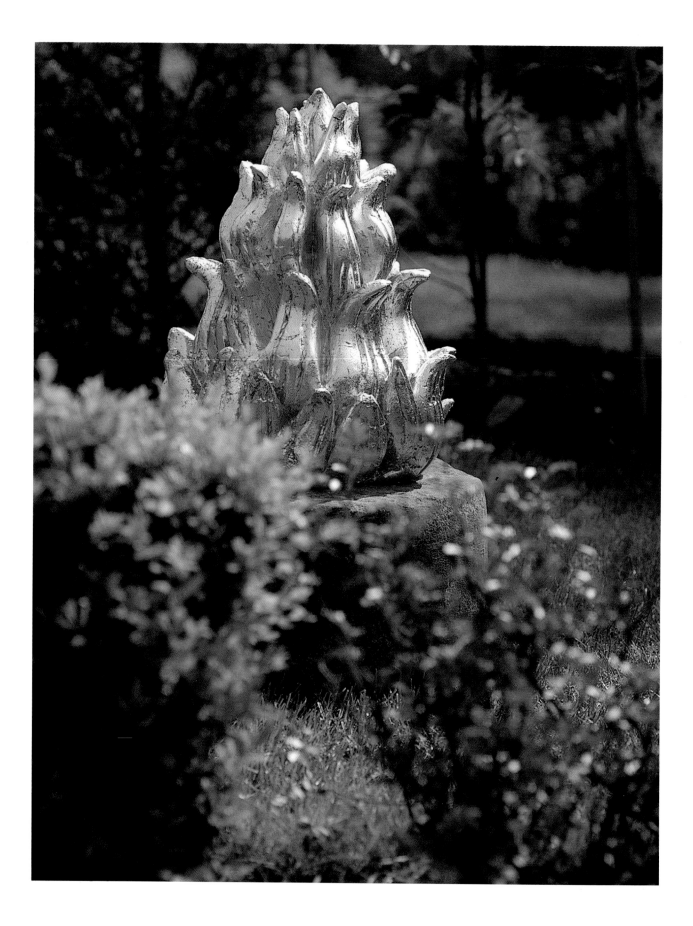

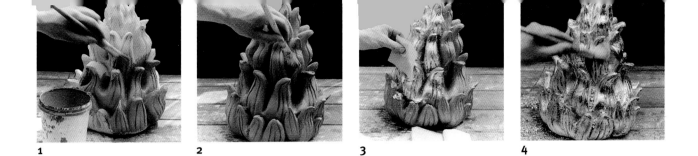

1 2 3 4

gilded flambeau

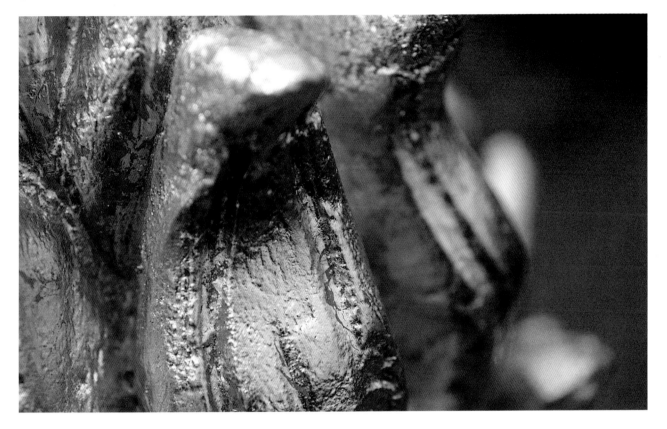

Gilding, particularly when positioned amongst greenery, has a potent, almost shocking, impact outdoors. Its overtones are classical, European, mythical; it is certainly not an Anglo-Saxon way of decorating. Gilding is therefore irresistible. What better and more appropriate way to use it than on a stone flambeau, originally taken from the top of an urn (although such a complex shape might not be the first choice of an amateur gilder)? It is necessary to point out that all gilding will deteriorate outdoors, especially in a harsh winter, so a modest approach to this technique is in order.

Materials: You will need some red or yellow oxide car primer, a pot of oil-based (*not* water-based) gold-size, some clean, stiff brushes, a soft cloth and books of 22 carat transfer gold leaf (the real thing won't tarnish outdoors). One book will cover one square foot or so, a good reason to choose a small object.

1 Make sure the object is clean and very dry (metals make a good surface for this technique). Coat it with primer – red for a rich, broken finish and yellow for a pure, bright quality.
2 When dry, apply a layer of gold-size, leave to dry for a day and then apply another coat, well brushed out. Follow the instructions on the tin and leave to dry for several hours till it is barely 'tacky'. **3** At this point, press the leaf on, holding the tissue paper on which it is mounted. Work carefully, brushing the leaf into the cracks and picking up and placing spare pieces with a brush. **4** Leave for a day and polish with a soft brush.

gold mosaic ball

I can't really decide which is more expensive, gold leaf or gold mosaic. Both are a little extravagant, but true gold is the only material that will withstand the elements, because it is itself a noble element. If you use mere brass, it will tarnish quickly, while bronze and copper will patinate gradually to verdigris. The great advantages of mosaic against 22 carat leaf are its ease of use and the fact that the gilding is locked safely inside the little glass tile. It is a piece of gold leaf, a few microns thick, sandwiched between two layers of soda glass, and it will last as long as the glass itself. Of course, if you treat objects decorated with glass mosaic badly, the tiles will splinter and crack. Although I have mosaiced a ball here, it isn't suddenly going to roll away, since it is a concrete sphere from a garden ornament company, normally used to cap a gatepost, and is quite a weight.

The frame, on the other hand, is made of metal. Galvanized steel would have served the purpose here, but I preferred a sheet of 3 mm-thick aluminium. We cut out the inner shape of the frame in one, using a heavy-duty metal jigsaw. Alternatively, you could get a local forge or metal workshop to do the cutting for you and, while they're about it, to construct a couple of legs and a brace or stand for the frame to sit on. Our frame is quite classical, but if you are particularly adventurous, you could have a fancy shape cut. The result will in any case be a firm base on which to work. It should be lightly scored by rubbing down with coarse sandpaper in order to give it a key for the mosaic pieces to adhere to. Aluminium will oxidize on its surface, but will not rot like steel and so it provides a weatherproof 'chassis' for the mosaic.

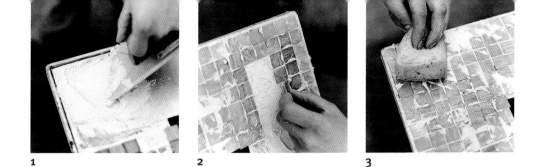

1 2 3

bright mosaic frame

Materials: You will need, first of all, an object to mosaic: anything with a vaguely smooth surface made from stone, ceramic, glass or metal (wood is unsuitable as it is too humid and will flex, resulting in your tiles falling off). Concrete is ideal, because of its structural stability. You will also need mosaic tiles, which come either loose, lightly glued to a paper sheet in grid formation or permanently attached to a fibreglass webbing. For multi-coloured patterns and for 3-D objects you will need to use loose tiles. Other needs are the correct adhesive (both for the tiles and the surface), a little acrylic varnish and some waterproof grout (as used for bathroom tiles).

1 Clean, dry and prepare the surface of the object to be mosaiced, keying it lightly with sandpaper or wet and dry paper if necessary. Apply the adhesive with a serrated trowel (they are usually supplied free with the tub), following the manufacturer's instructions. Use an exterior, cement-based tile adhesive over concrete, stone and ceramic, and an epoxy, silicone or polymer exterior adhesive on metal and glass. **2** Apply the mosaic. When using individual tiles (*tesserae*), space them to allow for the grout. Tiles supplied on a fibreglass webbing should be laid with the webbing down onto the adhesive. Tiles on a paper backing are applied with the paper uppermost (it is removed when the adhesive is set by soaking with water). Remove any excess adhesive before it has completely dried. **3** The next day, grout the tiles, using an exterior grade or waterproof grout and a plastic scraper to apply it. I mix in a little water-based, acrylic varnish to waterproof it further and colour the grout either with artists' acrylic or powder pigments. Scrape the grout on and scrape off any excess. Leave to dry and, finally, buff up to a shine with a cloth.

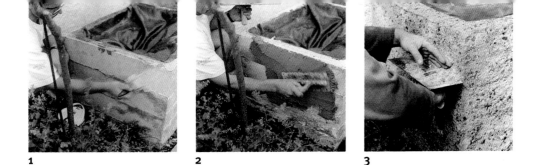

1 2 3

glass and pebble fountain

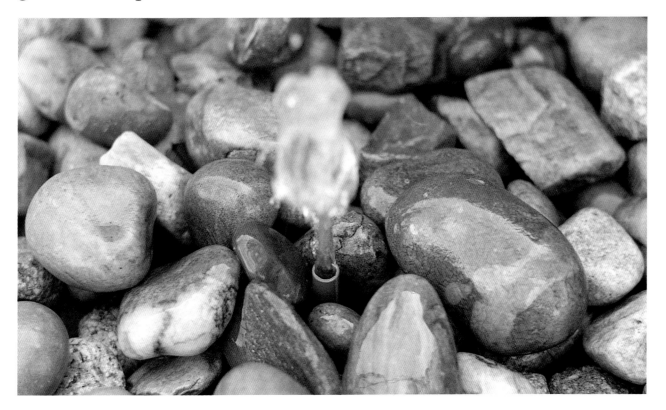

The most common misconception about water features in a garden is that they are expensive, difficult to make, complicated to run and that they always get choked and blocked with weed and rubbish. I can dismiss all these illusions with this one project. My fountain is not expensive, although it is unique. It consists of three rectangular, concrete manhole sections placed one on top of the other, rendered with coloured cement and studded with some pieces of recycled glass. The machinery is a small and cheap garden pond pump. Building this was simplicity itself. Neither was the process complicated: the pump came with several metres of cable that I could pass into a nearby building. Maintenance is also problem free, because this design uses pebbles sitting in a great pile in the water, so that no light can reach the water to encourage the growth of algae and weed. Consequently, the filter does not clog up (or, at least, it hasn't in eight months...).

1 The basic form of the fountain can be built from anything, as long as it is sound. I used three concrete manhole sections because I happened to have them. I filled them with rubble, then smaller stones, then finally with a layer of sand to support a small area of pond lining. This I cemented into the top ridge of the top section. As preparation for the render, I primed the surface with a weak solution of EVA (waterproof cement bonding agent). **2** The render was prepared as a standard 3:1 sand and cement mix with some EVA and cement pigment added. I trowelled it on to a depth of 2 or 3 cm (about 1 in) **3** As soon as it had been applied, I pressed the ground glass into the surface. This product comes from a bottle recycling plant and is no more dangerous to handle than gravel, but infinitely prettier in the light.

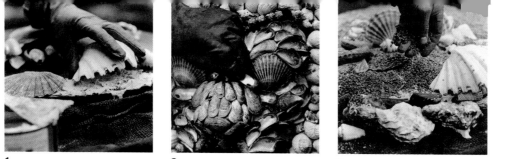

1 2 3

shell fountain

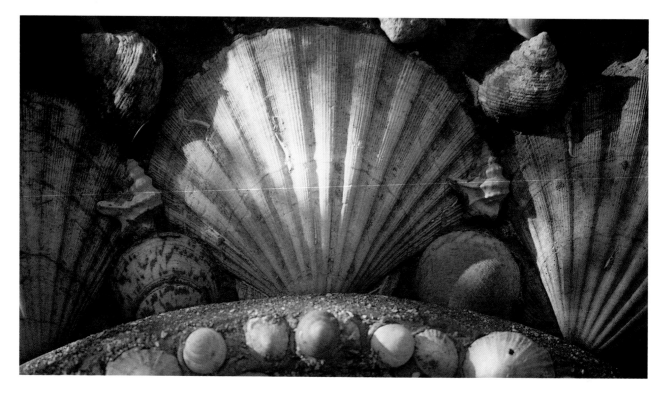

Shell decoration in the garden has a fine pedigree, appearing in the Roman Empire and revived during the Renaissance. The fashion for shells declined, but now there is something of a revival of interest in their beauty and versatility. This fountain may appear adventurous, but it is in fact remarkably easy to make. What looks like an eighteenth-century rococo fantasy is a ready-made, fibreglass wall fountain. I stuck the whole thing together using modern resins and, as a result, it has now survived two winters intact. The finished project is nearly 2 metres high and took 32 hours to make – worth it, as it will last a lifetime.

Materials: You will need a fibreglass fountain (or equivalent), rubber gloves, body-filler and liquid resin as used for car body work, spatulas, old spoons and a large quantity of shells. Mussels, scallops and oysters can be cadged from restaurants and other specimens bought or collected. Observe health and safety precautions for fibreglass and resins.

1 Lightly sandpaper the fibreglass surface. Lay out the large shells first to plan your design. Mix the body-filler with its hardener and spoon it around the inside edges of each large shell, and apply more to the fountain. Press the shells down and secure temporarily with adhesive tape. **2** When the larger shells are dry – 20 minutes or so – remove the tape and continue the design with smaller shells. Lay them in rows or swirls to add movement. **3** Put some remaining shells or broken pieces into a strong plastic bag and hammer them into powder. Mix up the liquid resin with its hardener and spoon it over any gaps between the shells where the fibreglass is exposed. Sprinkle the shell powder over these areas, gently pressing it into the resin with a dry cloth. Allow the finished fountain or decorative piece to dry overnight before fixing in place.

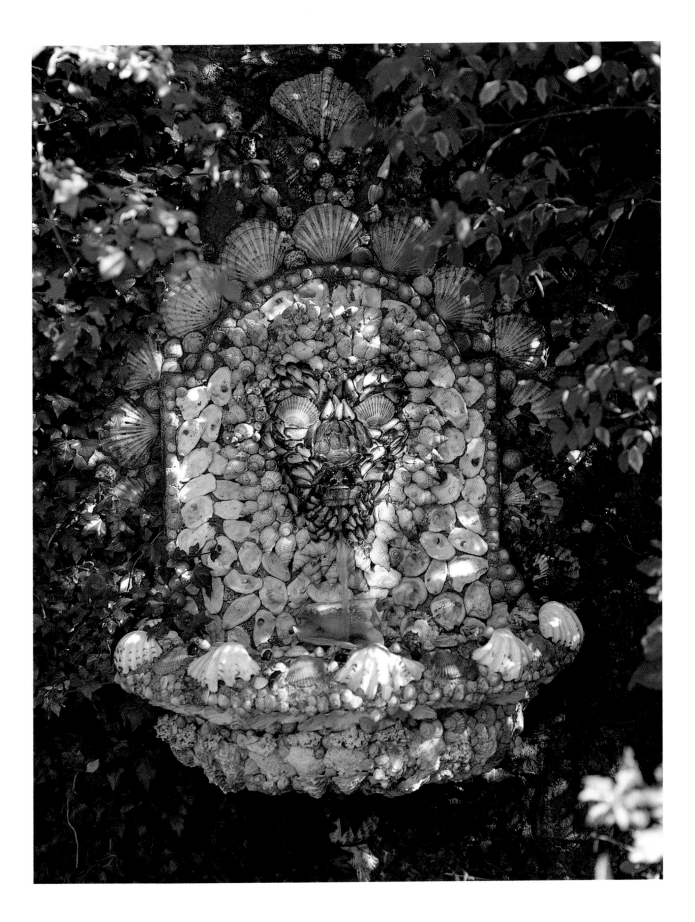

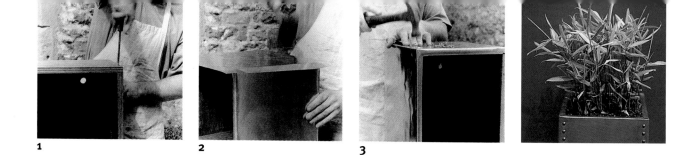

1 **2** **3**

a zinc container

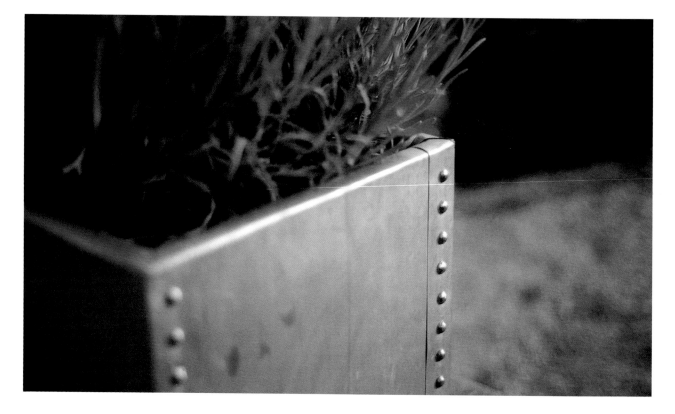

Zinc is currently a very fashionable garden decorating material. This, of course, means that at any moment it will be out of fashion and very possibly will appear at a downmarket DIY store near you. But I cannot resist it because it is relatively cheap and very malleable in sheet form. It resists the elements admirably and weathers to a white-splashed, grey patina. It also looks very good planted with silver or greyish foliage, such as lavender. If you can't find old zinc water tanks or galvanized agricultural troughs (galvanizing, named after a Signor Galvani, is the hot dipping of steel in molten zinc, to protect it), you can make your own zinc-covered tubs and repeat your design around the garden.

Materials: You will need sheets of thin-gauge zinc, a sheet or so of marine plywood, a hammer and nails, panel saw, drill and screwdriver, heavy duty stapler screws, metal shears, contact adhesive and brass furniture tacks.

1 Measure and cut out the marine plywood to make a basic box, drill it and screw together. Drill holes in the bottom for water drainage. Marine ply is quite serviceable for containers, but must be screwed rather than nailed to prevent it distorting. **2** Cut out pieces of zinc to wrap around the box, leaving enough to fold over the top and bottom edges. Glue the sheets of zinc onto the plywood with the contact adhesive to hold and stretch them. Then hammer the zinc carefully round the corners and over the edges. Trim the edges and staple the zinc into place where it cannot be seen. **3** On the edges that will be seen, secure the zinc with dome-headed furniture tacks.

rendered terracotta pots

Terracotta is such a practical and sympathetic material to look at and handle, but, unfortunately, it is nearly always the same colour, a very difficult one to assimilate into some colour schemes. I find it unappealing with blue or silver planting, for example. This problem is compounded by brand-new, machine-made pots bought off the shelf: terracotta made this way has a hard, synthetic finish that does not patinate well. The solution is to obliterate that factory finish and nasty colour in one by applying a coat of render coloured up to a creamy stone tint. In every way, this is an out and out winner of a trick.

Materials: You will need a container for mixing, sharp yellow sand (or sand plus powder pigment or cement stain), a trowel, garden peat or coir-based fertilizer, an old brush, coarse wet and dry paper, a small quantity of EVA (cement waterproofer) and white cement.

The render is a mixture of materials that allow moulds, algae and lichens to grow. To prevent it from turning grey, use white Portland cement (see page 184). Prepare a 2:1 mix of yellow sand and cement, turning the mixture yellow-beige. Sift in 1 part fertilizer and add a small quantity of pigment or cement colour (yellow ochre and raw sienna will not bleach in the cement), remembering that the mixture will dry to a much paler shade. Finally, add a little cement waterproofer. Sand your pots to give them a rough surface, apply a dilute coat of EVA to seal and then trowel on the mix to a depth of about 1 cm. When half dry, brush over with a damp old paint brush to smooth out the surface.

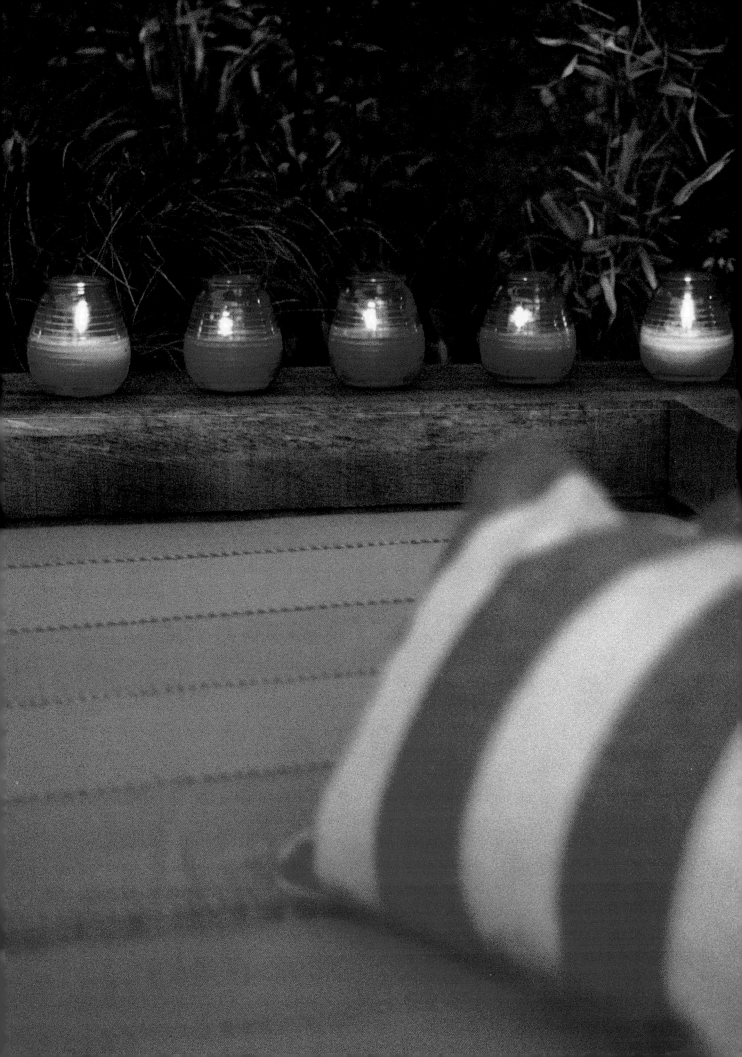

LIGHTING

THE PERSONALITY OF A GARDEN CHANGES FROM ONE
SEASON TO THE NEXT AND THROUGHOUT THE COURSE OF A
SINGLE DAY, IS RECAST A THOUSAND TIMES AS THE SUN
WHEELS ROUND, LENGTHENING SHADOWS AND ALTERING
COLOURS. AS THE SUN SETS, SO WE CAN REMAKE THE
CHARACTER OF THE PLACE AGAIN, WITH ARTIFICIAL LIGHTING
– QUIET HIDDEN LAMPS, CANDLE FLAMES AND FIRE.

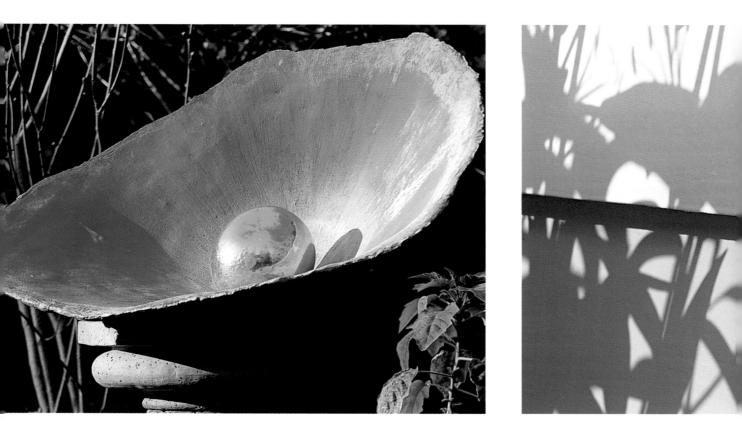

LIGHT AND SHADOW The quality of light on a cold, dull, grey day and that on a warm, clear, summer's day is dictated by a difference in light temperature, or colour. On a grey day, the colours we see are a murky blue, compared to the full spectrum light of sunshine, in which colours appear bright. But there is also a difference of intensity, direct sunlight being a thousand times stronger. No wonder a sunny day cheers us up. It also adds instant complexity to a garden, doubling up the shapes of plants and structures with the casting of their own shadows, creating scintillating reflections and intensifying the depth of colours.

LEFT Texture and reflectivity are qualities that when mixed with colour under full, direct sunlight, give
a complex and rich character that is always present in planting, but that can also be brought out in
sculpture and hardscaping. CENTRE The colour of a wall will modulate the power of shadow, a white
surface giving the strongest contrast. So if you feel a particular plant's shadow is just too confusing,
paint the area behind it black. RIGHT You do not need to go to complicated lengths to achieve effects:
clear glass, for example, is a magical material for the garden, as is seen in this piece by Neil Wilkin.

CHANGING COLOURS Sunlight and shadow are never constant. The effects they create are changed and shaped by clouds and by breezes blowing through the leaves of trees. The colour of the sun also changes dramatically through the day, from limpid yellow-orange in the morning, through clear white at midday to deep orange, copper, bronze or even pink at dusk, depending on the amounts of moisture and dust in the atmosphere. Unlike the muted, shadowless light of a cloudy day, that provided by the sun in a clear blue firmament is full of surprises and drama.

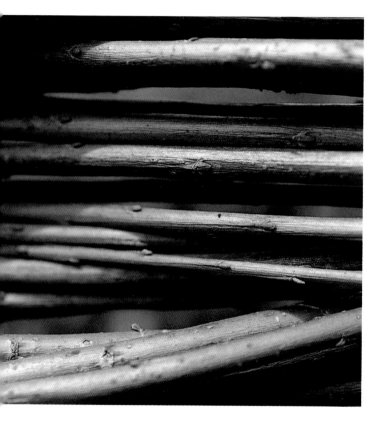

LEFT Materials (and plants, of course) that have in them the latent colours of, say, an evening sunset will, like this willow, suddenly illuminate at a certain time of day and explode with colour, as though somebody had switched a light bulb on inside. CENTRE Glass responds amazingly to direct sunlight and clear or lightly coloured glass will sing at any time of day, as is evident in this two metre-high seed-head sculpture in crystal. RIGHT Other materials like lead and stone have a subtlety and delicacy that can only be appreciated in softer, evening light.

REFLECTIONS Water has a quite magical capacity for capturing and transforming light in myriad ways. The artist Monet painted water as often as he painted the atmospheric effects of daylight. Water is the only one of the elements that seems to be able to trap light and toy with it like a plaything, reflecting it off its oily surface, refracting it through a cascade or fountain as though through a piece of liquid crystal, and splitting it into a rainbow spectrum in sunlit spray and mist.

 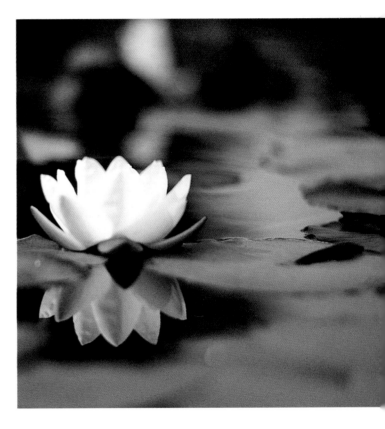

LEFT Miraculously, all these effects are achievable in any garden that is lit by the sun, with a pond or with a fountain, spout or garden hose. ABOVE RIGHT Even a small pond will take on an eerie depth if lined with a dark liner, reflecting glossy black images of the world above. ABOVE LEFT By contrast, the effect on a paler background is vivid. In the paddling pool of the hot garden, I used green and gold glass mosaic, which scintillates in the sun but also clearly shows the undulating rays of watery, refracted light that hit it.

ABOVE LEFT *Transmitted light* This old galvanized field gate is backed with bamboo matting and then back-lit, like a giant lampshade, modifying a harsh garden light source into a pleasant confusion of pattern. BELOW LEFT *Refracted light* The spears of blue glass of these pond sculptures deflect the light to make surreal shapes. RIGHT *Reflected light* Water is the easiest and most flexible material for reflection of light in the garden. When combined with repeated forms like these trays, it easily takes on a sculptural role.

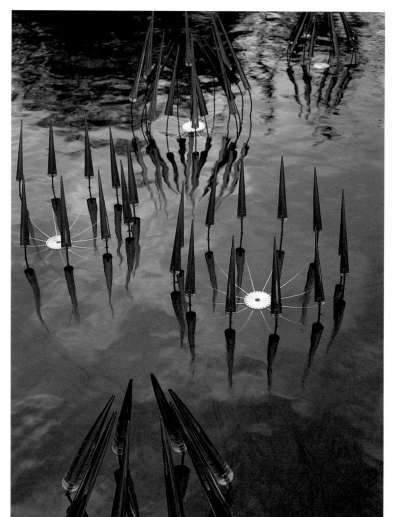

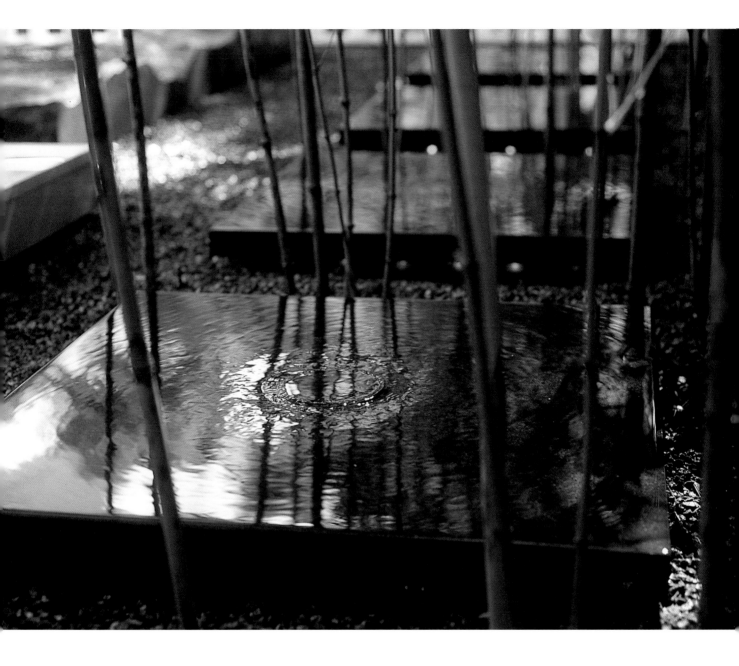

DAYLIGHT HOURS There are six ways of creating interesting optical effects: by *transmitting* the light through some kind of filter, such as a canopy, plant leaf or lampshade; *refracting* light through lenses, crystal, glass and water; *reflecting* light off mirrors, water, gilding, metals and glossy surfaces; *hiding* lighting sources and mirrors in the ground, in trees, jars, pots and behind plants; *directing* light with spotlights, glare shields, covers, lenses, mirrors and shades; and *shielding* the light source with shades, covers, lids, canopies, trees and plants, hedging, sails and screens.

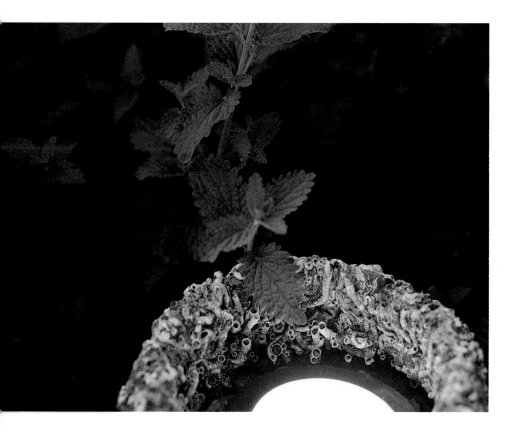

NIGHT LIGHT Indoors, we use lighting to facilitate our daily activities, reducing glare, direct-
ing light into pools and areas and bouncing it off ceilings and walls. In the garden, however,
there is no ceiling, maybe no walls, and the purpose of lighting is much less specific, much
more to do with a general and aesthetic appreciation of the space. The practical requirements
are light to help you see where you are going, background lighting for entertaining and perhaps
a decent task-light over a barbecue. Other lighting is simply to flatter and illuminate the
garden design, layout and planting. It is a big, dark space outside at night, so my first rule for
outdoor lighting is to keep its levels low and soft to avoid harsh contrast between the lit areas
and the shadows around them. Low levels of lighting cause the pupils to dilate and take in
more of the poorly lit areas, so that the garden design is seen as a whole, as it is during the day.

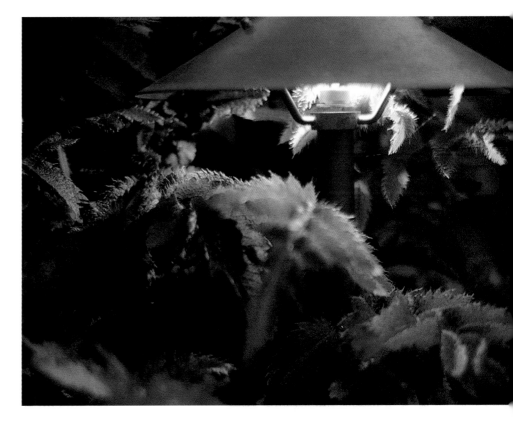

LEFT *Hidden light* Placing lamps and light sources in pots, recesses, walls and under plants means that the scheme is immediately subtler, by day at least. At night, recessed lighting will give less glare. CENTRE *Directed light* Lighting pathways is not only helpful, but it also aids our understanding of the layout of the garden, and ensures a low and subtle level of lighting. RIGHT *Shielded light* Around seating areas and barbecues higher levels of illumination are needed, but wherever possible they should be covered or point down, as does this excellent but simple copper post light.

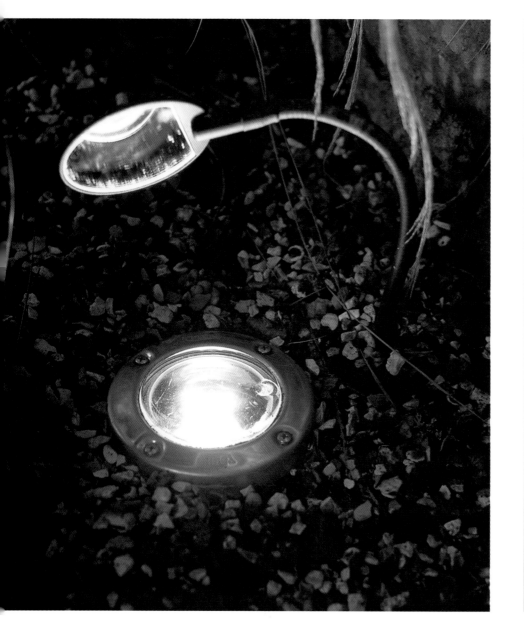

LAMPLIGHT Although there is a wealth of lighting products out there on the market, most of them are designed to perform highly specialized tasks; their high-tech aesthetics might impress you, but their job can often be done by a cheaper and more modest fitting. Large landscape projects and buildings may require specialist lamps, but I believe that the basics of a good garden lighting scheme can essentially be provided by the three types of light illustrated here.

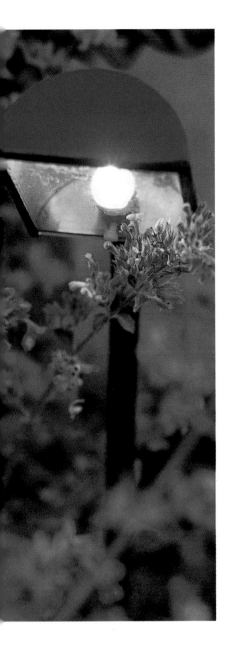

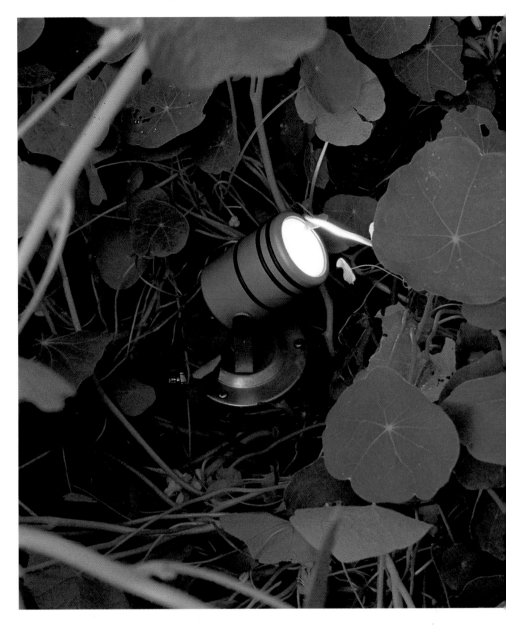

LEFT One basic fitting is the recessed up-lighter. This is perhaps an odd choice, given that there is no ceiling outdoors to reflect light off, but when fitted with a low wattage bulb, it is very serviceable. It can act as a wall-washer, can be covered with glass pebbles, used to light a path or covered walkway – or used with a flexible-arm mirror for versatility. CENTRE The simple, flexible down-lighter points all its light down or away and completely shields the source. It is discreet and can also serve as a plant front or back light when angled up. RIGHT The flexible spot, or flood, will up-light a canopy roof, a tree or dramatically cross-light a wall.

POSITIONING LAMPS In practice, a good lighting scheme will be subtle, low level and made up of several repeated lamps placed at intervals, rather than one big one with a heavy glare. Admittedly, this is a more expensive option, but it's what the doctor orders. Plants can be picked out, back-lit or front-lit, or the walls behind them lit to throw them into shadow. And your whole scheme can be brought alive for parties with all kinds of additional kinetic (moving) light: *torchères*, flambeaux, candles, oil lamps and Chinese lanterns that flicker in the breeze and cast shifting shadows.

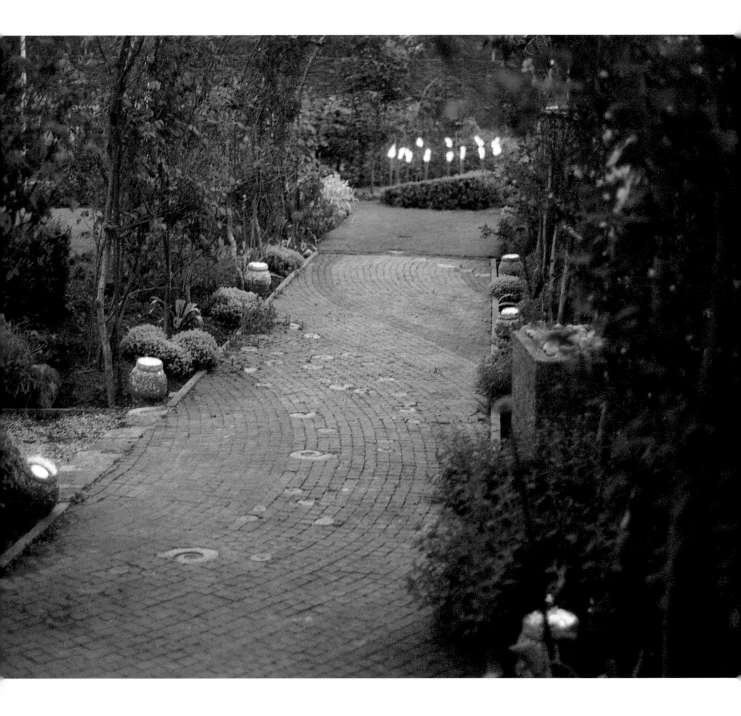

LEFT AND BELOW RIGHT
The rosewalk in our garden is lit with up-lighters, each one hidden inside an old Portuguese fishing pot and sprinkled with green re-cycled glass mulch. The glass serves three purposes: it disguises the lights during the day, it eliminates glare and it modulates the colour of the light cast. Up-lighters under a pergola or tree make perfect sense, as they illuminate the structure and make the space feel enclosed. **ABOVE RIGHT** The same light fixture can also be repositioned to back- or up-light a plant, lighting up the foliage. This is a particularly good trick with a plant that has a strong architectural or graphic form.

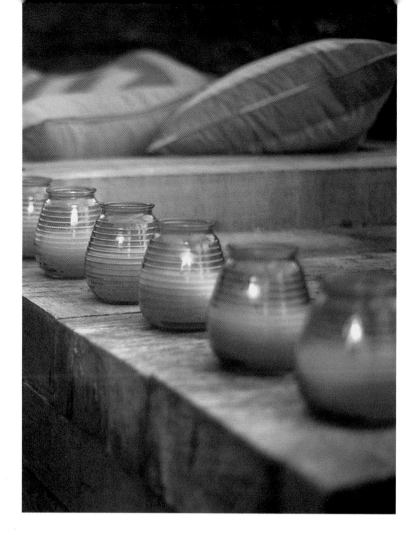

ABOVE AND BELOW LEFT
Given that many of us use
the garden for entertaining
just a few times a year, the
easiest and cheapest way of
providing low level lighting
is with naked flames: can-
dles, torches and flares.
They should be used repeat-
edly rather than singly, in
order to give an overall
ambient illumination. They
are doubly effective if used
under a pale-coloured
canopy that reflects the
light. RIGHT But electric
light has its place, parti-
cularly around food prepara-
tion and cooking areas,
where you will need a con-
stant, brighter level. This
flexible, three-arm, low volt-
age spot lamp ensures that
only a specific area is lit.

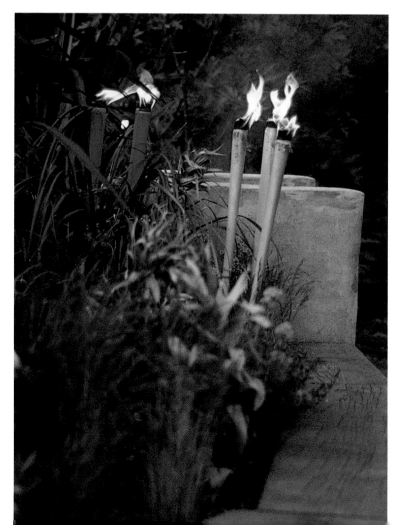

EVENING ENTERTAINING Gardens are not just abstract spaces to be planned and lit like stage sets, but are part of our homes, of the environment that we build. We have a responsibility to make sure they are ergonomic, 'user friendly'. At no time is this more important than at night, which means that our lighting has to work especially hard, creating both a beautiful space and also helping us to see where we're going. Although lighting levels in a garden generally need to be kept low, partly to avoid sharp contrasts and partly to avoid glare, paths, benches, barbecues and seating areas all need to be picked out.

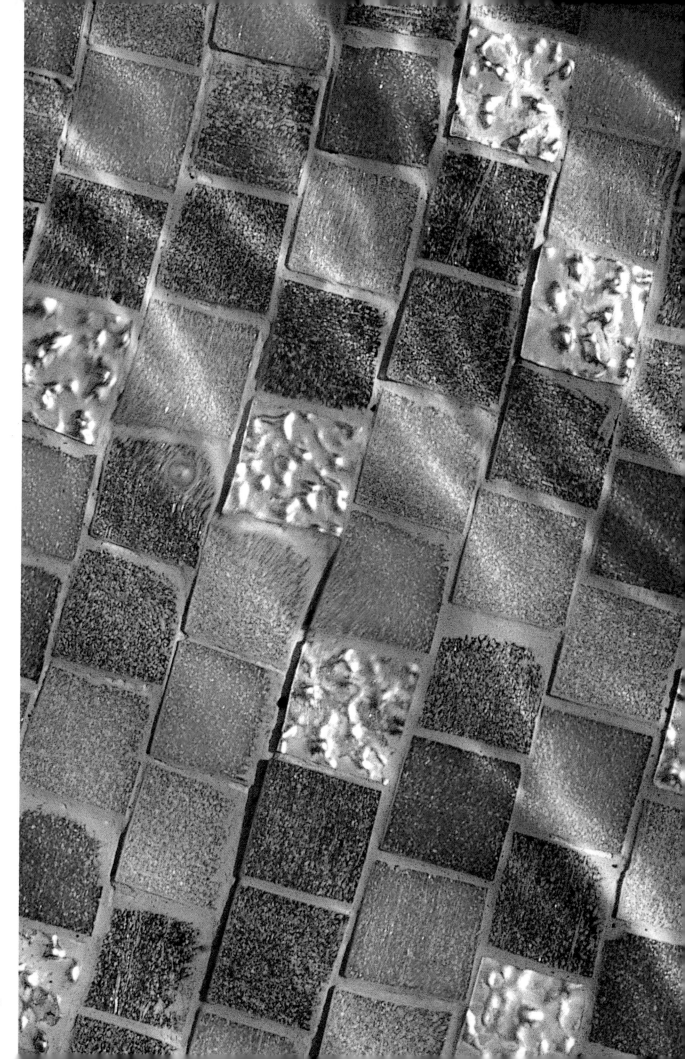

Basic skills

None of the outdoor decorating projects in this book is particularly complicated. Some are really fantastically easy, whilst others might require more patience and a little carpentry experience. But nearly all of them need an acquaintance with a few basic skills, tricks and tips that seem peculiar to working outdoors. Just as when decorating a room you might be familiar with the right techniques for thinning paint, preparing woodwork or mixing wallpaper paste, so outside you will need to get a few skills under your belt. They sound terrifying – and costly and difficult. In fact, they are amazingly easy techniques that you can master in a morning. And they will save you money: in the short term, by not needing to pay builders; and in the long term, by ensuring that what you build in your garden is properly constructed. The three basics are mixing cement, getting a level and laying shallow foundations.

MIXING CEMENT

An essential basic component of any reasonably long-lasting structure in any garden will be some kind of mortar to keep it stuck together. One or two of the projects in this book call for lime putty, the traditional mortar material, but nearly every job will be well serviced by Portland cement.

Cement is made by heating chalk and clay together and is bagged as a fine grey powder that is rather alkaline, and therefore dangerous. Avoid breathing in the dust and getting it on your skin. As standard it comes grey, but it is also available white, useful when a project's demands are aesthetic as well as functional; grey cement tends to muddy the colour of everything it makes.

The three familiar uses of cement are as mortar (when mixed with coarse sand), as render (when mixed with fine sand) and as concrete (when mixed with coarse stones or aggregate). Builders exchange much technical banter about the right mixes, but for the kind of work I do, there is only one formula, one way to mix it and one way to use it.

The standard mix is 3:1, that is, three parts sand to one part cement, three shovels to one shovel – whatever. You can use a fine, coarse or sharp sand and it often comes coloured red or yellow by the clays naturally present in it. When mixed with white cement, they yield very clean and elegant pastel shades.

To mix, a cement mixer makes the job incredibly easy (you can hire them cheaply), or use a shovel and a barrow and some elbow grease. Put the sand in first, then add the cement. Make sure it is well mixed and of a uniform colour before adding the water. Add just a small amount at first. Most builders at this stage add a 'wetting agent', such as a cement waterproofer or some EVA water-based glue. I can thoroughly recommend this, because it makes the cement much easier to work. The cheapest wetting agent is a quick squirt of washing-up liquid. Whichever you use, the cement will begin to coalesce and seem much more liquid than before, allowing you to decide how much more water to add. The mix should never be even vaguely liquid: it should fall about the mixer or sit on your trowel as one big glistening lump. After a few minutes mixing, it is ready to use.

Whatever you are building, you will need a few basic tools: a gauging trowel to put the stuff on with, a mortar-board or

bucket to keep it in and a brush and some water. A stiff brush is also useful for cleaning up afterwards.

Always start by wetting the surfaces to be mortared or rendered; this is crucial, because otherwise they will suck the water out of the cement, causing it to lose its adhesion, and the work will later fall apart. Apply the cement with the trowel. When half dry, after an hour or so, it is useful to come back with the trowel and a stiff, dry brush and clean up all the excess you will inevitably have left behind. Water may help in the most extreme cases.

GETTING A LEVEL

Ensuring that things are vertical and horizontal in your life is more important than you might think. Not only will everything around you seem all at kilter if you don't, there are good technical reasons why things should be straight. For example, if a path dips, that area may collect water when it rains; if a fencing post goes in at an angle, the fencing panel won't meet it properly; if a floor is uneven, you might easily trip and fall on it; and if a pond edge isn't level, then the pond will attempt to redefine its boundaries.

The real key to getting it right is one tool – a decent, long spirit-level. It will tell you when the vertical is true and when things are truly flat. You can extend it, to 3 metres say, by laying it on a plank and using the whole as a giant level. (Use the plank on its side to prevent it sagging and check that it is not warped by first looking down its edge from one end.) Over large distances, for example, when marking out the garden, use a string line wrapped round two small stakes or spikes and check to see if it is level by gently offering up the spirit-level underneath so that it barely touches the stretched-out string.

LAYING SHALLOW FOUNDATIONS

Almost every structure in the garden – be it a floor, deck, gazebo, play-house, fountain or wall – needs to sit on a bed of something if that structure is going to remain upright. Anything built on top-soil will eventually start to lean one way or another. Even a gravel path will last longer and in better shape if it is laid over some kind of base.

When building a house, it is often necessary to start the walls a metre or two down. I have never advocated such depth for a garden shed, but a few centimetres will certainly help. Having marked out your site, dig down several inches until you hit soil, or sub-soil, that is reasonably compacted. A hole for a path need only be 10 cm (4 in) deep, that for a folly or small play-house a good 15 cm (6 in) . The 'footings' for my greenhouse are 30 cm (12 in) deep.

Back-fill your hole with stone or rubble. The deeper the hole, the coarser it can be, but finish with a finer layer that will allow you to level off. A path of timber or terracotta blocks might need a 5 cm (2 in) deep bed of fine stone and then a further 5 cm (2 in) of sand. My favourite material under paths and decking is scalpings, a waste material from quarrying that combines chunky stones of various small sizes with clay. It can be shovelled in, compacted with a machine (a vibrating plate, for example) and then watered with a hose to form a hard, smooth surface, ideal under gravel.

Glossary

ACRYLIC VARNISH Varnish made from acrylic polymers, usually water-based.

BESOM BROOM Traditional 'witch's broom' made from birch twigs tied to a stick.

COIR Coconut fibre, used in compost manufacture as a sustainable alternative to peat.

COPPICE Wood from coppicing, the cutting of mature hardwood trees back to a stump every few years, allowing for new growth and providing a renewable source of small-section timber.

CRAZY PAVING Paved areas composed of randomly laid pieces of stone or tile.

CREOSOTE Traditional timber treatment made from coal-tar or pitch. Toxic to plants and animals.

EVA Ethyl Vinyl Acetate, a simple and cheap polymer plastic, usually suspended in water and used as a binder, plasticizer (in cement) and adhesive. Waterproof, unlike its more common sister, PVA.

FOOTINGS The foundations or base of a building or area of hardscaping, such as a pavement.

GASH TIMBER Rubbish or waste timber.

GAUGING TROWEL A hand-trowel used for masonry work.

GAZEBO Decorative garden building or summerhouse.

GOLD-SIZE An adhesive used for adhering gold and metal leaf to a surface. Traditionally made from linseed oil, modern interior versions are made from acrylic.

GREENHOUSE SHADING Dense netting made specifically for reducing light levels in greenhouses.

GROUT Filler applied between mosaic and tiles as a sealant and decorative finish.

HARDSCAPING Landscaping using hard materials: paving, concrete, steel, timber and structures.

HURDLING/HURDLES Lightweight panels of woven or worked coppice wood, usually willow, chestnut or hazel, traditionally used for sheep-pens.

HYGROSCOPIC Water absorbent.

KELVIN SCALE The scale on which the 'colour temperature' or colour value of light is measured, from red to orange to yellow, to white to blue. It corresponds to the colours emitted from an iron bar when heated through a range of temperatures.

KNOT GARDEN Traditional garden design where the ground-plan follows a complex, interwoven design formed in turf, planting or hedges.

LINSEED OIL Oil from the flax plant, traditionally used in paint and varnish manufacture, and now supplanted by synthetic oils and resins. One of a range of naturally occurring 'drying oils' that harden to a dry skin.

LUMP HAMMER Heavy, square, hand hammer.

MARINE PLY Plywood used in boat manufacture and consequently water-resistant.

MULCH MAT Mat of plastic, felt or rubber designed to sit at the base of newly-planted shrubs and trees to suppress weeds.

OEIL DE BOEUF Literally 'bull's eye'. A decorative window, usually round or oval.

PAVERS Tiles or bricks designed specifically for flooring.

PERMACULTURE Method of cultivation and care for the external environment, based on sustainability.

pH (of soil) Measurement of a soil's acid/alkaline levels that is crucial to successful planting.

POLYMERS Long-chain molecules found in synthetic plastics that bond to each other to form matrices. Polymer paints dry by the evaporation of solvents to leave a tough, freshly-formed matrix of polymers, a hard skin.

PORTLAND CEMENT Grey cement, usually made from clay and chalk according to a process patented in the eighteenth century.

REFRACTION A phenomenon whereby a transparent material will bend light or split it into its component wavelengths.

SCALPINGS Clay and stone mix coarse gravel.

STADDLESTONE Traditional tall stone used to support English timber grain stores off the ground to prevent rat infestation.

STRAWBERRY NETTING Fine, open netting used to protect soft fruit from bird damage.

TOPIARY Hedging cut to decorative shapes.

WILLOW WITHIES Tall stems of a variety of willow, *Salix viminalis*, coppiced for use in hurdle manufacture.

ZEN GARDENING A style of gardening developed by Zen Buddhist monks and reflecting their philosophy.

Suppliers

AQUATIC PRODUCTS

Lotus Water Garden Products Ltd
(pumps, ponds and sundries)
Junction Street
Burnley
Lancashire BB12 0NA
Tel: 01282 420771
Fax: 01282 412719

Oasis Water Garden Products Ltd
(pumps, ponds and sundries)
Units C1 & C2
Deacon Industrial Estate
Chickenhall Lane
Eastleigh
Hants SO50 6RS
Tel: 01703 602602
Fax: 01703 602603

COPPICE WOOD, HURDLES, SCREENING AND WOODS

Agriframes Ltd
(peeled reed, split bamboo, coppiced
willow and heather screening)
Charlwoods Road
East Grinstead
Sussex RH19 2HG
Tel: 01342 310000
Fax: 01342 310099

English Hurdle
(willow withies, hurdles, lining, willow
screens and plant frames)
Curload
Stoke St Gregory
Taunton
Somerset TA3 6JD
Tel: 01823 698418
Fax: 01823 698859

Withy Works
(bespoke work in coppice wood)
3 Victoria Road
Frome
Somerset BA11 1RR
Tel: 01373 465659

A J Charlton & Sons Ltd
(oak and other hardwoods)
Frome Road
Radstock
Somerset BA3 3PT
Tel: 01761 436229
Fax: 01761 433903

GARDEN FURNITURE

Jason Griffiths
(hurdles and coppice wood furniture)
Higher Tideford
Cornworthy
Totnes
Devon TQ9 7HL
Tel: 01803 712387
Fax: 01803 712388

Hazel Design
(coppice wood furniture)
Cowstalls
Gate Farm
North Road
Chideock
Dorset DT6 6LF
Tel: 01297 35656

Gaze Burvill Ltd
(contemporary and traditional
well-made furniture)
Newtonwood Workshop
Newton Valance
Alton
Hants GU34 3EW
Tel: 01420 587467
Fax: 01420 587354
e-mail: gazeburvil@AOL.com

Chatsworth Carpenters
(beautifully made historic
furniture designs)
Estate Office
Edensor
Bakewell
Derbyshire DE45 1PJ
Tel: 01246 582242
Fax: 01246 582394

Frolics of Winchester
(trellis, profiles and theatrical
embellishments)
82 Canon Street
Winchester
Hants SO23 9JQ
Tel: 01962 856384
Fax: 01962 844896

GARDEN ORNAMENTS

Bulbeck Foundry (lead statuary)
Unit 9
Reach Road Ind Est
Burwell
Cambridgeshire CB5 0AH
Tel: 01638 743153
Fax: 01638 743374

Avant Garden
(contemporary garden fixtures)
77 Ledbury Road
London W11 2AG
Tel: 0207 229 4408
Fax: 0207 229 4410

Barbary Pots
(hand-thrown pots)
45 Fernshaw Road
London SW10 0TN
Tel: 0207 352 1053
Fax: 0207 351 5504

Capital Garden Products
(fibreglass reproductions)
Gibbs Read Barn
Pashley Road
Ticehurst
East Sussex TN5 7HE
Tel: 01580 201902
Fax: 015809 201093

Redwood Stone
(stone garden ornaments)
The Stoneworks
West Horrington
Wells
Somerset BA5 3EH
Tel: 01749 677777
Fax: 01749 671177

Triton Castings
(high-quality reproduction stone casting)
Torbay Road Trading Estate
Torbay Road
Castle Cary
Somerset BA7 7DT
Tel: 01963 351653
Fax: 01963 351656

LIGHTING

The Light Corporation
(exterior lighting)
Unit 21B1 Bourne End Mills
Bourne End Lane
Hemel Hempstead
Hertfordshire HP1 2RN
Tel: 01442 877400
Fax: 01442 877500

Iguzzini Illuminazione UK Ltd
(high-specification exterior lighting)
Showroom: Business Design Centre
Unit 310-311
52 Upper Street
London N1 0QH
Tel: 0207 288 6025
Fax: 0207 288 6057

Price's Patent Candle Company
(outdoor candles, lanterns and
garden flares)
110 York Road
London SW11 3RU
Tel: 0207 228 3345
Fax: 0207 738 0197

Bruce Munro
(garden lighting design)
Paint & Light
Pear Tree Cottage
Wanstrow
Shepton Mallet
Somerset BA4 4TF
Tel/Fax: 01749 850903

MOSAICS, TILES AND CERAMICS

Focus Ceramics Ltd
(huge range of tiles and mosaics)
Unit 4, Hamm Moor Lane,
Weybridge Trading Estate
Weybridge
Surrey KT15 2SD
Tel: 01932 854881
Fax: 01932 851494
e-mail: focus@dial.pipex.com

Francis Ceramics
(frost-proof, hand-glazed tiles)
Llandre
Llanfyrnach
Dyfed SA35 0DA
Tel: 01239 831657
Fax: 01239 831857

MULCHES, GRAVEL AND STONES

Windmill Aggregates Ltd
(Crystaleis – crystal gravel 100% recycled
glass in assorted colours)
Windmill Works
Aythorpe Roading
Great Dunmow
Essex CM6 1PQ
Tel: 01279 876887/987
Fax: 01279 876959

Kirker, Greer Wholesale Ltd
(assorted oyster shells)
Belvedere Road
Burnham-on-Crouch
Essex CM0 8AJ
Tel: 01621 784647
Fax: 01621 785546

NURSERIES

Downderry Nursery
(specialist lavender grower)
Pillar Box Lane
Hadlow
Tonbridge
Kent TN11 9SW
Tel: 01732 810081
Fax: 01732 811398

Green Farm Plants
(unusual hardy perennials and
grasses)
Bury Court
Bentley
Farnham
Surrey GU10 5LZ
Tel: 01420 23202
Fax: 01420 22382

Iden Croft Herbs
(herbs, bee and butterfly plants)
Frittenden Road
Staplehurst
Kent TN12 0DH
Tel: 01580 891432
Fax: 01580 892416

Squires Fruit and Flowers
St Kilva
The Square
Mere
Wilts BA12 6DJ
Tel: 01747 860300

Tendercare
(mature plants and trees,
including bamboo)
Southlands Road
Denham
Uxbridge
Middlesex UB9 4HD
Tel: 01895 835544
Fax: 01895 835036

PAVING MATERIALS

Marshalls Mono Ltd
(full range of paving materials)
Hall-ings
West Lane
South Owram
Halifax
West Yorks HX3 9TW
Tel: 01422 306300 (Customer Service)

York Handmade Brick
(handmade terracotta, bricks and tiles)
Manor Farmhouse
Hulcote
Towcester
Northants NN12 7HT
Tel: 01327 350278
Fax: 01327 358820

Bibliography

SOIL AND COMPOST

Glenfields Organic
(peat-free soils and compost)
Glenfield Farm
Haselbury
Crewkerne
Somerset TA18 7NZ
Tel: 0460 73251

Greenfix Ltd
(specialists in soil stabilization and
erosion control)
Harcourt Mews
Royal Crescent
Cheltenham
Gloscestershire GL50 3DA
Tel: 01242 700092
Fax: 01242 700093

STAINS AND PAINT

Cuprinol Ltd
(wood stains, wood colouring products
and low toxicity wood preservative)
Adderwell
Frome
Somerset BA11 1NL
Tel: 01373 475000
Fax: 01373 475050

SUNDRIES

Wicksteed Leisure Ltd
(recycled rubber flooring for children's
play areas)
Digby Street
Kettering
Northants NN16 8YJ
Tel: 01536 517028
Fax: 01536 410633
e-mail: play@wicksteed.co.uk

Stitchcraftsman Ltd
(canopies and tents made to order)
Unit 2 Combe Buildings
Whatley
Somerset BA11 3JU
Tel: 01373 836008
Fax: 01373 836007

The Malabar Cotton Company
(cotton fabrics and trimmings)
31-33 The south Bank Centre
Ponton Road
London SW8 5BL
Tel: 0207 501 4200
Fax: 0207 501 4210

Builders Iron & Zincwork Ltd
(zinc and other metal sheeting)
Millmarsh Lane
Brimsdown
Enfield
Middlesex EN3 7QA
Tel: 0181 4433300
Fax: 0181 804 6672

TRELLIS AND EDGING

Forest Fencing Ltd
(fencing panels, trellis and forest floor
tiles)
Stanford Court
Stanford Bridge
Nr Worcester
Hereford & Worcester WR6 6SR
Tel: 01886 812451
Fax: 01886 812343

Ever Edge
(steel path edging)
The Willows
Ford Heath
Shrewsbury
Wilts SY5 9GX
Tel/Fax: 01743 860405

Cooper, Guy, and Taylor, Gordon,
Paradise Transformed,
The Monacelli Press, 1996,
ISBN 1-885254-35-0

Holden, Robert,
International Landscape Design,
Lawrence King, 1996,
ISBN 1-85669-085-7

Jarman, Derek,
Derek Jarman's Garden,
Thames & Hudson, 1996,
ISBN 0-500-01656-9

Landsberg, Sylvia,
The Medieval Garden,
British Museum Press, 1995,
ISBN 0-7141-2080-4

Lyall, Sutherland,
Designing the New Landscape,
Thames & Hudson, 1997,
ISBN 0-500-28033-9

Schroer, Enge,
Garden Architecture in Europe 1450-1800,
Taschen, 1992,
ISBN 3-8228-0540-8

Valery, Marie-Françoise,
Gardens in France,
Taschen, 1997,
ISBN 3-8228-7746-8

Index

AUTHOR'S ACKNOWLEDGEMENTS

I would like to thank Denise Bates at Ebury Press, Vanessa Courtier and Judy Spours for being such a supportive and co-operative team. Also Gilly Love for styling, Ruth for her administration, Andy Hobson for helping me to build our garden and complete the projects, and Tim Mercer for being that extra 'eye'. My wife also deserves unmitigated thanks and praise for tolerating the upheaval to our domestic lives and the flower beds.

Thanks must also go to Marshalls for supplying paving bricks, Forest Fencing for trellis, Agriframes for matting, Wicksteed for rubber play matting, Windmill Aggregates for glass mulch, Malabar for fabrics, English Hurdle for willow, Frome Reclamation for beams and tiles, Cuprinol for timber treatments and paints, Lotus Pumps for pond equipment and The Light Corporation for supplying garden lighting.

PHOTOGRAPHIC ACKNOWLEDGEMENTS

2-5 Tim Mercer; 11 Ianthe Ruthven/designer Charles Jencks; 12 Christian Sarramon; 13 Lanny Provo/architect Carlos Zapata/Jungles, Los Angeles; 14 Tim Mercer; 17 Jerry Harpur/designer Topher Delaney; 18 Jerry Harpur/designer Robert Tjebbes, Amsterdam; 19 Elizabeth Whiting & Associates/David Markson; 20-21 Tim Mercer; 23 Lanny Provo/Jungles/Yates/Amanda Jungles in South Miami; 24 Marianne Majerus; 25 Jerry Harpur/Yacout Restaurant, Marrakesh; 26 Tim Mercer; 27 Lanny Provo/Jungles Los Angeles; 28 Lanny Provo/Jungles Los Angeles; 30-31 Tim Mercer; 33 Courtesy of Martha Schwartz, Inc.; 34-35 Tim Mercer; 37 Deidi von Schaewen/Festival International des Jardins, Château de Chaumont-sur-Loire; 38 Jerry Harpur/designer Terry Welch, Seattle; 39 Jerry Harpur/designers J Sordoille, A Sottil and V Martinez, Chaumont Festival, France; 40 Axiom/James Morris; 41 Courtesy of Martha Schwartz, Inc.; 42 Deidi von Schaewen/Château de Vendeuvre à Saint-Pierre-sur-Dives in Normandy; 43 Jerry Harpur/designers Bradley Dyruff & Frances Shannon, Santa Barbara, California; 44 Vincent Motte/private garden near St. Tropez; 45 Andrew Lawson/designer Ivan Hicks; 46 Jerry Harpur; 46-47 Garden Picture Library/J S Sira; 47 Marianne Majerus; 48-49 Lanny Provo/Jungles/Yates; 50 Marianne Majerus/designer Paul Cooper; 51 Tim Mercer; 52 Marianne Majerus; 52-53 Andrew Lawson; 53 Garden Picture Library/Ron Sutherland; 54-60 Tim Mercer; 61 all Tim Mercer except 61 below centre Andrew Lawson; 62 Andrew Lawson; 63 above Lanny Provo/Morykami Delray beach, Florida; 63 below Beatrice Pichon Clarisse/designer Alexandre Thomas; 64 Marianne Majerus/Chenies Manor, Hertfordshire; 64-65 Tim Mercer; 65 Christian Sarramon; 66 Tim Mercer; 67 Christian Sarramon; 68 Tim Mercer; 69 above Andrew Lawson; 69 below Tim Mercer; 70 above, centre & below right Tim Mercer; 70 below left Andrew Lawson; 71 Tim Mercer; 72 Andrew Lawson; 73 Beatrice Pichon Clarisse/designer Roland Specker; 74-82 Tim Mercer; 83 above Beatrice Pichon Clarisse/designers Camille Muller and Hugues Peuvergne; 84-86 Tim Mercer; 87 above left Jerry Harpur/designer Margot Knox, Melbourne; 87 above centre & right Tim Mercer; 87 centre Tim Mercer; 87 centre left Garden Picture Library/Ron Sutherland; 87 centre right Marianne Majerus; 87 below Tim Mercer; 88 Tim Mercer; 89 above Lanny Provo/Jungles/Yates; 89 below Vincent Motte/landscape designer Erwan Tymen, UK; 90-91 Tim Mercer; 92 Garden Picture Library/Ron Sutherland; 93 above Tim Mercer; 93 below Marianne Majerus; 94 Tim Mercer; 94-95 Jerry Harpur/designer Margot Knox, Melbourne; 95-114 Tim Mercer; 115 above left & above right Tim Mercer; 115 above centre Jerry Harpur/designer Isabelle C. Greene, Santa Barbara, California; 115 centre left Jerry Harpur/designer Mirabel Osler, Ludlow, Shropshire; 115 centre and centre right Tim Mercer; 115 below left Andrew Lawson; 115 below centre Tim Mercer; 115 below right Jerry Harpur/designer Lon Shapiro, San Francisco, California; 116 above Jerry Harpur/designer Jim Matsuo, Santa Monica, California; 116 below Marianne Majerus; 117 Tim Mercer; 118 Jerry Harpur/John Wheatman, San Francisco, California; 118-119 Deidi von Schaewen/Desert de Retz, in Chambourcy near Paris; 119 Jerry Harpur/designer Mirabel Osler, Ludlow, Shropshire; 120 Beatrice Pichon Clarisse/Gardens of 'Prieuré N. D. d'Orsan', France; 121 left Jerry Harpur/designer Lon Shapiro, San Francisco, California; 121 right Andrew Lawson/designer Paul Anderson/Man with hands on knees/RHS Gardens, Rosemoor; 122 Tim Mercer; 123 above Elizabeth Whiting & Associates/Michael Nicholson; 123 below Jerry Harpur/designer Isabelle C. Greene, Santa Barbara, California; 124-141 Tim Mercer; 142 left Tim Mercer; 142 right Jerry Harpur/design C Cheikh-Gonzales & I Ropelato, Chaumont Festival, France; 143 Garden Picture Library/Gary Rogers; 144 Vincent Motte/a sculpture by Bruno Romeda in a garden near Grasse; 145 above Tim Mercer; 145 below Beatrice Pichon Clarisse/Gardens of 'Prieuré N. D. d'Orsan', France; 146 Tim Mercer; 146-147 Derek Fell/Cevan Forristt; 147 Tim Mercer; 148 Tim Mercer; 149 above Tim Mercer; 149 below Jerry Harpur/designer Jeff Mendoza; 150-164 Tim Mercer; 165 above left and above centre Neil Wilkin; 165 above right Tim Mercer; 165 centre Tim Mercer; 165 below left & below centre Tim Mercer; 165 below right Jerry Harpur; 166 Jerry Harpur/designers Little & Lewis, WA, USA; 166-167 Andrew Lawson/designer Anthony Noel; 167 Neil Wilkin/Guus Rijven; 168 left Tim Mercer; 168 right Neil Wilkin/Guus Rijven; 169 Tim Mercer; 170 Andrew Lawson; 171 Tim Mercer; 172 above Tim Mercer; 172 below Neil Wilkin/Guus Rijven; 173 Vladimir Sitta/Terragram Landscape Architecture and Urban Design; 174-178 Tim Mercer; 179 above Clive Nichols/Garden & Security Lighting; 179 below Tim Mercer; 180-183 Tim Mercer.